Advertising Campaign Design

Advertising Campaign Design

Just the Essentials

Robyn Blakeman

M.E.Sharpe
Armonk, New York
London, England

Library of Congress Cataloging-in-Publication Data

Blakeman, Robyn, 1958–
Advertising campaign design : just the essentials / by Robyn Blakeman.
 p. cm.
Includes bibliographical references and index.
ISBN 978–0-7656–2552–6 (cloth : alk. paper) — ISBN 978-0-7656-2553-3 (pbk. : alk. paper)
1. Advertising campaigns. I. Title.

HF5837.B53 2011
659.1′13—dc22 2010054314

Printed in the United States of America

The paper used in this publication meets the minimum requirements of
American National Standard for Information Sciences
Permanence of Paper for Printed Library Materials,
ANSI Z 39.48-1984.

∞

IBT (c) 10 9 8 7 6 5 4 3 2 1
IBT (p) 10 9 8 7 6 5 4 3 2 1

Contents

Introduction vii

Part I. Understanding What Drives a Campaign 1

 1. Advertising and the Campaign Process 3
 2. Research Helps Define the Target and the Message 27
 3. The Role of Branding and Positioning in a Campaign 38
 4. Bringing the Business of Creative to Life 50
 5. Type: Giving the Brand a Voice 65
 6. Copywriting and Layout Nuances 78

Part II. Campaigns Speak Through Numerous and Diverse Media 101

 7. Public Relations 103
 8. Traditional Advertising 124
 9. Out-of-Home 148
 10. Direct Marketing 157
 11. Sales Promotion 174
 12. Electronic and Mobile Media 187
 13. Guerrilla and Other Forms of Alternative Media 208

Glossary 225
Bibliography 233
Index 237
About the Author 248

Introduction

Advertising campaign development is a complex creative process that fuses a strategic business plan with a great idea—an idea that can be easily used and consistently recognized across a diverse mix of media vehicles. This formula has been around for more than a few decades, so you would think there would be dozens of books available on the subject, right? Many large texts do offer individual chapters on advertising design, but few, if any, provide comprehensive coverage of campaign design or explain how to adapt a concept to a strategic business plan or to varied media vehicles.

Advertising Campaign Design: Just the Essentials fills the informational gaps in other texts by offering a straightforward yet extensive look at the varied issues concerning campaign design and development. My simple step-by-step approach dissects the creative process necessary to design a successful Integrated Marketing Communication (IMC) campaign one topic at a time, creating an invaluable research tool that small business owners, professors, and students alike will refer to time and again for information on both the strategic development and design of campaigns. Furthermore, this qualitative study helps break down the campaign development process into smaller, more manageable and digestible chunks of information, thereby erasing the fear and prejudice that typically surround the design process. It is my hope that readers will find this text an invaluable research, business, and design development tool.

Because today's advertising campaigns are multifaceted, creative teams need to possess more than just basic design skills: they need a comprehensive mixture of business knowledge and an abundance of creative ingenuity. Both must be harnessed to visually and verbally manipulate the various media vehicles used to deliver a brand's overall message.

Topics for discussion in this volume are organized into four separate development issues. The first focuses on how to develop a business plan that will lay the foundation for the creative development stage.

The second focuses on the development of a creative idea. This idea must be imaginative, memorable, and designed to resonate with the target audience.

Emphasis is placed on how the development of a good idea is not subjective but rather a precisely planned and executed visual and verbal experience that strategically accomplishes the objectives set forth in the overall business plan.

The third topic aims to simplify the design process and identify those components that, when repetitively used across multiple media, help an idea consistently maintain its visual/verbal voice. The use of repetition and consistency gives each campaign an individualized look and sound that can successfully establish or enhance a brand's image and build equity.

Finally, we will take an in-depth look at the multitude of traditional and alternative media vehicles that, when employed strategically, will deliver the strongest message to the right target at the right time. This media specific examination will dissect the creative nuances associated with each medium and look at how each visual/verbal component can be used to exploit the strengths of various vehicles.

To take even more of the fear out of design, student examples have been used throughout the text to demonstrate varied design options, as well as to show wide-ranging approaches to style, the process of developing an idea, and what is possible when first learning design. Most of the apprehension generated by the term "design" stems from the assumption that, to be successful in the field, you have to be able to draw; however, good design is actually the result of a great idea that solves a client's communication problem. The layout of the idea is the easy part!

I would like to dedicate this book and these ideas to every student or businessperson who has ever sworn they had no talent, or claimed they have never had a good idea. Each figure used throughout the text shows creative and business types alike that a good idea is based more on knowledge than on well executed technique. Power is in the construction of the details in a strategically pleasing way. Working from a strong knowledge base ensures a good idea is just as powerful when shared verbally as when drawn physically on the page.

Part I

Understanding What Drives a Campaign

1

Advertising and the Campaign Process

Figure 1.1 **Sample Ad: Sharpie**

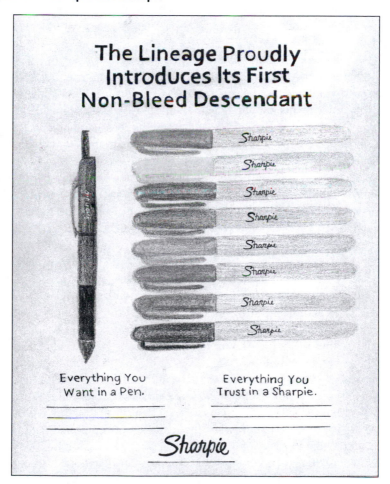

Source: Created by Caitlin Bradley, The University of Tennessee, Knoxville.

Defining IMC and Its Role in Advertising

In this saturated world of advertised messages, the only way to reach the targeted consumer or those buyers that research has determined are most likely to purchase the product or use the service is to take an integrated approach.

Integrated Marketing Communication (IMC) is all about creating a relationship with the intended *target audience* and delivering one coordinated message through multiple *media vehicles.*

Customized advertising efforts like those used in IMC are a far cry from the simple sales-oriented approaches used in traditional advertising efforts. It is no longer feasible to send out an impersonal, generalized message to a mass audience. IMC works to build a long-term one-on-one relationship between buyer and seller by engaging the target in a two-way exchange of information.

IMC makes the traditional mass-advertised message personal. Computerized databases have given the consumer a name and an identity, allowing marketers to personalize advertising efforts based on interests and/or past purchase behavior. This knowledge also helps to isolate those media vehicles most likely to be heard, read, or viewed by the targeted consumer.

Consumer driven, IMC works to build a long-term brand-loyal relationship with the target. In order to do this successfully, IMC relies less on traditional vehicles such as print (newspaper and magazine) and broadcast (radio and television) and more on *alternative media* vehicles, including direct marketing, *out-of-home media* (outdoor, transit, or point of purchase advertising), sales promotions, various interactive vehicles, and *guerrilla marketing* tactics. These methods reach the target where they are and with a message they can relate to.

The use of traditional vehicles alone requires frequent repetition before a message is remembered and acted upon. A customized IMC campaign is individually targeted, requiring less advertising to encourage repurchase. This highly targeted approach encourages *brand loyalty,* employs less media waste, and allows the advertised product or service to be individualized to fit the target's overall lifestyle.

It took marketers a long time to understand the lifetime value of existing customers. Research proves that it is more expensive to advertise repeatedly than it is to retain existing consumers: a loyal consumer will buy without the repeated urging of advertising and without special promotions.

Many argue that IMC is popular only because the recession of 2008–2010 has caused marketers to use more media outlets to reach a more fractionalized target. Although recessionary times do call for better-managed advertising budgets, it is IMC that has put a greater amount of emphasis on relationship-

building tactics by personalizing the overall visual/verbal message. More important, the more diverse the choice of vehicles collectively delivering a cohesive visual/verbal message, the better the return on investment (ROI) will be. In simpler terms, the marketer or client will make more money than he or she spent.

The recession may have temporarily altered buying habits, but it has not changed consumer media habits. Buyers are still searching the web, blogging, tweeting, chatting on social media sites, and talking and texting on their cell phones. These interactive media outlets engage the consumer in a way that traditional media vehicles cannot. Because of this, technology has forever changed how corporations market their brands. Thanks to the Internet and other forms of electronic media, consumers can check on the prices and quality of goods from the comfort of their own homes or offices, by using any number of interactive options to compare and contrast user experiences. Today's savvy consumers have taken control of the buying experience by managing whom they buy from, as well as when, where, and how they do their buying.

Traditional Advertising versus IMC

Traditional advertising—also known as mass media advertising because it concentrates on communicating to a mass, mostly unidentifiable audience— relies on a generalized message delivered through mass media vehicles such as print or broadcast. Although not highly targetable, it is still great for launching or reinventing existing *brands,* creating *brand awareness,* and building *image.*

Traditional advertising used alone is not consumer focused, does not encourage feedback, and thus does not create a relationship with the target. In today's diverse media environment, traditional vehicles will not even be employed if research has determined that alternative media options will more successfully reach the target with the most engaging message. IMC on the other hand, uses a diverse *media mix* and focuses directly on the consumer. Using databases or computerized lists that electronically catalog the target's personal information and buying habits, advertising efforts can address the target by name, identify target interests and needs, and allow for more individualized and personalized messages.

When the promotional mix employs both traditional and alternative media vehicles, the message has a greater chance of reaching the target with an integrated message. To create more interactive and engaging opportunities, consider employing both media options simultaneously. For example, research has shown that many consumers watch television or listen to the radio while using their computers. Consider turning listening—a passive activity—into an interaction

with the message—an active and more memorable activity. Simple examples of this tactic involve the inclusion of website names in television advertising or directing radio listeners to a website for contest information or coupons.

Successful engagement must also ensure all internal and external contacts are working from the same page and are integrating knowledge in three key ways: (1) by offering quality products the customer needs and wants; (2) by using the talents of educated employees who both understand and know how to market the product or service; and (3) by presenting a brand that offers the target a relevant reason to buy. Internal or corporate employees such as customer service representatives need to know what the external advertising efforts are saying and promising. Any problems can affect the brand's or service's image.

Alan Mitchell, in an article appearing in the *Journal of Marketing Management,* sums up coordinated internal and external messaging this way: "An organization can only 'walk the talk' when its managers deliberately shape its internal reality to align with its brand promise. . . . [The brand's] values must be internalized by the organization, shaping its instinctive attitudes, behaviors, priorities, etc."

What Makes a Campaign a Campaign?

Basically, an advertising *campaign* can be defined as a family of ads that shares a visual/verbal identity and promotes a single idea to a defined target audience. Multiple targeted media vehicles are used to reach the intended audience with a specific message about a particular product, service, or company. A multimedia campaign's job is to introduce a project or service, create an identity, build increasing awareness for the product or service, and promote a sale.

A campaign can be directed at either a business or a consumer. Either way, it is safe to say that research has already identified the target's needs and problems: The goal of all advertised messages—and the first step in engaging consumer interest—is addressing those needs and solving those problems. Ineffective messages often recognize the problem yet fail to offer a solution.

Although the visual/verbal style of a campaign is delivered through multiple media vehicles, it is defined by a very individualized and personalized repetitive voice and creative style. The *tone* set by this voice and style will reflect the brand's identity, use, and reputation—often for years.

It takes more than a good idea and a coordinated look to ensure a campaign's success. Good timing, appropriate media use, and a bit of old-fashioned luck are also required. While it used to be common to see almost every campaign launch use traditional media, today's inventive and highly targeted campaigns may ignore traditional vehicles altogether. Quite often, media choices will rely on vehicles more customized to reach the target, among them the Internet, direct mail, sales promotions, and mobile or social media outlets.

In twenty-first century advertising, nothing is traditional. The most successful campaigns go where the target is and capture their attention with unusual and engaging devices such as intercept teams, mobile advertising, and cinema, as well as guerrilla events and *product placement,* to name just a few of the hundreds of media options available to today's advertiser.

Every product or service needs advertising in order to stand out from competing brands. A good ad campaign gets a product's name, *logo,* and purpose in front of an apathetic public that sees well over a thousand or more advertising messages every day. To help break through the advertising haze, it is important for every campaign to have its own look, style, and personality. The total effect of a successful ad campaign is greater than any of its individual parts. The combined impact of the visual/verbal identity employed can push the *key consumer benefit* to the right target, stand out from the competition, and accomplish a set of communication objectives with the right strategy, in the right media. Success takes time—most campaigns will take anywhere from 90 days to a year to complete—and the length of a given campaign is typically determined by what needs to be accomplished, the product's life cycle, and the overall strength of the competition, to name just a few key factors.

Over a product's lifetime, a consistent theme is established, developed, and molded into a lasting image. Apple has always promoted its hipness, ingenuity, and innovative spirit to those target members who would rather be on the cutting edge than simply one of the crowd. Allstate wants you to know "You're in Good Hands," and Capital One wants you to think about "What's in Your Wallet?"

Traditionally, advertising campaigns often lasted for years, but today this trend has become less and less common. Why? Because in a world of multiple media options, disinterested targets, and product parity, it is important for campaigns to be ever evolving, ever ramping up their image and goals. When adjustments are warranted, it is important that they be integrated into the campaign slowly and that they avoid any abrupt changes that might confuse or even anger loyal brand users. To avoid the appearance that messages lack brand integrity or clear direction, many campaigns will tweak their messages while retaining *slogans* or *taglines* and/or character representatives indefinitely. Familiarity, after all, suggests quality, longevity, and reliability.

The Life Cycle of an Advertising Campaign

A campaign's life cycle will assume several different incarnations as it launches, evolves, is improved upon and eventually put out to pasture to make room for the look and sound of a new generation of consumers. When to toss or evolve a brand's message often depends on where it is in its *life cycle stage.* Most successful brands will go through three stages: (1) a new

product launch, 2) a mainstream or maintenance phase, and (3) reinvention. Each stage requires a different message and often employs different media vehicles to reach the target. Let's take a quick look at each one.

A new product launch typically employs traditional media vehicles that provide broad reach and the ability to build brand awareness and promote image. As the brand reaches phase two, mainstream popularity in the marketplace, it requires not only less advertising, but the use of less traditional advertising vehicles. At this point, the campaign can make use of alternative media to reach loyal users by name, wherever they are, and with a message they will respond to. The goals during this phase are to remind users, to strengthen the relationship with the buyer, and to build or maintain *equity*. The third phase, reinvention, comes into play when a brand (1) needs a face-lift to update its image or promote a new and improved feature, or (2) must overcome a damaged reputation.

There are no individual media vehicles or outlaw messages in an IMC campaign. Each vehicle must convey the same look and message. Any contact points, such as customer service representatives or sales clerks, must be aware of the campaign's message and promotional efforts, in order to personally convey or represent the advertised message and accomplish the campaign's overall *objectives.*

Campaigns can run into the millions of dollars, so why use them when you can run an ad or two as needed? Good question. Advertising today bombards consumers, so in order for a brand to be top of mind, or the first brand people turn to, a product needs to keep its name and reputation in the public arena. A single ad buy is successful only if it can guarantee the target will see that particular media vehicle and need that particular item on that one day or within that one week when it is advertised. Repetition, reliability, and quality are what make a brand memorable. One ad cannot build an image, promote reliability, or guarantee quality. To ensure the ad is recognizable, understood, and acted upon requires the synchronization of all images and all messages.

If a single ad is needed, for whatever reason, it is important to make sure the ad uses the same imaging and messaging devices used in the campaign. Even though it may seem like an anomaly in what was an orderly pattern, it is important it be seamlessly integrated into the campaign, matching both the existing voice and style as closely as possible.

Marketers employ a campaign for several reasons, but the four most common are to: (1) increase brand awareness; (2) launch a new product; (3) create name/brand recognition; and (4) bring attention to a reinvented or improved product. To accomplish any of the above it is important to employ a diverse array of media vehicles that not only reach the target but also promote trial with action devices such as contests and sweepstakes, free trials samples, or coupons. The timing of an advertising campaign is also very important. What kind of message will be used and when? What kind of media vehicle(s) will

deliver the message and when? Will more than one message in multiple media be running at the same time? Will *public relations* be used to create interest? Will sponsorships, coupons, or sample promotions be used to encourage trial and/or feedback?

The answers to these questions and more will be found in the multiple media options and unlimited creative options available to both traditional and alternative media vehicles. The goal is to create a memorable visual/verbal identity for products even in the most saturated brand categories, by making them stand out from competing products.

Campaigns use a single voice or key consumer benefit, talk to a single target audience, and employ a consistent set of cohesive images and messages throughout multiple and very different media vehicles. These unifying images include headlines, *layout styles, typefaces,* photographs, illustrations or graphics, color(s), and perhaps employ the services of a spokesperson or character representative or *jingle.* Longevity describes a successful campaign, as does its ability to build or improve a brand's image and create equity while fostering a long-term relationship with the targeted consumer. A campaign is only as good as the product or service, its customer service efforts, and a brand's reliability to perform consistently with each and every purchase.

Each touchpoint that members of the target audience have with the product or service must engage them by requiring them to do something, whether it is going to a website for coupons, visiting a showroom, taking a test drive, trying a product sample, or attending a sponsored event.

Deciding on the Type of Campaign to Employ

The type of campaign that will be used for a given brand is nowhere near as diverse as the creative methods available to bring them to life. Choices generally fall into one of five basic categories: national, local, service, corporate, and retail. Let's take a quick look at each one.

National Campaigns

National campaigns are usually undertaken by the corporate elite. They have large enough budgets to create spectacular ads that are seen across the country and often employ a diverse array of media vehicles. The main job of these vehicles is to attract the target's attention—wherever they may be. These are the clients who can also afford to dip their toes into *new media* and participate in creative guerrilla marketing events. Clients are seen in the news and at events large and small across the United States. Most national campaigns

represent brands that are so well known and trusted that creative efforts need be little more than a reminder of the name, quality, service, and longevity.

Local Campaigns

Local campaigns feature local businesses in a specific area. They are often tied to local events or tout their length of time in a community. Such campaigns usually feature a special price or some type of sales event to encourage immediate action on the part of the consumer. National brands can run local campaigns if they are involved in local sports or other events, or if sales are sluggish in a particular area.

Service Campaigns

The job of a service campaign is to sell a service—something not as tangible as a product. Everybody sells customer service, but few offer it on a consistent basis. We can't eat or wear a service; instead, we experience or participate in it. The best service campaigns use an *inside out* approach, where employees at every level know what the promotion is, what the company's policies are, and how to solve potential problems. Service campaigns must guarantee that what is being said in advertising and promotional efforts is understood and practiced by every employee who has contact with the target. There is nothing more aggravating than for a consumer to call in about a promotion, only to find out the customer service representative has no idea what they are talking about, puts them on hold, or worse yet, cannot help them at all.

Successful advertising, then, works from the inside out. Suppose an insurance company assures the target that if they remain accident free for the first six months of their policy, the second six months will be free: it's important that the target not be billed for those second six months or told after the fact that they didn't qualify for the promotion in some way. Good service campaigns should promote positive word of mouth while offering the same security, knowledge, and customer care the campaign says it will. Selling a service like carpet cleaning, car repair, or insurance is no different than selling a product. However, it is more difficult to ensure its success, because service campaigns deal with some type of customer service or customer contact issue that cannot be controlled. Any two-way dialog or interaction between buyer and seller is about service.

Corporate Campaigns

Corporate campaigns are all about what the company or organization is doing to help the community or the planet. Being a "green" product these days is

an important political and social issue and is an advantageous way to stand out from competing products. During economic or weather-related hardships, many products become active in national or international projects. International efforts frequently offer money, medicine, or food to undernourished children or war-torn communities around the world. Hair care product giant Paul Mitchell, for example, uses print ads to focus on his Food4Africa project. National projects such as the one sponsored by Tide supplied washer and dryer facilities to areas ravaged by Hurricane Katrina in 2005.

Advertising that focuses on repairing a damaged reputation is something all corporations hope to avoid. The loss of brand-loyal consumers, and thus brand equity, can often be very expensive and time-consuming to remedy. However, in our technology-driven age of blogs, Twitter, Facebook, and YouTube, corporations can respond quickly and publicly to situations or rumors before they become a major crisis. For example, when Domino's Pizza employees in a YouTube video were seen adding disgusting items to a pizza, the president of Domino's quickly responded to rumors by reporting that it was nothing more than a hoax, heading off any further discussions.

Retail Campaigns

Retail campaigns sell price or promote image. Merchants such as Wal-Mart, who sell inexpensive products, tend to push price or volume buying. It is often the only thing that separates them from competitors. The job of a price-based retail campaign is to sell a product, and sell it quickly, not "wow" customers with cutting-edge creative ingenuity.

Image-based retail advertising is most often used by high-end dealers to sell reputation, quality, and so on. This type of retail advertising is typically more creative and emotionally focused, since most of the products in this category are "wants" rather than "needs." Both work at getting the consumer to act now—due to a sale, limited time offers, a coming holiday, or an on-site designer visit. Retail advertising promotes quick action for some kind of reward.

Selling is the ultimate goal of a retail campaign. Techniques may include customer service efforts, store ambiance, sales stickers, coupons, or even the way a purchase is boxed, bagged, or wrapped, to name just a few. Retail campaigns have to do more than just remind the target about their existence. Product parity makes retail advertising about more than shampoo or diamonds: it's about great buys, customer service, social status, the shopping experience, or quick, no-frills service. Retail advertising must inform, entice, and initiate action on the part of the consumer.

Figure 1.2 **Sample Ad: Southwest Airlines**

Source: Created by Carly Reed, The University of Tennessee, Knoxville.

Making the Message Last

"Unless a product becomes outmoded," explains Randall Rothenberg in the book *Where the Suckers Moon: An Advertising Story,* "a great campaign will not wear itself out." A lengthy life span will have a long-lasting effect on brand equity and brand loyalty, so it is important for a campaign's cycle to outlive

those of its competitors. New technology, scientific discoveries, new flavors, sizes, and colors are no reason to change the overall look of a campaign. In order for a brand to be trusted, it must be consistent and have longevity. Pillsbury for example, holds its varied brands together with one consistent character representative (the Pillsbury Doughboy), as does Energizer batteries (with its pink Energizer Bunny).

Brand awareness attaches itself to a consistently used audio or visual cue such as a jingle, a slogan, a character representative, or an easily recognizable spokesperson. Campaigns that are on-target and on-strategy do not need to compete against a competitors' consistently changing message.

The reusability of visual/verbal design elements depends largely on the media vehicles employed in the campaign. Some media vehicles—magazine ads, the Internet, or direct mail pieces, for instance—have a lot of room to talk about the brand. Broadcast vehicles like television only have 30-second spots, but they can make them memorable using sight, sound, and motion. Other vehicles, including out-of-home or mobile advertising, have to get the same point across as those used in more copy-heavy media with as few as five to seven words. How can this be done effectively? Personalize it. Each product or service will have one key consumer benefit or feature/benefit combination that research has shown is important to the target and that the competition is not pushing in their advertising efforts. This one idea is featured in headlines and screamed out in broadcast or other digital media. It's the one point hammered home in seven-hundred words or five.

The media vehicle(s) selected for the campaign should reflect the target audience's lifestyle. If they drive to work, think radio placing the ad during morning and afternoon drive times. If mass transit is the way to and from work, then ads on bus sides or within transit shelters or stations would work well, as would other varied out-of-home vehicles. If they are into gaming, think product placement. If they live in large metropolitan areas, think of guerrilla marketing events. The options are endless.

What Makes a Campaign Fail or Succeed?

It is hard to say what makes one campaign fail and another successful when all things are equal. Sometimes, faulty research techniques are employed, and the message is not strong enough or direct enough to hold the target's attention. Perhaps the message is too complicated to understand or oversimplified to the point that it does not seem special. It is also possible that the media vehicle employed didn't reach the target. Whatever the problem, advertisers keep trying to stand up and stand out against the message sent by their competi-

tors. Failure requires more research to define direction and more one-on-one contact with the target to improve the message.

A good campaign is not based on budget; it is based on a good idea. A larger budget offers up more creative options, but a good idea that's correctly targeted will reach the target no matter what the size of the budget. Great creative is not for every product. In fact, it works best for products we already know intimately, such as Coke, Budweiser, and Apple. This type of advertising simply reminds us about the brand. The ads that do not "wow" creatively are not necessarily unsuccessful. Campaign goals vary: Some products need to introduce who they are, tell us how they work, or show us how they differ from competing products. Others, like direct response ads, overwhelm us with information-heavy ads and fast-talking—often screaming—announcers who not only inform, but also educate their viewers.

So what makes a campaign successful?

1. It is highly targeted.
2. Each ad strongly represents the key consumer benefit in both the imaging and verbal messaging chosen.
3. All advertising and promotional devices strategically accomplish the communication objectives.
4. The key consumer benefit clearly addresses the target's lifestyle.
5. A consistent image and message appear across multiple media vehicles.
6. The brand's identity is clearly and easily recognizable in all advertising and promotional vehicles.
7. The creative package delivers a message differently from that of the competition and talks to the target in a language they can understand.
8. It appears in media vehicles the target is sure to see.

The Look and Sound of a Campaign

For a campaign to be recognized as a series of coordinated messages, it must have both a repetitive visual appearance and a cohesive verbal message, no matter where it appears. A coordinated message consistently uses the same types of visual images, such as similar layout styles, a color or combination of colors, a slogan or tagline, and spokesperson or character representative. Attention to detail is critical to maintaining a visual/verbal identity: all visuals must be similarly sized, cropped, and displayed; all typestyles and logos should be the same size and similarly placed when possible. Elements such as a key consumer benefit, typeface(s), headline style, and copy tone of voice must remain the same throughout the campaign. Determination of the

visual/verbal devices will depend a great deal on the media mix employed in the campaign. For example, how would you turn a copy-heavy direct mail piece into a copy-light text or mobile message? The easiest way is through a consistent key consumer benefit. If the consumer benefit is weak, perhaps a great slogan or tagline is more memorable. The whole point of consistent visual/verbal messaging is to make it memorable through repetition and set it off from the competition.

Employing the Best Media Vehicle to Reach the Target

Once the account, creative, and media teams understand the target to be reached, the problem to be solved, and the feature they need to promote, they can more accurately determine the most appropriate promotional mix that will strategically reach the intended audience. The *promotional mix* or category of vehicles employed in the campaign most commonly includes: public relations, traditional advertising, alternative media, out-of-home, direct marketing, sales promotion, and the Internet. The mix that will be employed depends on how much the target already knows about the product or service.

The *media mix,* on the other hand, dissects the promotional mix down into individual vehicles such as direct mail, TV, magazines, outdoor boards, bus wraps, blogs, text messaging, and so on. The media mix can be either concentrated or assorted. A *concentrated mix* uses one or two single vehicles, whereas an *assorted media mix* uses a variety of vehicles. The choice of mix depends, ultimately, on the budget, the target, and the overall strategic direction of the campaign. Once the creative team knows which promotional and media mix they will be using, they can begin determining how the varied creative ideas will translate between vehicles.

Advertising: A Business First and a Creative Idea Second

If asked, most people would define advertising as a creative process. However, the creative element is really only a small part of the advertising process. Advertising is more about generating revenue than generating a great idea. Determining the right message requires strong business knowledge. Rooted in research, advertising is a business that strategically combines the study of trends, economic cycles, research analysis, idea testing, and media analysis into a creative idea that attracts attention, makes a sale, or encourages further inquiry. Creative output is a by-product of a great deal of research.

These ideas are not just a creative showcase, but also a creative solution to a business problem. They are more than clever slogans or funny television ads; they must be interactive, memorable, relationship-building, informative

devices. Beyond that, campaign efforts must also ensure the target sees the ads, acts on the ads, and then talks about them to friends and family. Giving a campaign life takes a lot of work, time, and people of varied talents.

Successful campaigns are all about education, timing, and flawless execution. Every good idea begins with research on the brand, its target, and its competitors. Before the creative team can even begin the *brainstorming* process, research must first be analyzed and organized into a marketing plan and then dissected, simplified, and presented in a creative brief. Brainstorming sessions must ignite that one great idea. Ads must be designed before photo and television shoots or any events can be planned and then executed. The appropriate paper stock must be bought, promotions announced and developed, and printers and production teams hired. Media must be analyzed and purchased, and a timeline must be laid out to ensure everything happens not only on a budget but also on schedule and without any surprises or hitches.

A well-oiled campaign machine begins by organizing stacks of data into two separate business plans known as a *marketing plan* and a *creative brief.* Let's take a quick look at each one.

It All Begins with a Marketing Plan

The American Marketing Association (AMA) defines marketing as "the activity, set of institutions, and processes for creating, communicating, delivering, and exchanging offerings that have value for customers, clients, partners, and society at large." A definition as it applies to the relationship between marketing and advertising is probably worded best by marketing strategists Al Ries and Jack Trout, who claim that "marketing is simply 'war' between competitors." It is advertising's job to be sure the competition keeps its head down.

Basically, both marketing and advertising need to have the product and/or service defined in the clearest and simplest way so that the most clearly defined target market can be paired with the product or service being advertised. The best way to do this is to dissect the marketing process into digestible parts.

Businesses Use Marketing Plans to Define Action

Great ideas can grow only after the product or service (i.e., the brand) has been thoroughly researched. The client's business plan of action is laid out in a *marketing plan* that defines sales initiatives, usually for the coming year.

This lengthy, detail-oriented plan of action is prepared by the client. The document looks at the brand's overall strengths and weaknesses compared to the competition; it also examines any opportunities and threats the brand

might want to capitalize upon or avoid in the marketplace. The business plan of action is vital for getting a campaign on track: it introduces the target, determines a set of marketing-related (usually sales-oriented) objectives or goals that need to be met, defines a marketing strategy for accomplishing the objectives, analyzes competitors, projects a budget, and finally looks at varied implementation and evaluation techniques.

Because IMC is consumer-centric, a strong marketing plan needs to incorporate a customer feedback mechanism. Such a mechanism makes it easier to determine a single selling point or key consumer benefit that research has guaranteed will attract the target's attention. It will also assist in defining the overall visual/verbal tone of voice to be used throughout the campaign so that an integrated communicated message is mimicked in all advertising and promotional vehicles as well as at any customer contact points.

Once the marketing plan is complete, the creative team will receive a smaller, more concise document known as a creative brief, which focuses on communication initiatives.

The Creative Brief Adapts the Marketing Plan into a Communications Plan of Attack

A creative idea begins life buried under a pile of research. Each image used, and every word spoken, lies somewhere in the dry statistics that make up the creative brief, so before the creative team comes up with one idea, draws one image, or places one word on the page, they need to review the creative brief.

The account executive or agency representative handling an account uses the marketing plan to develop the *creative brief.* A much smaller document, usually no more than one to three pages, the creative brief defines the communications plan of attack. It offers an abbreviated look at what the client wants to accomplish via creative efforts.

Bill Bernbach, in his book *Bill Bernbach Said . . . ,* believes the creative team uses the brief to "bring the dead facts to life." Such an undertaking requires that the team undergo a thorough education on the focus of the communication efforts: the goal is not only to solve the client's business problem, but also to strategically reach and talk to the intended target.

The brief, then, is a document that concerns itself with facts, not creative direction. It does not describe or suggest what the creative efforts should say or show. Instead, it serves as an informational springboard the team will use to generate ideas and solidify the campaign's visual/verbal direction.

Briefs, like marketing plans, vary in length and content, but most will include all or some combination of the following: a target audience profile,

communication objectives, brand features and benefits, product positioning, key consumer benefit, creative strategy, tone, support statement, slogan or tagline, and a logo. Let's take a little more in-depth look at each one.

Target Audience Profile

Successful message construction depends on how well the creative team knows the target. This section will briefly define the *primary target audience* based on *demographic, psychographic, geographic,* and *behavioristic* profiles. Sometimes, advertising efforts will focus on a *secondary target audience,* or those most likely to purchase the product *for* the initial or primary target or influence their purchase. For example, a nutritious cereal for children may have a primary target of moms, with ads placed in *Good Housekeeping* or *Parents* magazine. The secondary market may be children, with a message of good taste and fun appearing in advertising spots on Cartoon Network.

The more the team knows about how the target thinks, what their lifestyle is like, and what they find important, the easier it will be to direct the visual/verbal message directly to them. The target audience or target market is the reason the product or service will ultimately succeed or fail.

Communication Objectives

Communication objectives, as opposed to marketing or sales-related objectives, are the goals advertising and promotional efforts need to accomplish—how the target should think or feel about the brand and what the consumer should do after being exposed to the message, whether it be visiting a brick-and-mortar store, doing further research, or buying on the spot.

Brand Features and Benefits

This section is used to educate the creative team on the brand's main features or attributes and how those features will benefit the target. Because IMC is consumer focused, it is important to push benefits over features. A feature is a specific attribute—color or size, for instance—or may be based on image or status—anything that reflects the target's individual style.

On the other hand, a benefit tells members of the target audience *why* a product or service is important to them. Benefits, therefore, should offer a solution to a problem, enhance image, or improve the target's quality of life. Features cannot sell a product if targets do not know or understand how it will make their lives easier or better. Benefits sell, features support. It is easy

for a competitor to match a feature, but impossible to match a benefit without being repetitious and appearing second best. Benefits are also easier to tie to a creative concept because they have substance and are grounded in what the target finds important.

Product Positioning

Positioning refers to how the brand is thought of or "positioned" in the mind of the consumer in comparison to competing brands. This section should compare and contrast the competition's product or service and current advertising with the client's brand. Knowledge about competing products allows the creative team to set the product apart visually and verbally and exploit areas or features the competition may or may not have overlooked.

Key Consumer Benefit

A key consumer benefit is that one feature/benefit combination that research has shown the target is interested in and will respond to. This benefit, if you're lucky, may be unique to the brand, but it doesn't necessarily have to be. Sometimes competitors ignore the most obvious, mutually inherent qualities common to a certain product and fail to feature them in their advertising efforts. Creative teams can take advantage of such a situation, exploiting these untouted features for their own benefit. The key consumer benefit will become the single visual/verbal voice of the campaign. It will be screamed out in headlines, featured in visuals, and expanded upon in body copy.

The key consumer benefit can be promoted as a *unique selling proposition (USP)*, a *big idea*, or a *multiple selling proposition (MSP)*. The choice of which one to use will be based on the target and objectives to be accomplished. If a brand is new or has a unique feature its competitors do not have, chose a USP. Consider the Apple iPhone: It is unique because it broke new ground, and none of its competitors will ever be able to be "first" with this particular piece of ingenious technology. Use a big idea to creatively promote a commonplace brand or feature as unique, or find a creative way to make it important to the brand and thus the target. Competing products may have the same feature or sell the same service without focusing on it as part of their advertising and promotional efforts. Aflac made their common brand big by using a duck to repeatedly quack out the name, making it both repetitive and memorable. Super Bowl ads usually use a big idea approach to stand out creatively. These two key consumer benefit options typically use one repetitive message in a limited number of media vehicles. An MSP, on the other hand, uses rotating

multiple messages in multiple media to sell its consumer benefits. This tactic allows multiple messages to reach the target no matter where they are or what they are doing. GEICO uses this approach when rotating between geckos, cavemen, and a spokesman.

Creative Strategy

The creative strategy of an ad campaign defines how creative efforts will accomplish the stated objectives, promote the key consumer benefit, and talk to the target. If the strategy reflects the key consumer benefit in a way that will attract the target's attention and encourage action, the strategy is considered on-target. If the choice of visual/verbal direction and media mix reflects the strategy, the campaign is said to be on-strategy.

Tone or Execution Technique

The tone or execution technique gives the key consumer benefit a visual/verbal voice and defines the brand's personality and image. The tone may be overtly humorous, tongue-in-cheek, educational, or scientific in nature, to name a few possibilities, and the ad may feature testimonials or demonstrations to drive home a point.

Support Statement

The support statement is an additional feature/benefit combination that further highlights the key consumer benefit. If the key consumer benefit deals with the virtues of electric-start lawn mowers, the support statement might push cutting range, speed, or ease of starting. Its job is to make the key consumer benefit both irresistible and understandable.

Slogan or Tagline and Logo

The final two elements—the slogan or tagline and the logo—close the brief.

Pulling Off a Successful Campaign

Every campaign has a mission. That mission as laid out in the creative brief must be reflected in every piece of copy and in every visual, no matter what media vehicle is used. It is important that the creative team recheck the brief while developing ideas, as each visual/verbal choice must reflect back to the

Figure 1.3 **Sample Ad: Ray-Ban**

These shades don't have a breaking point.

Ray-Ban introduces the Bender; affordable sunglasses that fit your face and will never break.

We know comfort is essential.

So many color choices, too.

Ray-Ban

Bringing a new outlook.

Source: Created by Allison Schepman, The University of Tennessee, Knoxville.

directives laid out there. Does the creative strategy accomplish the objectives, speak directly to the target, and clearly position the brand away from competing products in some memorable way? If it does, then the campaign is considered on-target and on-strategy.

It takes a lot for a campaign to successfully and repeatedly deliver the campaign's overall message without going astray or becoming boring. To be memorable, ad campaigns must creatively entice, engage, and educate with a cohesive visual/verbal message. In the chapters that follow, we will take a comprehensive look at some of the items that build this cohesive look.

"*Ad Age* Top 100 Advertising Campaigns of the Century"

1. Volkswagen, "Think Small," Doyle Dane Bernbach, 1959
2. Coca-Cola, "The pause that refreshes," D'Arcy Co., 1929
3. Marlboro, The Marlboro Man, Leo Burnett Co., 1955
4. Nike, "Just do it," Wieden & Kennedy, 1988
5. McDonald's, "You deserve a break today," Needham, Harper & Steers, 1971
6. DeBeers, "A diamond is forever," N.W. Ayer & Son, 1948
7. Absolut Vodka, The Absolut Bottle, TBWA, 1981
8. Miller Lite beer, "Tastes great, less filling," McCann-Erickson Worldwide, 1974
9. Clairol, "Does she . . . or doesn't she?" Foote, Cone & Belding, 1957
10. Avis, "We try harder," Doyle Dane Bernbach, 1963
11. Federal Express, "Fast talker," Ally & Gargano, 1982
12. Apple Computer, "1984," Chiat/Day, 1984
13. Alka-Seltzer, Various ads, Jack Tinker & Partners; Doyle Dane Bernbach; Wells Rich, Greene, 1960s, 1970s
14. Pepsi-Cola, "Pepsi-Cola hits the spot," Newell-Emmett Co., 1940s
15. Maxwell House, "Good to the last drop," Ogilvy, Benson & Mather, 1959
16. Ivory Soap, "99 and 44/100% Pure," Procter & Gamble Co., 1882
17. American Express, "Do you know me?" Ogilvy & Mather, 1975
18. U.S. Army, "Be all that you can be," N.W. Ayer & Son, 1981
19. Anacin, "Fast, fast, fast relief," Ted Bates & Co., 1952
20. Rolling Stone, "Perception. Reality." Fallon McElligott Rice, 1985
21. Pepsi-Cola, "The Pepsi generation," Batton, Barton, Durstine & Osborn (BBDO), 1964
22. Hathaway Shirts, "The man in the Hathaway shirt," Hewitt, Ogilvy, Benson & Mather, 1951
23. Burma-Shave, Roadside signs in verse, Allen Odell, 1925
24. Burger King, "Have it your way," BBDO, 1973
25. Campbell Soup, "Mmm mm good," BBDO, 1930s
26. U.S. Forest Service, Smokey the Bear, "Only you can prevent forest fires," Advertising Council/Foote, Cone & Belding
27. Budweiser, "This Bud's for you," D'Arcy Masius Benton & Bowles, 1970s
28. Maidenform, "I dreamed I went shopping in my Maidenform bra," Norman, Craig & Kunnel, 1949
29. Victor Talking Machine Co., "His master's voice," Francis Barraud, 1901

30. Jordan Motor Car Co., "Somewhere west of Laramie," Edward S. (Ned) Jordan, 1923
31. Woodbury Soap, "The skin you love to touch," J. Walter Thompson Co., 1911
32. Benson & Hedges 100s, "The disadvantages," Wells, Rich, Greene, 1960s
33. National Biscuit Co., Uneeda Biscuits' Boy in Boots, N.W. Ayer & Son, 1899
34. Energizer, The Energizer Bunny, Chiat/Day, 1989
35. Morton Salt, "When it rains it pours," N.W. Ayer & Son, 1912
36. Chanel, "Share the fantasy," Doyle Dane Bernbach, 1979
37. Saturn, "A different kind of company, A different kind of car," Hal Riney & Partners, 1989
38. Crest toothpaste, "Look, Ma! No cavities!" Benton & Bowles, 1958
39. M&Ms, "Melts in your mouth, not in your hands," Ted Bates & Co., 1954
40. Timex, "Takes a licking and keeps on ticking," W.B. Doner & Co. & predecessor agencies, 1950s
41. Chevrolet, "See the USA in your Chevrolet," Campbell-Ewald, 1950s
42. Calvin Klein, "Know what comes between me and my Calvins? Nothing!"
43. Reagan for President, "It's morning again in America," Tuesday Team, 1984
44. Winston cigarettes, "Winston tastes good—like a cigarette should," 1954
45. U.S. School of Music, "They laughed when I sat down at the piano, but when I started to play!" Ruthrauff & Ryan, 1925
46. Camel cigarettes, "I'd walk a mile for a Camel," N.W. Ayer & Son, 1921
47. Wendy's, "Where's the beef?" Dancer-Fitzgerald-Sample, 1984
48. Listerine, "Always a bridesmaid, but never a bride," Lambert & Feasley, 1923
49. Cadillac, "The penalty of leadership," MacManus, John & Adams, 1915
50. Keep America Beautiful, "Crying Indian," Advertising Council/Marstellar Inc., 1971
51. Charmin, "Please don't squeeze the Charmin," Benton & Bowles, 1964
52. Wheaties, "Breakfast of champions," Blackett-Sample-Hummert, 1930s
53. Coca-Cola, "It's the real thing," McCann-Erickson, 1970

54. Greyhound, "It's such a comfort to take the bus and leave the driving to us," Grey Advertising, 1957
55. Kellogg's Rice Krispies, "Snap! Crackle! and Pop!" Leo Burnett Co., 1940s
56. Polaroid, "It's so simple," Doyle Dane Bernbach, 1977
57. Gillette, "Look sharp, feel sharp," BBDO, 1940s
58. Levy's Rye Bread, "You don't have to be Jewish to love Levy's Rye Bread," Doyle Dane Bernbach, 1949
59. Pepsodent, "You'll wonder where the yellow went," Foote, Cone & Belding, 1956
60. Lucky Strike cigarettes, "Reach for a Lucky instead of a sweet," Lord & Thomas, 1920s
61. 7 UP, "The Uncola," J. Walter Thompson, 1970s
62. Wisk detergent, "Ring around the collar," BBDO, 1968
63. Sunsweet Prunes, "Today the pits, tomorrow the wrinkles," Freberg Ltd., 1970s
64. Life cereal, "Hey, Mikey," Doyle Dane Bernbach, 1972
65. Hertz, "Let Hertz put you in the driver's seat," Norman, Craig & Kummel, 1961
66. Foster Grant, "Who's that behind those Foster Grants?" Geer, Dubois, 1965
67. Perdue chicken, "It takes a tough man to make tender chicken," Scali, McCabe, Sloves, 1971
68. Hallmark, "When you care enough to send the very best," Foote, Cone & Belding, 1930s
69. Springmaid sheets, "A buck well spent," In-house, 1948
70. Queensboro Corp., Jackson Heights Apartment Homes, WEAF, NYC, 1920s
71. Steinway & Sons, "The instrument of the immortals," N.W. Ayer & Sons, 1919
72. Levi's jeans, "501 Blues," Foote, Cone & Belding, 1984
73. Blackglama–Great Lakes Mink, "What becomes a legend most?" Jane Trahey Associates, 1960s
74. Blue Nun wine, Stiller & Meara campaign, Della Femina, Travisano & Partners, 1970s
75. Hamm's beer, "From the Land of Sky Blue Waters," Campbell-Mithun, 1950s
76. Quaker Puffed Wheat, "Shot from guns," Lord & Thomas, 1920s
77. ESPN Sports, "This is SportsCenter," Wieden & Kennedy, 1995
78. Molson Beer, Laughing Couple, Moving & Talking Picture Co., 1980s

79. California Milk Processor Board, "Got Milk?" 1993
80. AT&T, "Reach out and touch someone," N.W. Ayer, 1979
81. Brylcreem, "A little dab'll do ya," Kenyon & Eckhardt, 1950s
82. Carling Black Label beer, "Hey Mabel, Black Label!" Lang, Fisher & Stashower, 1940s
83. Isuzu, "Lying Joe Isuzu," Della Femina, Travisano & Partners, 1980s
84. BMW, "The ultimate driving machine," Ammirati & Puris, 1975
85. Texaco, "You can trust your car to the men who wear the star," Benton & Bowles, 1940s
86. Coca-Cola, "Always," Creative Artists Agency, 1993
87. Xerox, "It's a miracle," Needham, Harper & Steers, 1975
88. Bartles & Jaymes, "Frank and Ed," Hal Riney & Partners, 1985
89. Dannon Yogurt, Old People in Russia, Marstellar Inc., 1970s
90. Volvo, Average life of a car in Sweden, Scali, McCabe, Sloves, 1960s
91. Motel 6, "We'll leave a light on for you," Richards Group, 1988
92. Jell-O, Bill Cosby with kids, Young & Rubicam, 1975
93. IBM, Chaplin's Little Tramp character, Lord, Geller, Federico, Einstein, 1982
94. American Tourister, The Gorilla, Doyle Dane Bernbach, late 1960s
95. Right Guard, "Medicine Cabinet," BBDO, 1960s
96. Maypo, "I want my Maypo," Fletcher, Calkins & Holden, 1960s
97. Bufferin, Pounding heartbeat, Young & Rubicam, 1960
98. Arrow Shirts, "My friend, Joe Holmes, is now a horse," Young & Rubicam, 1938
99. Young & Rubicam, "Impact," Young & Rubicam, 1930
100. Lyndon Johnson for President, "Daisy," Doyle Dane Bernbach, 1964

Source: Bob Garfield, *Advertising Age,* http://adage.com/century/campaigns.html.

Figure 1.4 **Campaign Essentials List**

_____ 1. Does the creative brief clearly outline what the campaign needs to accomplish?

_____ 2. Does the key consumer benefit reflect the target's lifestyle, needs, and wants?

_____ 3. Does each visual/verbal element employed strategically accomplish the stated objectives?

_____ 4. Is the visual/verbal tie consistent across all media vehicles?

_____ 5. Do both the visual and verbal design elements used in the campaign reflect the overall strategy and tone of voice?

_____ 6. If using a jingle, are the words and music clearly spelling out the key consumer benefit, strategy, and tone?

_____ 7. Is the key consumer benefit clearly screamed out in every vehicle?

_____ 8. Is the key consumer benefit unique from competitors' messages?

_____ 9. Does the body copy open with a discussion of the key consumer benefit?

_____ 10. Do the middle paragraphs tie the key consumer benefit and additional features to the target's lifestyle?

_____ 11. Does the closing paragraph tell the target what to do next?

_____ 12. Is there more than one way to purchase or place an order?

_____ 13. Does the copy talk to the target in a tone and style they will respond to?

_____ 14. Do the visuals reflect what the headline and copy are saying?

_____ 15. Is the headline style consistent between vehicles?

_____ 16. Are the visual images used throughout the campaign consistent between vehicles?

_____ 17. Does each ad close with the logo, slogan, or tagline?

_____ 18. Is the same color or color combinations used consistently across vehicles?

_____ 19. Are the same typeface and typestyle used consistently across vehicles?

_____ 20. Is the same layout style used consistently across vehicles?

_____ 21. Is each visual/verbal component similarly placed, sized, and cropped across each vehicle?

_____ 22. If using a character representative or spokesperson, are they seen and/ or heard consistently across vehicles?

_____ 23. Does the logo, packaging, character representative or spokesperson match the brand's image?

_____ 24. Does the campaign use cross promotion where possible?

_____ 25. Are all internal employees thoroughly educated on any outside promotions and messages?

_____ 26. Does the media mix include vehicles the target is sure to see?

_____ 27. What kind of interactive device(s) if any are being used to engage the target?

_____ 28. Does the campaign's visual/verbal message strategically accomplish the objectives, reflect the key consumer benefit, and talk to the target in a language they can understand and in the tone laid out in the creative brief?

_____ 29. Is the campaign both on-target and on-strategy?

2

Research Helps Define the Target and the Message

Figure 2.1 **Sample Ad: Tootsie Roll**

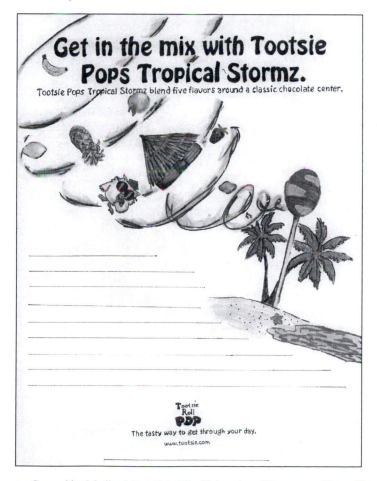

Source: Created by Madhuri Jagadish, The University of Tennessee, Knoxville.

Research Is the Foundation for a Successful Campaign

Dealing with research is certainly not a typical creative team's idea of a good time: it can be tedious, lengthy, and dry. Without it however, they would never be able to develop an idea that really speaks to the target. They could not define that one characteristic that will attract the target's attention or enable them to accomplish the objectives laid out in the creative brief.

Initial research is most often gathered by the client and goes through considerable analysis before being used to imagine a creative solution that meets both the client's and target's unique needs. Working from little more than an outline, the creative team must turn statistical data into an idea that engages and sells.

Before the idea generation process begins, the creative team will study the brief, look at the brand's life cycle stage, its current message if any, its packaging, its overall use(s), and even the product's name for inspiration. It will define the competition, the target's lifestyle, and their reactions or feelings about competitors' products.

Research will help the team to employ the correct tone in the correct media vehicle(s). The answers to any questions about message direction can be found in research results. Additional information can be garnered from focus groups or varied types of surveys. The goal is to build or maintain a unique brand image, challenge competitors' claims, and answer the target's question, What can this product or service do for me?

The data help the creative team get inside the target's head and avoid replicating competitors' advertising efforts. Findings can suggest the best way to solve the target's problem, whether it is through the use of demonstrations or testimonials or copy-heavy informational ads. Research results also confirm the level of knowledge the target has with the brand, what it will take to get them to switch brands, or how to get them to take a second look at a reinvented brand. Research educates the creative team so they can seduce the target with statistics; these statistics, however, are camouflaged as a creative idea that not only attracts their attention, but also creates buzz.

This plethora of new and existing data improves the dynamic between visual/verbal vehicles, ensuring they are clear and concise—and never simply implied. Creative ideas that are not thoroughly grounded in research findings will be ignored by the target. Incorrectly targeted or vague messages lead the target audience to seek out competing brands that more precisely meet their needs, wants, and lifestyles. A "clever" message may be more interesting from a creative standpoint, but if it doesn't ultimately reach the target and make a sale, it will fail.

What Is Marketing Research?

The AMA defines marketing research as "the function that links the consumer, customer, and public to the marketer through information. [This] information [can be] used to identify and define marketing opportunities and problems; generate, refine, and evaluate marketing actions; monitor marketing performance; and improve understanding of marketing as a process." Marketing research is all about providing multiple ways to implement, collect, and analyze data. This data will eventually point the way to a visual/verbal solution to the client's advertising problem.

Understanding Qualitative and Quantitative Research

Most research gathered by the client is used to define a marketing strategy for the promotion of their product or service. Very simply, a marketing strategy defines the target, outlines the product, and defines its place among the competition. This data will be used in the development of the marketing plan and influence what information appears in the creative brief. Data can be compiled using either quantitative or qualitative methods.

Quantitative (or primary) *research* refers to new data and involves collecting relevant information in order to find an answer to a particular set of marketing needs. Quantitative data are very specific: such research often employs the use of controlled response surveys, where participants choose the best answer from a finite number of responses. There are two types of surveys available to researchers: formal and informal. *Formal surveys* include close-ended questions that ask participants to choose from a predetermined set of responses such as "strongly agree," "agree," "disagree," and "strongly disagree," or from a set of multiple-choice questions. *Informal surveys* feature open-ended questions that allow participants to express their opinions.

Formal surveys are most often employed when the survey taker wants to know how the respondent feels about something or needs responses to be ranked in some kind of categorical order. Informal surveys are great when there is no single definitive answer, or the survey taker wants respondents to give an opinion in their own words. These surveys can often be a rich source of insightful and quotable material.

Additionally, primary data may be gleaned from field tests, market surveys, questionnaires, or interviews to study market feedback on a particular product or service. Quantitative research is a particularly good resource when more specific product-focused or service-focused results are needed, or when preparing for new product launches or reinventing brands.

Unlike quantitative research, *qualitative* (or secondary) *research* often uses

a smaller group of representative respondents and does not analyze results using statistical techniques. Qualitative surveys are frequently conducted outside of a controlled environment using a predetermined set of questions, but instead of controlling the type of response given by the target, participants are allowed to express their opinions freely. Several different types of research collection methods, including focus groups, one-on-one interviews, and random sampling, are used to define a problem or understand a respondent's knowledge, attitudes, beliefs, and experiences with the brand. Surveys can be conducted in person, through the mail, via phone, or online. Qualitative research also employs the use of observational research techniques that reveal shopping or TV habits, or show how a product is perceived or used by the target.

Primary research should rely on secondary research, or existing data, to understand any changes in the marketplace or identify any emerging trends or opportunities. In the article "Secondary vs. Primary Market Research," AllBusiness.com sums up the need for incorporating both types of research: "Secondary research lays the groundwork and primary research fills in the gaps." This critical relationship helps marketers assess the marketplace and gives advertisers a better understanding of the product, its competitors, and the targeted audience most likely to purchase the product or use the service.

As mentioned earlier, utilizing secondary data involves researching, organizing, and processing data that has already been collected by previous research studies. Abundant materials can be found at many government agencies, such as the U.S. Census Bureau or chambers of commerce, as well as through non-government agencies such as local libraries, university archives, Nielsen ratings, and trade association sites, or through the use of existing or prepurchased databases, to name just a few. Secondary research is less expensive than primary research but not always as accurate.

Both types of research are used to uncover information regarding the amount of knowledge the target has about the product or service, including how it is used; how it tastes, smells, or feels; any customer service initiatives; and the target's level of knowledge about competitors' brands.

Employing both primary and secondary research techniques assists marketers and advertising agencies in better understanding the target and their needs and wants. This knowledge will ultimately help define the key consumer benefit and direct the campaign's creative development.

Advertising agencies rely on the client to supply the majority of research; however, when searching for the target's opinion on one or more specific topics, agencies will often conduct research using focus groups, pretesting, and posttesting.

Focus groups are usually made up of 10 to 12 representative members of the target audience who will interact with the brand in a controlled environ-

Figure 2.2 **Sample Ad: Starbucks Coffee**

Source: Created by Douglas Haas, The University of Tennessee, Knoxville.

ment. Participants are asked to give their overall opinions or impressions of the product or service. Focus groups often participate in *pretesting,* also known as *copytesting.* This type of research tests both the visual and verbal aspects of an idea. Usually conducted using a single ad or a representative sample from

the campaign, respondents are asked to record their impressions on creativity, brand awareness, and informational quality of the visual/verbal message. The creative team can lead the group, or they can hire an experienced moderator and watch the proceedings through a two-way mirror. *Posttesting* keeps track of how the brand is performing at regular intervals during the campaign's life cycle or is completed after a campaign ends.

Ultimately, research results must be comprehensive enough to help define the target, the key consumer benefit, the objectives, and the overall strategy and tone to be used in creative executions.

Zeroing in on the Target

Once all the surveys and interviews are over and the analysis is complete, the client will know exactly who is most likely to buy their product or use their service. This important group of individuals is known as the *target audience* or *target market*. For advertising efforts to be more consumer-centric, researchers break the target audience down into four specific market segments, including demographic, psychographic, geographic, and behavioristic.

Demographics deal with the target's personal characteristics—among them, gender, age, income, ethnicity, educational level, marital status, number of children, and occupation. This type of statistical information allows for a certain amount of speculation about how the targeted group will purchase. For example, a single professional usually can afford to own more emotionally-based products than a single mom with children. Other identifiers such as buying habits might suggest that older consumers are more open to switching brands than previously thought.

Demographically, age groups can tell a lot about the target's psychographic profile. A target's age tells us whether they have money to spend because they are retired, are cost conscious because they are raising a family, are on a fixed income, or must rely on mom and dad to make an emotionally-based purchase on their behalf. The following classifications will help determine both lifestyle and visual/verbal tone in advertising.

Matures:	Born 1909–1945
Baby Boomers:	Born 1946–1964
Generation X:	Born 1965–1984
Generation Y or Millenniums:	Born 1985–present

Psychographics deals with lifestyle issues, attitudes, beliefs, activities, and personal interests such as the target's view of trends or fads, whether they are product initiators, their political leanings, and how they spend their leisure

time. Are they into sports, shopping, or books? Are they environmentally conscious, economically frugal, ethnically or culturally influenced, or security conscious?

Psychographics also plays a big role in where the target lives geographically. A *geographic* profile shows where the target lives by region, state, city, or zip code. Such information may offer cultural insights into their purchase habits: a four-wheel drive vehicle is more likely to be purchased by people living in snowy or mountainous states, while surfboards are typically purchased by sporting types in coastal regions. Geographic profiles are also excellent indicators of the type of media vehicles and events the target will be exposed to most often.

A *behavioristic* profile combines the three previous market segment profiles together to determine why a person buys and how. Are they prone to more emotional wants or more conservative with their money? Are they brand loyal? Do they look for status products? Are they the first to buy new technologically advanced products?

Profiling is particularly important to brands that are marketed internationally. Messages directed at international audiences will often require a different visual/verbal approach due to cultural and/or language barriers.

These varied target segments can be used in any combination to determine a brand's visual/verbal voice and the best media vehicle(s) to deliver the overall marketing message. Other target segmentation classifications are based on usage patterns, as well as a product's strengths, weaknesses, marketplace opportunities and threats, or any other relevant segment depending on the product or service's business objectives.

Targeting by ethnic group is yet another way to define the buyer. A target's ethnicity apparently influences buying habits and lifestyle. Of the four main ethnic groups in the United States—White, African American, Hispanic American, and Asian American—each group purchases differently and uses different media vehicles.

Market segmentation personalizes the advertised message and determines the appropriate media vehicle(s) to reach that target, thus eliminating media waste. Messages that appear where the target is, that talk about issues the target is interested in, and that offer multiple ways to seek additional information or initiate purchase help to create a relationship with the target. Advertising without the collection of detailed consumer data is not consumer focused and does not encourage an exchange of information on product performance. Nor does it focus on any additional needs and wants the target may have that can lead to suggestions for product improvements, updates, or additional uses.

Beyond isolating target attributes, data collected will also define how the competition positions itself within the market category and help characterize

Figure 2.3 **Sample Ad: Toro Lawn Mowers**

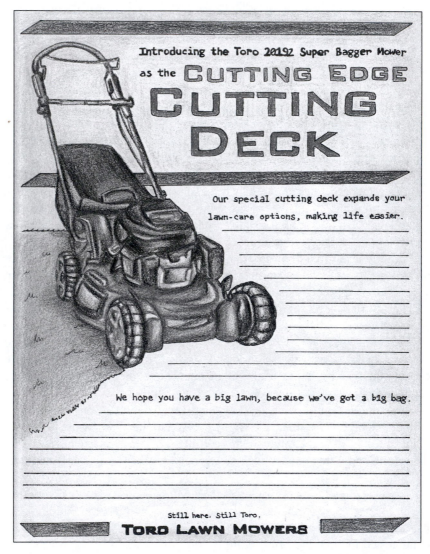

Source: Created by Jina Eun, The University of Tennessee, Knoxville.

their message, packaging, media vehicles, and so on. Additionally, it will provide ideas on how the product or service can set itself apart in some memorable way from the competition. Advertising efforts should never mimic what competitors are doing. This type of "me too" or "wanna be" message will not build a unique identity for a brand—something necessary for brand recognition.

Primary and Secondary Market Segments

There are two classifications of target audiences, primary and secondary. A *primary target audience* are those individuals who are known to use the brand, have used the brand in the past, or are targeted as most likely to use the product in the future. Depending on the product or service, a campaign may have a secondary audience it is trying to reach. This audience is usually smaller than the primary audience and includes those who play influential roles in the target's life.

Secondary audiences include those most likely to influence a purchase or those most likely to purchase the product on behalf of the primary audience—family and friends and/or those who have previously used the product or service. For example, an expensive sneaker purchase might have been influenced by a celebrity spokesperson and purchased by a grandparent or parent. Secondary targets will often require a different strategy, key consumer benefit, approach, and media mix.

Although primary targets will receive more attention and marketing dollars because research has determined they are the most likely to purchase, secondary markets can be profitable as influencers or as purchasers.

When advertising efforts are focused on a small, underserved, narrowly defined group that is not targeted by a competitor, advertisers are said to be pursuing a *niche market*. This market can include a specific ethnic or age group, a particular geographic area, or even some type of specialty industry. Members of niche markets buy products that are either highly specialized or traditional favorites; examples of the market include Polaroid camera buffs, Harley Davidson lovers, or Volkswagen Beetle drivers. Due to the small market share connected with these buyers, the number of competitors in any one category is quite low.

The Internet has created a savvier, more informed target. Before they buy, they can compare products' features and benefits, prices, return policies, and quality of customer service assistance. Twenty-first-century buyers have taken control of how they purchase, when they purchase, and where they purchase. It is important, then, that research efforts identify a way to set a brand apart from its competitors, define what media targeted consumers are sure to see or use, and suggest ways to tailor copy and layout to address their particular interests or concerns.

Why the Target Buys

So what makes the target buy? Typically, they buy for one of two reasons: to fulfill a need (rational) or to satisfy a want (emotional). Routine or rational

purchases require little thought or research due to the target's loyalty to a particular brand or reliance on price or the latest promotion to make a buying decision. Purchases based on need are often no-frills staples such as food items and basic clothing.

Typically, expensive purchases are triggered more by emotions than rational thought. Depending on the reason for buying and/or the price, consumers often conduct their own research prior to making such a purchase. The more the target knows before the purchase, the easier it is to compare products and make an intelligent buying decision. However, it often does not successfully eliminate all doubts after purchase. Buyers may feel guilt or purchase remorse, known as *cognitive dissonance,* after purchasing a big-ticket item. IMC's consumer-centric approach deals with these post-purchase fears before and after the sale by addressing them during the purchasing and research stages. After the sale, it's important to offer technological support, including follow-up calls, service guarantees, or instant web support to help alleviate customers' concerns.

Knowing who the target audience is and how they perceive a brand can help determine (1) how that target buys, (2) their anticipated level of brand loyalty, and (3) the best promotional mix to reach the target. In his book *Strategies for Implementing Integrated Marketing Communication,* Larry Percy identifies four possible target audience groups beyond simple segmentation. They include:

1. New category users, or those who, through advertising efforts, can be convinced to try a product for the first time;
2. Competitor brand loyals, who are already loyal to a competing brand;
3. Brand switchers, who are loyal to no one particular brand; and
4. Brand loyals, who will not switch brands under any circumstances.

Understanding how the target buys will help pinpoint the proper set of media vehicles advertisers will use to convey the overall creative message. For example, will adding sales promotions such as coupons, samples, or free trials encourage the target to switch brands, or will a personalized direct mail letter better educate the target on how the brand will fit into their lives? Can television be employed to tie a new product's image to that of the target? Media choice will also depend on whether the product is an emotional or rational purchase. Traditional vehicles are a likely choice for routine or rational product purchases. However, consumers can be very loyal to a particular food or shampoo, and it may take more alternative media options to reach them effectively. Tactics might include employing sound, smell, or taste tests, or

on-the-spot demonstrations. Those loyal only to the next sales promotion need not be overlooked. Although harder to reach, persuading them of one product's superiority over another is possible, but an ongoing informational assault may be necessary to convince them of a product's uniqueness, reliability, and/or usefulness.

Percy also contends that the target's purchasing decision may be influenced positively or negatively by several outside sources. Before the sale is made, successful advertising efforts need to consider how the target is influenced and by whom. These secondary audiences include:

1. The initiator, the individual who first suggested or introduced the brand;
2. The influencer, that single person or group of people who do or do not recommend the brand;
3. The decider, the individual who actually decides to make the purchase;
4. The purchaser, the individual who buys or orders the product; and
5. The user, the individual who actually uses or consumes the product.

In the final analysis, it doesn't matter how the information is collected or the target is defined, as long as the material can lay the foundation for differentiating the brand from competitors, identify those most likely to buy the product or use the service, determine what they find important and why, and strategically isolate the best media vehicles to reach the intended target. Additionally, solid research will (1) ferret out both market and target needs, (2) delineate current economic or cultural trends to exploit or avoid, and (3) help the creative team settle on a definitive creative direction.

3

The Role of Branding and Positioning in a Campaign

Figure 3.1 **Sample Ad: Advil**

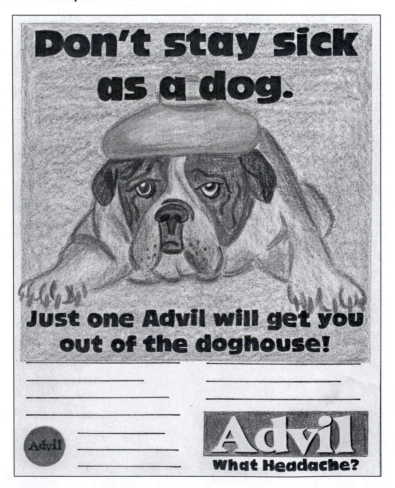

Source: Created by Carly Reed, The University of Tennessee, Knoxville.

Building a Brand: The First Step Toward Defining Image

Mass marketing to a mass audience is all but extinct. The new world order is all about niche markets and personalized messages delivered on a one-to-one basis, primarily to repeat customers. Digging up new customers is expensive, and research indicates that it does not reinforce the brand image, build brand loyalty, or establish *brand equity*.

Collectively, each stage in the buying process must (1) highlight the key consumer benefit, (2) work to build an environment that reinforces quality and service, and (3) lay the foundation for a long and mutually beneficial relationship.

Today, any message that is not individualized is almost sure to fail. Armed with 24/7 access to the Internet, buyers can compare products, shop at their convenience, avoid pesky salespeople, long lines, and inadequate parking by shopping at a time and a place most convenient for them.

To be successful in this technologically-driven age of advertising, marketers need to initiate an ongoing two-way dialogue with the target. An individualized approach offers multiple opportunities to engage the target in conversation by offering customized products or by encouraging feedback on product development, performance, uses, future needs, and/or any customer or technological service issues. Advertising that consistently addresses the target's lifestyle, needs, wants, and special interests can set a product or service apart from competitors and successfully execute the communication strategy. When it's done right, a campaign that focuses a tailor-made message on a specific group of people will build a lasting relationship with the target while strengthening brand equity.

Brand Development

In order to stand out from competing products in the target's mind, every brand must have an identifiable look and personality or image assigned to it through advertising and promotional efforts. The word *brand* in advertising refers to a product or service's name and anything used to represent that name visually or verbally. *Brand awareness* is achieved when the target uses this visual/verbal identity to recognize one brand over another. Name recognition creates a certain feeling in the target—such as reliability, longevity, pompousness, or cutting-edge technology—every time it is seen or heard. "A brand," wrote Robert Blanchard, former Procter & Gamble executive, "is the personification of a product, service, or even entire company" ("Parting Essay," 1999). When creating a brand's image, you give a personality and a visual/verbal voice to the brand. This personality is how the target ultimately perceives the product

or service as compared to the competition. The more remarkable the brand's image, the more memorable the brand and its uses will be.

Being memorable is good; however, a long-lasting relationship built on service, product quality, and reputation precedes the establishment of brand loyalty, brand equity, or ownership in the product or service's category. When a brand offers everything the target needs, it becomes harder for competitors' promotions or peer pressure to entice them to switch to another brand.

The brand's name says a lot about a product or service, as does the choice of spokesperson, the representative graphic symbol, and any typographic style and color choices employed in the logo or advertising vehicle. The choice of brand name is often based on a characteristic associated with the brand: its use, the solution to a problem, its reputation, or the perception of trust and reliability associated with the product. There are basically three different types of brand names: descriptive, comparative, and independent. Descriptive names hone in on one of the brand's specific features. Comparative brand names describe the brand's use or outcomes based on use. Independent brand names have no recognizable ties to the brand.

Consistent product performance and high-quality customer service representatives are far more important to the target than a clever ad campaign. Perhaps Jerry Della Femina puts it best in his book *From Those Wonderful Folks Who Gave You Pearl Harbor:* "There is a great deal of advertising that is much better than the product. When that happens, all that the good advertising will do is put you out of business faster."

Along with an overall visual/verbal image, a successful brand is defined by promoting its strengths while exploiting the competitor's weaknesses. Advertisers must recognize a brand's weaknesses from the start in order to turn them into possible opportunities that will further engage the target.

The next step in the brand building process is to define the brand's image.

Building Brand Image

According to David Ogilvy (1985), one of the most important things the creative team needs to do is "decide what 'image' you want for your brand. Image means *personality.* Products, like people, have personalities, and they can make or break them in the marketplace."

Image personality can be developed based on a product's reliability, use, longevity, or its innovative positioning in a product category. If a brand has parity with other competing products, it is important to assign it a unique and creative appearance to give it personality. This can be achieved by using visually distinct packaging or logo designs. Assigning a jingle to the product or an interesting spokesperson or inquisitive headline style can also give the

brand a personalized voice. In "Parting Essay," Blanchard describes *brand image* this way: "Like a person, you can respect, like and even love a brand. You can think of it as a deep personal friend, or merely an acquaintance. You can view it as dependable or undependable; principled or opportunistic; caring or capricious. Just as you like to be around certain people and not others, so also do you like to be with certain brands and not others."

The best way to build or maintain a strong brand image is to deliver a product that meets or exceeds the target's needs, purchase after purchase. Additionally, each customer contact point must consistently deliver educated, helpful, and courteous assistance. To be the target's first choice when shopping, a brand must value its image—building it, maintaining it, and periodically tweaking it to ensure it remains top of mind.

A brand's essence is more than just a logo; it is also based upon the target's combined knowledge of and experiences with the brand and must be reinforced during every interaction or touchpoint with the target, including its packaging, customer service, delivery drivers, sales personnel, store ambiance, and so on.

Reputation or brand image doesn't stop with advertising and promotional events. It also needs to appear on shopping bags, invoices, receipts, trucks, wrapping paper, anywhere the consumer takes the brand's image. It is important to keep in mind that the brand represents the entire customer experience—everything else reinforces it.

A brand will ultimately succeed or fail based on its image or reputation. A carefully developed image gives a brand its personality—one that sets it apart from competitors even if the brand has no recognizable product differences. Image is not bulletproof, however; it must be monitored and maintained constantly, and strengthened when necessary. If ignored, this hard-won image undoubtedly will be jeopardized: It is very difficult to overcome bad publicity resulting from offensive or misleading advertising efforts, a spokesperson's public scandal, or poisonous viral sharing on social networking sites.

Building Brand Loyalty

Modern-day advertisers realize that the target is inundated with advertised messages, making it harder and harder for a single brand to stand out in a field of indistinguishable competitors. Searching for the right target is an expensive process. Today, marketers realize that the most cost-effective way to advertise is to develop long-term brand-loyal consumers. Actually, consumer loyalty has very little to do with advertising and much more to do with product reliability and the quality of customer service efforts. Although advertising first ignites brand awareness and may encourage trial, it cannot overcome inconsistently

Figure 3.2 **Sample Ad: Starbucks Coffee**

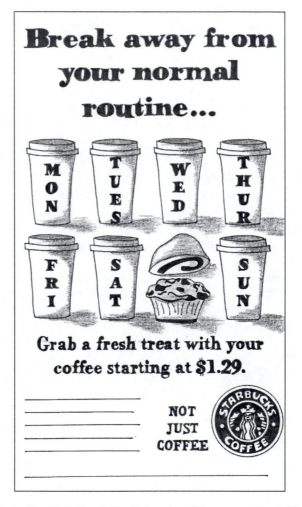

Source: Created by Carly Reed, The University of Tennessee, Knoxville.

performing brands, poorly made products, or rude or incompetent customer or technical service representatives.

What does it mean to be brand loyal? A consumer must regularly repurchase the product or use the service without the assistance of advertising, without thought, and without concern for price or competitor promotions.

A brand that consistently delivers on its advertised promise and performs reliably—exactly the same way each time it is used—develops a loyal following of satisfied consumers. So, it could be said that loyalty begins with the satisfaction

of an emotional need or want and is maintained by quality products and services. Brand-loyal consumers require less advertising and promotional persuasion to repeatedly repurchase their favorite brand. Brands that additionally employ an IMC relationship-building campaign know that the level of loyalty will be stronger if the target can reach out to customer service representatives anytime, day or night; leave feedback online; actively participate in blogs; and be the first to be informed about any upgrades or additions to the product or service.

In an online article titled "Want Loyalty? Buy a Dog!" Egbert Jan van Bel describes loyalty as "a sense of attachment to or even affection for a company's people, products or services." However, this affection can quickly take a negative turn when:

1. Products do not perform reliably with each purchase.
2. The brand's image is tarnished due to any type of negative publicity.
3. The brand lacks quality or customer service initiatives.
4. A revolving door of employees leads to massive worker turnovers.
5. Negative word of mouth runs rampant.
6. The brand becomes known for its lack of comprehensive return, guarantee, or warranty policies.

Loyalty is measured by the lifetime value a customer brings to a brand. Overall, the cost of acquiring a new customer is anywhere from five to ten times greater than to the cost of retaining an existing customer. Therefore, it is important to understand that brand loyalty is more than just a repeat purchase; it is an experience with the brand. If this experience is continually nurtured, a loyal customer will:

1. Spend more money over the long term;
2. Repurchase without the need for additional advertising;
3. Generate educated referrals;
4. Tolerate small mistakes or inconveniences; and
5. Be willing to pay higher prices to attain a quality product or service that offers them a measurable value.

Because a loyal customer can deliver a big return on investment, it is important that the relationship be nurtured through customer service efforts. The quality of customer contact can build or destroy a relationship.

Internal and External Employees

Employees are a big part of brand management; their look, demeanor, and knowledge reflect on both the brand and corporate image. Creating and main-

taining strong relationships is a marketing must. Many businesses consider relationship management—both among employees and with the targeted consumer—a linchpin in their day-to-day business practice.

Quality customer service is developed from the inside out. High turnover or unhappy, poorly treated, and product-ignorant service representatives negatively affect customer interactions. Loyal employees who are personable and well educated about a brand reap loyal customers. It is important, then, to ensure all customer contact points are fully informed of any changing advertising messages, product alterations, recalls, or government investigations that may reflect poorly on the brand or company's image.

Rudeness, aloofness, or disinterest exhibited by customer service personnel can also affect image. Exercising even the smallest amount of common courtesy is one of the best and least expensive ways to make an impression on both new and repeat customers. Service begins the minute the target calls or walks in the door and does not end until the target is satisfied. Each encounter should offer product or purchase assistance and close with a specific call to action. This one-on-one interaction does not end after the initial inquiry or purchase; maintaining quality service after the sale is a marketing must. Any questions or concerns should be quickly and politely answered, and returns should be granted easily with no questions asked. Any promises made to the target must be accurate and immediately addressed. In today's competitive marketplace, the delivery of incorrect information or the breaking of promises can cost the brand a loyal customer. Follow-up should also include an e-mail or snail mail survey that documents both the buying and product experience. Quality customer service empowers the target, helps solidify brand loyalty, and strengthens the brand's image.

Brands that are assisted by exceptional customer service initiatives offer a type of loyalty program that is entirely marketer driven and cannot be individually matched by competitors. On the other hand, consumer loyalty that is bought through incentives and platitudes rather than earned via a rich, helpful customer service environment will not last. Incentives are a dime a dozen and are easily matched by competitors; personalized assistance is a rare quality that is difficult to duplicate.

Maintaining Brand Equity

Brand equity is the brand's value in the mind of the consumer. This "value" is based on the target's repeated experience with a product, on word of mouth, or on reputation. The more satisfaction the consumer receives with each successive purchase, the more brand loyal they become.

When a brand is easily recognizable for its overall quality and is the con-

sumer's first choice in a brand category, it has achieved *brand equity* or has ownership of its particular brand category. Ownership in any category assures a positive return on investment and usually requires little more than an occasional reminder ad to maintain a secure hold on the product category.

Even brands with strong equity need continuous management in today's world of instant messaging, product parity, and economic ups and downs. A good product can go bad fast if social sites are not monitored for rumors or consumer complaints, as Ford Motor Company found out in 2008. Twitter rumors abounded when the blogosphere lit up with claims that Ford was forcing the shutdown of a popular website accused of selling unlicensed products bearing the Ford logo. Legal actions set in motion by Ford called for the site owners to "cease and desist." Luckily, Scott Monty, Ford's social media savvy PR manager for digital media, addressed the issue quickly and used Twitter and the merchant websites to keep outraged posters updated on both the facts of the case and the progress of its resolution. Monty is credited with strengthening the Ford brand by defusing the situation quickly and diplomatically.

A high level of brand equity in a product category can also have its downside. Sometimes, a brand's name becomes so closely linked and representative of a product category that it becomes a generic label for the entire category; such is the case with Kleenex, Wite Out, or Xerox, to describe any kind of tissue, copy correction fluid, or photocopy. Once a product's name becomes a generic marker for any product category, it can lose its trademark or ownership of its name. Consequently, leaders in these categories must use their relationship with the target and alert consumers to the differences that set them apart from their competitors.

As noted earlier, a brand's positioning and equity in the marketplace can be deeply affected by prevailing economic conditions. During economic slowdowns, marketers (like consumers) have to make some hard decisions. Brands that respond to economic conditions will attract consumer attention. Many brands find ways to ease consumers' burdens by keeping prices low, reducing the size of packaging, or offering coupons or "two for one" offers. Marketers who stay in the public eye during economic slowdowns will reap financial benefits when the market recovers. Those who pull back on their advertising efforts will often lose both their positioning and their hard-earned equity. These brands may save money in the short term but will likely end up spending more money over the long term to regain what they have lost.

To consumers, it's not all about money. High-quality, reliable, and long-lasting brands will sell just as well in a slow economy if the target understands that paying more saves money over time. As a rule, most consumers do not let price drive their buying decisions when making high-end purchases such as cars, computers, and the like. Price does play a role, however, in the purchase of more disposable items such as food or entertainment.

Figure 3.3 **Sample Ad: Toothpick**

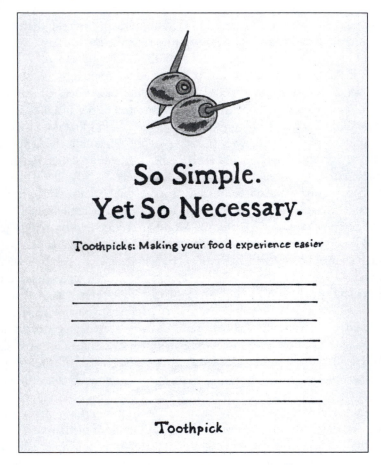

Source: Created by Kristen Laurenzi, The University of Tennessee, Knoxville.

Positioning Is All About Image

Positioning is all about a brand's image and how the consumer ranks that image relative to competing brands. Well-known author Jack Trout defines positioning as the process of "owning space in a person's mind." So what's the difference between brand image and positioning? Positioning is developed through advertising and promotional efforts; a brand's image is a result of the target's personal interactions with the brand.

Being the target's first choice takes creative ingenuity. To stand out, it often means taking a chance or picking up where competitors leave off. Apple, for

example, chose to point out their competitors' perceived flaws. In this successful campaign, Apple positioned its image in direct opposition to the one projected by PCs. They accomplished this by comparing Apple's superior customer service, innovation, and its implied "super cool" image against that of the PC's faulty technology and stodgy, outdated persona. This approach was a better choice than targeting price or individual features, as they are not static or consistent like images, but easily copied or changed.

In today's product parity environment, image is often the only feature or benefit a brand has to set it off from the competitors in its category. Unfortunately, not all brands can be blessed with a unique image. Brands without a unique identity require a big idea that identifies an underused or underexposed feature and uses it to develop an exclusive niche or new position for a brand. Still others, say Jack Trout and Al Ries in their 2000 book, *Positioning: The Battle for Your Mind,* need to look for even more creative ways to stand out in a crowded product category. For example, "If you can't be the first in a category, set up a new category you can be first in." In the 1960s, Volkswagen gained success after positioning the Beetle as a small, ugly lemon. This was a position no one else wanted to belong to and was certainly a unique departure from the big and luxurious positions claimed by other cars at the time.

To stand out when competition in a product category is fierce, brands must take a strong look at their current position within that category. New product categories make securing a position in the mind of the target easier without competing noise. Products that must compete against a stronger, well-known competitor will have a more difficult time securing an individualized and unique position in the consumer's mind.

When a brand has entered its maintenance phase and no longer has to rely on its specific features and benefits to make a sale, it can focus more on its image or reputation to secure a loyal following. Mature products with an established position allow the creative team a little more latitude to expose a brand's exclusivity or cutting-edge science or technology. When there is more focus on image and less on establishing a foundation for the key consumer benefit, the visual/verbal message and promotional activities can be a lot more creative and inventive.

Repositioning the Brand's Image

Basically, a brand is *repositioned* when its image is changed in order to attract a new target market. The goal is to change any preconceived ideas the target may have about a product, service, or company as compared to the competition. Avis was successful in the 1960s against Hertz, the leader in the car rental category, when it repositioned its brand claiming, "We Try Harder." To

ensure success, management traveled to each Avis branch location around the country, briefed customer service representatives on the campaign direction, and encouraged each to provide a superior level of customer service with each target contact. As a reminder, every employee was given a copy of the current advertising in his or her pay stubs each month. This early example of an integrated marketing campaign put Avis in the black within one year.

The time to think repositioning is when: (1) the brand is attached to trends or evolving technology; (2) the brand has a negative or nonexistent image; (3) there is no product differentiation other than price; and (4) the product, service, or corporation needs to be reinvented.

Small changes that can be announced by using "new and improved" in ads and on packaging will require little creativity, while brands that are undergoing a major face-lift will require a lengthier, more educational, and perhaps more spectacular approach to attract attention. Those emerging from some kind of scandal may need years of informational ads that meet past problems head on and keep the public updated on corporate direction and product improvements.

When the goal is to encourage trial, the new product or service must surpass the current brand in some meaningful way. One way to do this is to launch an image campaign that sets the new product so far and uniquely apart from the leader that everyone wants to be a part of the change. This is known as *repositioning the competition.* For example, Tylenol overtook Bayer Aspirin in the pain relief category by touching on the fact that aspirin is not for everyone, especially those with stomach problems. The campaign was so successful that Tylenol became the number-one selling aspirin substitute. Coke, on the other hand, has held onto its number-one position because it's "the real thing." Coke introduced the category: All competitors can do is fight over the number-two spot.

Every piece of advertising, every contact with sales personnel and customer service representatives, and even how a brand is packaged must solidify the brand's importance in the target's life. A product's worth, or overall *brand value,* must be reinforced consistently with every contact to assure the brand is the first and only one the target thinks of when repurchasing.

The Symbols That Encompass the Brand

A brand's image is projected every time it is advertised, so consistency is of the utmost importance. For a brand to attract the target's attention, it must parallel their interests and lifestyle. Every design choice must be made with an eye toward enhancing the product's image and defining how the target will use the brand in their life. What does the brand name say or represent?

Is the product's image inherent in its name or use or because of its parent company's reputation (think Apple)? Will you be maintaining the product's image, reinventing it, or starting with a blank canvas for a new product launch? Are there any close competitors in the category? If so, what is their advertising saying and showing about their brand? Above all, the creative team must understand what the target needs and wants.

Both brand image and brand awareness are created with repetition and consistency. It is important to employ the same visual/verbal imaging throughout the brand's lifetime. A change in look or sound should be used only to signify a noteworthy modification to the brand. Repetitive symbols are like old friends: When we see them, we see that brand's position in the marketplace and in our own lives. Images such as the Golden Arches would be recognizable anywhere, with or without copy. Do you need help recognizing Coke's signature color or the Aflac or GEICO character representatives? Each one of these examples brings an image, a name, a message, and a reputation to mind, all because of one little symbol, figure, or splash of color.

David Ogilvy, writing in *Confessions of an Advertising Man,* stated, "Every advertisement should be thought of as a contribution to the complex symbolism which is the brand image." The strongest visual/verbal voice a brand has is the logo. It will appear in every advertisement and promotional piece. The logo is the brand's core identity, its reputation in its brand category. Ultimately, the choice of graphic symbol, typeface, and/or color combinations will express this personality, while simultaneously representing the brand's reputation and reflecting the target's own self-image.

Once image and message have been determined, the creative team must also consider whether the brand's lifecycle phase is new, mature, or in need of reinvention. A brand's current lifecycle stage will strategically affect the way in which a product's visual/verbal message will be delivered. Before any brainstorming sessions begin, the advertising team must determine (1) the target's level of brand awareness, (2) their current knowledge of the brand's image or reputation, (3) how they would rate its performance as compared to the competition, and (4) whether or not they are currently using the product. Understanding a brand's lifecycle stage is critical to its success within the product category: it helps the creative team zero in on what the brand needs to say, repeat, or disclose before the target will purchase or repurchase.

4

Bringing the Business of Creative to Life

Figure 4.1 **Sample Ad: Soothing Naturals**

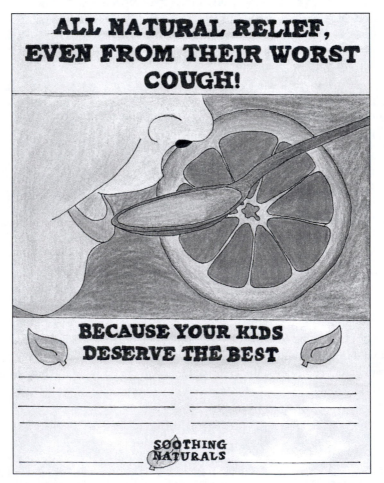

Source: Created by Katie Gilles, The University of Tennessee, Knoxville.

Taking a Walk Through the Design Process

Creativity isn't all imagination; it's also about solving a business problem creatively. Creative execution is the last phase in a lengthy process that started months earlier with intensive research gathering, analysis, projecting, and planning. It is the creative team's job to mold the creative brief into a unique and memorable idea. It is also their responsibility to make sure the idea can be used successfully across multiple types of media vehicles without losing its identity. Great ideas are often elusive and can take a great deal of time and energy to develop. No idea is disregarded, no source ignored. "I have learned to respect ideas, wherever they come from," said legendary advertising executive Leo Burnett in his 1995 book, *100 LEO's*.

A great idea is usually built around something concrete, something the target can relate to. The more memorable and compatible the message, the more targeted and successful a truly great idea will be. The creative direction should be reflected in the key consumer benefit and strategically expressed in a visual/verbal tone of voice that the target will understand and react to. It is especially important that the message appear in a concentrated or assorted media mix they are sure to see, hear, or view.

Good Ideas Take Their Place at the Front of the Creative Line

Conceptual development, also known as *brainstorming,* is all about thinking the *"un-imagined."* The creative team conducting these idea exploration sessions is usually made up of at least one copywriter and one art director. Once the team knows what they need to accomplish strategically, the next step is finding a visual/verbal solution that defines it.

Every memorable campaign begins with a good idea that is painstakingly molded to accomplish the initiatives laid out in the creative brief. Many good ideas are accidents; others are developed from a couple of bad ideas that have been thoroughly reworked. Still others rely on overactive imaginations, a bad sense of humor, keen observations of human nature, or past experiences to give them life. A good idea is the hammer that drives the strategic nail.

Good designers need a kaleidoscope of experiences and interests to draw from. They should be open-minded, adventurous, and receptive to others' ideas. A solid creative direction will often come from the power of observation, a well-honed sense of curiosity, and a wee bit of witty cynicism. Members of the creative team must be students of human behavior and know a little about psychology, economics, art, music, and history. They cannot always expect to find inspiration in everyday monotony. They must be able to employ historical references and use movies, television, and radio references from

today and yesterday to represent a brand's image and set the visual/verbal tone for creative direction. Designers should never get a dreamless night's sleep, miss an opportunity to do a little inappropriate eavesdropping, miss a much-deserved cocktail hour, or waste a quiet drive home.

Conceptual development sessions allow the creative team to eliminate worn-out solutions and replace them with unique or cutting-edge ideas. The more distinctive the visual/verbal identity, the more a brand can step out and away from its competitors. Unique ideas are the springboards to developing a memorable brand image that solidifies the brand's superiority in the mind of the target.

Brilliant results often take hours of throwing out both good and bad ideas; some will be reworked, and some will be quietly retired, so it is important to generate as many ideas as possible. Every bad idea spoken aloud makes the team work harder to find a better, more expressive or informative one. In the end, a creative solution will never be found in a single idea. It is often a colorful collage of several intertwined ideas that creatively solve the advertising problem.

It is the mingling of these ideas that will promote the right message, to the right target, in the right media. It is often tweaked in small but purposeful ways along its short but winding creative path before it is ever presented to the client. Each detail is accompanied by worry, making stress as much a part of the creative process as conceptual development, copywriting, or design. The creative team is usually working on a tight timeline, and often does not have long to generate ideas. Depending on the product, and in order to make publication or production dates, team members may have anywhere from a few hours to a couple of weeks to complete the creative execution phase. Any art director or copywriter must be able to come up with a creative solution for both major and minor problems with little or no advanced notice.

A successful creative team must:

1. Imagine the possibilities. How can the product be used in new and imaginative ways? How will it alter or enlighten the target's lifestyle? What do its size, color, or color combinations say or symbolize? Think beyond the obvious.
2. Keep ideas from becoming stale. Obsessive tweaking ensures the creative solution is in a constant state of organized disorder. Ongoing dialogue with the target will help keep ideas fresh and cutting-edge.
3. Know the brand and target's image. It is important to ensure the brand's image reflects the target's self-image. This idea should be evident throughout each media vehicle employed in order to attract

attention and engage the target through events, trials, promotions, or purchase.

4. Be well rounded. Good advertising draws on a diverse knowledge of the old, the new, and the futuristic. Good creative teams use research and their diverse arsenal of visual/verbal anecdotes to beef-up product categories, introduce new uses, looks, or styles, or launch the newest trend or fad.

5. People watch. Go to the mall, the airport or take a seat along a crowded street and people watch. Use the diverse array of passing characters as inspiration. Each will have their own form of dress and an unusual array of mannerisms that display their individual personality and sense of style. The human species is fat, skinny, bald, hairy, old, young, slow and fast. Many are overdressed, underdressed, spaced out, talking too loudly on cell phones or dropping a big bite of lunch in their lap. We are unique—use it to give the target a view of life with the brand.

6. Know the brand and competition. Understand the brand's place in the product category as compared to the competition. How is it different from or similar to the competition? What does the target think about the brand versus the competitors' brands? To find out, consider using both the client and competitors' products yourself to gain an intimate insight into both the pros and cons.

7. Solve a business problem. Before the campaign can take on a visual/ verbal identity, the creative team must come up with a great idea that stands out from the competition, talks directly to the intended target audience about the key consumer benefit, accomplishes the overall objectives, and stays strategically on-target.

8. Make quick, creative decisions. The creative process is often one rejection after another, and revisions are an accepted part of the procedure. The team must be able to make changes quickly and be creative on demand often for hours at a time. Stress is a big part of the job and, if channeled creatively, can be a good source of expressive energy and inspiration.

Without an Identity, All Brands Are the Same

Not only is there a lot of product parity out there, there is also a lot of creative repetition. For a brand to be positioned as unique, it cannot react to competitors' advertised messages or mimic them. The first time the target sees an idea, it's an anomaly; once they see it repeated by a competitor, its "me too" or visual/verbal advertising noise—and relegated to second place

Figure 4.2 **Sample Ad: Agri Feed & Supply**

Source: Created by Reece Crawford, The University of Tennessee, Knoxville.

in consumers' minds. Because today's consumers can successfully ignore the thousands of advertisements they are exposed to every day, to stand out a product not only must be distinctive, but it also must directly parallel the target's needs and wants.

A creative team's seemingly endless banter and doodles are the first step toward developing a memorable idea, concept, or theme. The goal of a conceptual development session is to illuminate the obvious and search for a new

and innovative direction. At the root of innovation lie clichés and stale ideas. Inspiration stems from the unfettered discussion of hundreds of ideas, many of which are weird, slightly off strategy, or downright ridiculous. But design is not really about great ideas: it's about selling or promoting a product or service in such a way that the message is memorable and sets the brand apart from its competitors.

Not All Ideas Are Created Equally

The creative phase is the final step in the execution of the client's business plan, so time is always in short supply during this stage. Team members must be able to navigate professionally between what they want and what is best to successfully complete the brand's visual/verbal tone of voice.

Every visual/verbal aspect of a campaign must be developed with the targeted audience in mind. Creatively, solutions must relate to the target's lifestyle and self-image, as well as solve a relevant problem or fulfill a need. Media choices must be scrupulously researched to assure they reach the target where they are.

A cohesive visual/verbal message is the tie that binds a multiple media campaign together. To be cohesive, all messages must deliver one visual/verbal tone of voice that is recognizable and repetitive in one or more memorable ways. Cohesion drives home the key consumer benefit and attracts the target's attention. The need for a multimedia campaign to reach the target in the same visual/verbal voice, no matter where the message is encountered, is vital. Messages that lack cohesiveness deliver an inconsistent message that directly erodes both memorability and the brand's identity. Every contact point must duplicate the campaign's message to ensure consistency and recognizability.

Storming the Idea Bastion

Originality can only be attained if the creative team pushes past the mundane to the exotic. Creative problem solving cannot be done on a computer; it still requires a visual/verbal solution that takes shape in the imagination of each member of the creative team. Once shared with the group, the solution becomes a collection of multiple ideas that work to solve the problem initiated in the creative brief. There are no rules, no boundaries, no limit to the number of ideas a conceptual development session should generate. The only absolute is to solve the problem creatively and imaginatively by coming up with "*the idea*" that promotes the key consumer benefit.

Most brands do ordinary things with expected results. The key is whether

the creative team can find a way to visually and verbally show ordinary in an extraordinary, unique, and memorable way. Isolating a brand's creative direction requires an atmosphere of informality where thoughts can be shared openly. Most development sessions will never look or sound the same way twice or last for a set amount of time. The only constant is to come up with as many ideas as possible. Reliably, dozens and dozens of these ideas will crash and burn on impact; others will linger awhile. Only a small few will live to see further development. These ideas will define the brand's image, talk directly to the targeted audience in a language they will understand, and appear in situations they will relate to. Still fewer ideas will successfully weave the target's self-image with that of the brand, because they are on-target and on-strategy. That is the ultimate definition of a great creative and memorable idea.

What Does a Good Idea Look and Sound Like?

Many young designers and small businesspeople alike often ask themselves, How do I know a good idea when I think of it? The answer is simple! If it hasn't been done before, talks directly to the target audience, strategically addresses the objectives, pushes the key consumer benefit, and has a different visual/verbal tone of voice than the competition, chances are it is a great idea.

The key to solving any problem is not to dwell on it for long. Leave it alone and let it marinate for a few hours, or, if time permits, a few days, before deciding on a visual/verbal direction. When possible, take the time to search for the best solution. For example, if you normally drive to work, take the bus or train. Look out the window, daydream, go to lunch by yourself and talk to a stranger or two. Ask people to describe your product, to feel it, wear it, or taste it; record their thoughts and reactions. What happens if the product is placed in an unusual setting, how do people react? Manipulate its use or look, compare it to the competition, question its shape or color, find unique answers to questions once thought irrelevant to the brand's image or key consumer benefit. Give the brand a personality. It is more than a toaster, a sneaker, a boat, or a can of peas. Through discussions, experimentation, and basic trial and error, it is only a matter of time before the "I got it" moment arrives.

Even after the creative team "has it," the idea still faces many hurdles. Tight budget restrictions, time constraints, a client's own creative ideas, and media limitations that often require downsizing or pulverizing the visual/verbal message can have an impact on the overall creative direction of a campaign.

Ideas are only the first rung on the creative ladder. Execution is the second and, by far, the most time-consuming. A great idea poorly designed and/or produced will fail as quickly as an idea that is off-target or off-strategy. Good design requires a keen eye for organization, the ability to recognize visual/

verbal relationships, and a thorough knowledge of technical or production techniques. Let's take a look at a few of the areas that help an art director envision the idea during the various stages of idea development.

The Elements and Principles of Design

The elements and principles of design describe good aesthetic design practices. They teach the designer how to organize the page and communicate effectively by using those techniques that ensure the layout is effective, creative, and easy to read and understand. Every component that goes into an ad has a purpose and a point it needs to make. The elements and principles of design exploit each and every point, making sure nothing in the design is random. Understanding how the components interact on the page is critical to presenting a clear and concise visual/verbal message. These invaluable rules help an idea come alive, attract attention, and create a memorable visual/verbal identity for the product or service.

The Elements of Design

The elements of design are those essentials that can be independently manipulated. They are considered the building blocks of a design's visual structure. Although no single source agrees on what those elements are, the most commonly referenced are color, line, shape, texture, value, and volume.

Color. Color can mean many things to many different people. It can be bright, dull, bold, soft, minimalist, or saturated. It can manipulate the viewer's emotions and represent a brand's identity. Color can attract attention and/or be used to set a mood. Bold colors are youthful, while more traditional solid colors such as navy or black show stability. Bold colors attract attention, appearing to advance on the page, while light colors tend to recede into the background. Color is a good way to show emotion.

Line. A line should lead the viewer to a visual or verbal destination. A simple line can be implied, twisted, curved, or appear stoically straight. Variations in a line's appearance can illustrate varying emotions. For example, a straight line can depict calm, a curvy line may appear sensuous, while a jagged line can seem angry.

Shape. Shape is basically a defined area that stands out from other shapes around or near it. This definition is created through the use of texture, value, or color. A shape can be either geometric (circles, squares, triangles, or rectangles) or organic (any shape that is not geometric) in nature, or it may be created through the use of positive/negative space. Like color and lines, shapes based on their pointed corners or curved edges can be used to imply specific emotions.

Texture. Texture, or what the item feels like, can be simulated through the use of lights, darks, and varied shapes. Texture as used in two-dimensional design is an illusion. Whether rough or smooth, texture sends a message to the viewer about the product, its use, or its outcome. As with contrast, using varied textures increases interest with implied details.

Value. Another variation on the difference and/or contrast between lights and darks is called value. The value of a color elicits emotion.

Volume. Volume is a measurable area of three-dimensional space. In design, contrast, color(s), and size can create depth, as well as imply bulk, density, and weight.

The Principles of Design

The principles of design are the visual rules that govern the way the elements are used in design. They include balance, dominance, eye flow, contrast, negative/positive space, asymmetrical and symmetrical design, repetition, anomaly, concentration, harmony, and unity.

Balance. Balance is achieved when an ad's components are equally spaced and weighted on the page. An ad can be unified and balanced either symmetrically or asymmetrically.

Dominance. There must be one big or highlighted component in every design. It should be either the most important visual way to promote the key consumer benefit or the most prominent verbal device or headline on the page.

Eye Flow. Eye flow is a predetermined trail the designer wants the viewer to follow. A design's components are arranged to ensure the reader views each one in the correct order. An ad should lead the viewer flawlessly from left to right and from top to bottom, ending (ideally) with the logo.

Contrast. Contrast is sometimes listed as an element rather than a principle of design. Either way, contrast must be created between components on the page. A contrast in color, size, and texture must be obvious enough to create interest and emphasis. Contrasts add visual interest by minimizing similarity between objects on the page. The generous use of contrasting objects creates a harmonious, unified look between components. The more obvious the contrast between objects, the easier the ad is to read and understand.

Negative/positive space. Negative/positive space breaks the page down into occupied and unoccupied space. Occupied space holds an ad's visual/verbal components; unoccupied space refers to the white area of the page. Judicious use of these unoccupied spaces increases readability and legibility of the ad and increases eye flow.

Asymmetrical design. Think of a design as being divided into two parts.

The weight of an ad's components—even though they are not of equal weight, size, or number—must be arranged or grouped so as to appear balanced on the page. This type of layout is generally more visually stimulating than one that is perfectly symmetrical.

Symmetrical design. In a symmetrical design, all components are either perfectly centered or balanced on the page, or they are shown as a mirror image. Well proportioned, a symmetrical design has an equal number of components of the same weight and size.

Repetition. Repetition is the repeated use of one or more of the components in a design. Repetition from page to page creates consistency: repeating a line from a headline, for example, attracts attention by emphasizing a specific point.

Anomaly. An anomaly is the irregular component in a regular and orderly pattern, the abnormal in the normal. A great way to set a brand off from the competition.

Concentration. This design principle is all about movement and eye flow. Solid or liquid streamers shoot out from a concentrated pool or spill from some type of liquid such as paint or water. These streamers can also be depictions of solid materials such as blocks, salt, cereal, or strewn clothing.

Harmony. Harmony in advertising design means all the visual objects relate to what is being said. Harmony on the page is also achieved through the repetition of colors, visuals, typefaces, and so forth, between pieces.

Unity. Unity is achieved in two ways: (1) when all the visual/verbal design components are working together to send a single message; and (2) when all the principles and elements of design work are in harmony on the page.

Design: The Diverse Stages of Development

There are five distinct steps that make up the idea, design, and construction process that include: concept, thumbnails, *roughs, super comprehensives,* and *mechanicals.* Let's take a quick look at each one.

Conceptual Development. As previously discussed, concept development or brainstorming begins with a thorough understanding of the creative brief. These idea generation sessions help to get dormant brain cells firing away and stagnant imaginations fired up.

Listening to others' ideas helps get the creative team's brain percolating. Any one brainstorming session can produce dozens and dozens of good and bad ideas. Many will be forgettable, but some will be worth further development.

These sessions can take many forms. Initial ideas may be placed on Post-it

Notes and stuck in strategic spots around the room, or a copywriter may throw out headlines that art directors quickly render. No matter the format used, each idea will eventually be discussed, further developed, or discarded. The key is to never feel inhibited. Ideas should spring forth with abandon. Alas, feelings of regret will often follow the bad ideas shared, and a sense of excitement will surround those with more potential. Once that one idea picks up momentum, *that* is when art direction gets exciting. The team will use these idea generation sessions as creative therapy. All the demons associated with crazy ideas are dragged out, exposed, analyzed, and reworked or discarded.

Thumbnails. Not much more than a doodle, these small, proportionate drawings get the creative ball rolling on paper. They can take several shapes, depending on the designer and the team's needs. Some may take on a more finished look, complete with readable headlines and subheads with simple lines indicating the position and layout of body copy; others may look more like a psychiatric inkblot only the art director can understand.

Development sessions may yield a variety of visuals that test out differing sizes, placement, colors, and layout styles. The goal is diversity: There is never a single way to depict an idea. Each thumbnail represents varied directions for promoting the key consumer benefit. Because they are a test run for ideas, the client never sees them.

Roughs. Roughs are full-sized renderings of what the final idea might look like. They are hand drawn and quickly executed, but they show both typeface and typestyle, a layout style, color(s) or color combinations, and sized illustrations, photographs, or graphics. Headlines and subheads are readable and placed in the correct position and size on the page. Body copy, although usually written by this stage, is represented using lines to show placement in one, two, or three columns. An actual copy sheet will accompany the rough to the client. Logo placement is present, as are any coupons, order forms, and so on, that might be a part of the final design. Roughs are just that, a rough drawing of the final ad, but because they are seen by the client, they must be tight enough for them to understand the visual/verbal direction. Today, roughs are usually done for quick turnaround jobs for long-term clients.

Super comprehensives. A super comp is the finished design executed and saved as a computer file. Most ads will skip the rough stage and go directly to the computer to complete an idea. As with roughs, the headline and subheads are readable and in their final typeface, and they are styled, sized, and placed in position on the page. The layout style is clearly evident, and any and all color is in place. If the photo shoot is not yet complete, a stock photo that closely resembles the final visual will be placed in the ad and clearly stamped with "for position only" (FPO), signaling the final photograph is yet to come. If the photo shoot is complete, all visuals will have been sized, cropped, and

Figure 4.3 **Sample Ad: Morton Sea Salt**

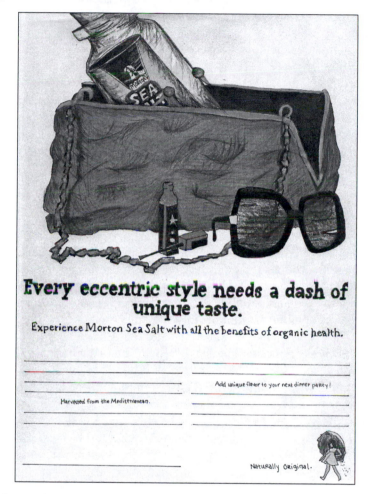

Source: Created by Ally Callahan, The University of Tennessee, Knoxville.

placed in their final position(s) for presentation to the client. Unlike a rough, a super comp contains readable body copy that has been set and placed in position in the ad.

Mechanicals. A mechanical is the rough or super comp's preparation for final printing. Here, an ad is broken down into its individual parts and colors. Mechanicals today are often prepared and color separated in-house or inside the agency.

Mechanicals must be scrupulously assembled and should be considered pieces of artwork in their own right. If every detail is not addressed during

construction, a once-great idea on paper can look disastrous in print. This is the point where exact colors are defined so colors will match from media vehicle to media vehicle. Details such as butting colors are aligned, and type and photographs are meticulously checked for alignment, grammar, spelling, and placement.

The mechanical is the final critical step in the idea, design, and construction process. Any errors that occur here are both time-consuming and expensive to fix. Worst of all, if missed entirely, mistakes will show up in the final printed piece, so a critical and detailed eye is required at this stage. To ensure accuracy, every creative piece goes through several approval stages before it ends up at the printer or in a production house.

The Approval Process

Once all the bad ideas are trashed and the good ideas are polished, the creative team will prepare three to five different options to present to the client.

The copywriter, the art director, the creative director, and the account executive will all sign off on the final design before presenting it to the client. Each one will look at the entire ad or mechanical for any gross errors or omissions such as spelling or grammar mistakes; incorrect, old, or misplaced visuals; or any mechanical preparation mistakes.

The client will see the design at least twice, once at the rough or super comp stage and then again at the mechanical stage. It is rare for a client to approve an idea in its original form. Most likely, it will return with one last change to the copy or one or more of the visuals before being sent to the printer or on to preproduction. As soon as these changes are delivered to the art director, the mechanical artist, or the graphic artist, the changes must be made quickly. When the final round of changes (there could be more than one) is complete, the mechanical will go back to the client for final approval. They usually have the authority to sign off on the final design or mechanical, but there are times when several stages of client signatures will need to be gathered before the final approval process is complete.

Ad Design Changes

No matter how easy or hard, expensive or inexpensive a project is, there will always be changes at the last minute—even if the client or account executive was fully engaged during the project's construction. A project does not take on a sense of urgency until it is about to be presented to the client, printed, or produced. At any of these key points, everybody seems to have an opinion. Most changes are quick and easy; others are detailed and time-consuming,

especially if the client changes their mind or does not approve of the final creative direction. Unfortunately, no matter what the level of alterations, the production or publication date never alters, so making changes is a very stressful yet inevitable part of the design process.

Printing or insertion deadlines are pretty much set in stone. If this deadline is missed for any reason, it will not reach the target; additionally, it will cost the client money and seriously disrupt the campaign's cohesive message.

Because of this, missed deadlines do not happen, period. If they do, they tend to cost people their jobs; therefore, it is important that the creative team keep on-strategy, work closely with the account executive, and watch for any misplaced details.

At every step in the design process, it is important that the visual/verbal idea be checked against the original strategy. If the piece is still on-strategy, then it will meet the target's needs, differentiate itself from competing products, and accomplish the set communication objectives. Rogue ads or campaigns that deviate from the original course laid out in the creative brief run the risk of seeing major changes in the critical final hours of the design process. A nervous client often makes big changes when they second-guess the creative team and/or attempt to view the idea through the target's eyes. It is important that any strategic changes be run by the account executive so they can, in turn, be presented to the client before venturing too far into the design process.

Business owners, client representatives, and advertising account executives often have a vague idea of what they want visually, but they may have trouble articulating it to their design team. Getting something down on paper will help the artistically challenged present their ideas. A great idea or even a mediocre one does not require great hand skills or beautifully finished pieces of artwork. Remember, one picture is worth a thousand words, so skip the epic discussion, embarrassing stick figures, and misunderstood directions and take a simpler, cleaner approach by drawing the ideas out geometrically.

Keeping It Simple: Geometric Layouts for the "Design Challenged"

Art directors are usually capable of sketching out their ideas rather quickly. However, most of them will say it is more important to have a good idea than it is to be able to replicate that idea on paper. The use of geometric layouts is a way around the traditional sketch. The computer has helped the drawing impaired, but there is no artificial tool that can imagine a good idea.

For the artistically challenged, a good idea will be just as good when laid out using geometric shapes such as circles, squares, triangles, and rectangles. Headlines can be written out or indicated with rectangles or squares of vary-

ing lengths and sizes, and aligned left or centered on the page. Subheads also can be written out or indicated using zigzag lines. Again, placement, length, and size can vary, but all lines should be clean and straight. Multiple visuals can be grouped into varying-sized boxes and shapes—placing a large "X" that stretches from edge to edge will help distinguish the boxes from copy blocks.

Any body or detail copy will be represented using parallel lines in the same way it would on a hand-drawn rough. These lines can be arranged into one, two, or three columns and be centered, flushed left, or justified. The designer can mimic real paragraphs of copy by indenting the first line of each paragraph and shortening the last line. This is also a great way to increase visual white space.

In the end, good design is more than a great idea. It requires a thorough understanding of basic design and production techniques, presentation skills, and deadline management. It is also about isolating good ideas from bad and being open to changes that may or may not advance the original idea.

5

Type

Giving the Brand a Voice

Figure 5.1　**Sample Ad: Vicks VapoDrops**

Source: Created by Reece Crawford, The University of Tennessee, Knoxville.

The Essential Design Elements of Copy

Before we talk about what type needs to say, let's get a few definitions under our belt. A *typeface* is the name given to an individual set of letterforms (characters) such as Futura or Garamond. A *font* is the actual set of upper and lowercase characters, numbers, and punctuation marks that make up a typeface. For example, you buy a font package, you use a specific typeface in an ad. The choice of typeface will help define an ad's personality and sell its features and benefits.

A careful study of available faces should be made before determining which one will ultimately represent a brand. Although considered one of the verbal design elements that makes up a page, type should be thought of as a visual representation of the brand's verbal image and, when possible, mimic its shape or use. When looked at as a graphic image rather than a letterform, each typestyle is a series of diverse shapes, thick and thin lines, and tall and squat curves. Some are gaudy or decorative, sporting a lot of swishes and swirling lines that can obliterate readability and legibility, while others tell a story or project an image in only a few words. No matter which face is used, just be sure it can be read easily and understood across all types of media.

Ensuring Readability and Legibility

The readability and legibility of any typeface is critical. *Readability* refers to whether an ad can be read easily—that type is not too small, too close together, or has lost some of its clarity during printing. Readability is also affected when large headlines or blocks of copy are set in all caps or reversed out of a dark background. Watch out for typefaces that are too decorative and layouts that are too busy.

Legibility means any one of the aforementioned devices is making it hard for the reader to understand what is being said quickly and easily. It is the art director's job to be sure that each of the essential elements on the page—such as the headline, subhead(s), visual(s), body copy, or logo—is logically placed, has one dominant element, and easily flows down the page. An organized page ensures each of the essential elements will be seen in the exact order envisioned by the designer, thus ensuring readability and legibility.

Type Is All About Image

The letterforms or typeface used to deliver a brand's message should reflect both its image and the key consumer benefit. There are many different typefaces available to the designer, each having its own voice and personality.

Type should be thought of as a graphic voice for the brand. Its visual/verbal identity will repetitively represent the brand in the same way as color, headline or layout style, or a spokesperson might do. In order to personalize a typeface further, many designers will alter a face's overall appearance by changing its weight, or the thick or thinness of its lines and curves, or by lengthening or shortening its *ascenders*—the lines that extend up from the body of the letterform such as in the letters "d," "k," or "h"—or *descenders*—the lines that extend below the letterform's body as seen in "p," "g," and "j." A face's overall look can also be altered slightly by tightening the space between letterforms, by overlapping *serifs,* or by joining a descender from one line to the ascender of the line below. When adjusting a face's design in any way, just be sure readability and legibility are not affected.

It is also important to understand that the typeface chosen to represent a brand's graphic voice is not a temporary choice, but one that will likely represent the brand for years or even decades. The search for the best face and style should begin with a match between the brand's overall use, packaging, strategy, and tone of voice.

Determining the Right Style for the Ad

The diversification among typefaces gives each one a unique look and personality. Careful consideration of the brand's image is critical when deciding on just the right face to tell the brand's story. The choice of typeface can also tell us if a brand has a feminine or masculine appeal. *Serif faces* like the one you are reading now, because of their fine lines and delicate feet or extensions, give copy a light and elegant appearance, making it a great graphic voice for jewelry, romantic getaways, or any other brand directed specifically toward women. *Sans serif faces,* on the other hand, have no delicate extensions, giving it a more solid or masculine appearance. These faces are ideal for products advertised primarily to men such as trucks, cologne, or weight equipment. It is important to note that this characterization of typefaces is not a sure definer of every available face. Goudy Old Style, for instance, is a boldish, squat, serifed face that crosses the gender gap, making it an acceptable choice for almost any product or service. Another surefire way to define a serif or sans serif face's personality is to alter its *weight,* or the thickness or thinness of its varied shapes. For example, a sans serif face such as Helvetica comes in so many different weights that it can take on many different personas.

A face's weight can further project a masculine or feminine appeal. Typefaces vary in variety and weights much like people do: Some are thick, round, and squat, while others are tall, thin, and wiry, and still others fall somewhere in between. Increasing or decreasing a face's overall weight can easily alter

its personality and gender. A style's overall lightness or darkness depends on the typeface chosen; some have many options such as thin, ultra-light, extra-light, light, book, regular, medium, demi- or semi-bold, bold, extra-bold, black, extra-black, or ultra-black.

Alternating weights is a great way to attract attention and add contrast to the page, but too many alterations or combinations can compromise the design. The typeface(s) chosen should tell the product's or service's story, not steal the show.

Following the Not-So-Hard-and-Fast Rules of Type Design

Unless a designer is using a type specimen layout style, or a layout that features multiple faces as a design element, the number of typefaces used in any one ad or series of ads should be limited to two. Usually the headline, the over and under subheads, and any prices or announcement devices are in one face, while smaller type like body copy and descriptive copy are in another.

For a design to look both unified and structured, the number of weights and point sizes used should be limited as well. Too few and there is not enough contrast on the page; too many and the ad can look messy and dis-organized, both of which affect readability and legibility. Although serifs and sans serifs can be mixed, a more unified look is usually attained using a single style throughout. Serif faces, because of their contrasting line and curve weights, are easier to read in smaller point sizes than the more solid-looking sans serif faces.

Type does more than speak the words it is assigned; it also represents the emotions of the words in its unadorned lines, peaks and valleys, or diversely shaped curves. Type is the brand's visual/verbal voice: Use it to tell the target not only what the brand can do, but how it should make them feel. Think of it as the brand's clothing—it needs to say a lot about the product or service at first glance.

A face can also be changed by altering the space between letterforms, known as *kerning* (a computer term) or letter spacing (a design term), or by altering the space between lines of text, known as *leading* (pronounced "LEDD-ing"; a computer term) or line spacing (a design term).

The delicate extensions that adorn the bottoms or edges of all but curved letterforms in serif faces can be tightened or pushed together to the point that they touch or even share a serif. Kerning allows the designer to manually adjust the space between letterforms for a more tailored appearance. Text set in all capital letters will need more kerning than text set in caps and lowercase letters, as all caps are prone to inconsistent spacing that needs to be equalized. As a rule, only the largest text on the page is kerned. Smaller text such as body

Figure 5.2 **Sample Ad: SPCA**

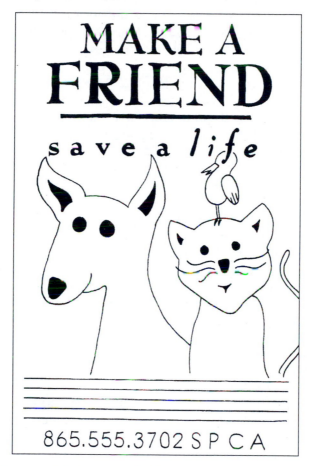

Source: Created by Eric Burroughs, The University of Tennessee, Knoxville.

or detail copy will be easier to read without any kind of spacing adjustments. Tight letter spacing for a headline, for example, adds bulk and increases its dominance on the page.

How do you know if you've gone too far with adjustments? Print out the copy and give it the squint test: If you can still see an equal amount of white space between each letterform, it's both readable and legible. This is called eyeballing, because the letterforms have not been mathematically or equally spaced. Because some or all of the letterforms have been manually manipulated, though, they will *appear* to be equally spaced. Kerning should not be thought of as an occasional need but as a type of signature that will become a part of the brand's distinctive identity.

Leading or line spacing, refers to the amount of white space appearing between lines of text—how much or how little depends on the size of the text and the designer's preference. Larger blocks of copy such as headlines or subheads will often have less space between lines to make them stand apart from other components on the page and appear even bolder. Small text such as body copy will often have more white space between lines of text, making it easier to read. Body copy that is too close together can be problematic. It keeps the eye from using the white space between two lines of text to travel back to the left side of the page, often causing the reader to reread the same line of text twice.

Type Placement on the Page

The graphic message can also be affected by its visual placement or alignment on the page. The four most commonly used alignments are (1) center on center, (2) flush left, ragged right, (3) justified left and right, and (4) wrapped.

Type that is set center on center or one line centered over another is a balanced and targeted way to highlight a cleverly worded headline or informative subhead. Headlines featuring multiple lines of copy can create white space and ease readability and legibility when line breaks alternate in a short-long-short or long-short-long pattern. Avoid setting body copy center on center, however, unless writing a poem or creating a greeting card, as it is too open and very difficult to read.

Body copy is most commonly set flush left, ragged right. This alignment style begins each line of text along a set left margin. The end of each line (or the right side) is of varying lengths. This is also a great way to display longer headlines.

A justified left and right alignment style aligns the left side of text to a set left margin and the right side of the text block to a set right margin, creating lines of equal text lengths. This alignment style is commonly used in newspapers and often features multiple hyphens, unsightly gaps between words, or multiple words that are stretched out across the column. Because of its inconsistent look, it is not used often in ad design. When it is used, these inconsistencies can be avoided only if the type is designed or written to fit the space—a very time-consuming process that often ends up difficult to read in large blocks. This is a great time to use multiple subheads and paragraphs to break up these solid blocks of copy. Unless the goal is to have the headline look like it could stop a train, avoid using justified alignments for large text.

Another popular alignment is called a text wrap. A *text wrap* occurs when type wraps around an image. It is important the wrap follow the shape of the image as closely as possible to avoid irregular holes of white space appearing

at the end of lines. Once alignment is determined, the next step is to decide how many columns of copy will be needed.

Depending on the design and media vehicles employed, body copy can be set in either one column or in two or more columns. Body copy needs to be designed just like the rest of the page, so there are a few things to watch out for. When using a text wrap, it is important to have at least one-quarter inch of white space between columns of text or around any visual placed in or near the copy. The eye needs this white space to keep it from jumping from column to column or getting lost in the visual.

When breaking lines of copy, watch for widows and orphans and eliminate them when they do appear. A *widow* is usually a single word, or possibly two short words, that appear at the end of a paragraph or column of text. One word appearing on a single line in a head or subhead should also be avoided. *Orphans* become a problem when body copy is broken into two or more columns of copy. An orphan occurs when one or two short words end a line of text that appears alone at the top of the second or third column. The resulting extra white space causes the ad to look unbalanced.

The length of typed lines of text also affects readability and legibility. As a rule, one column of text should be no longer than six inches. Anything longer makes traveling back to the left margin difficult for readers. Depending on the size of the ad, text set in two or more columns will measure anywhere from three inches to four and a quarter inches.

Also affecting readability and legibility is the size of type used in the design. Size directly affects what you want the reader to see first, understand, and do. Type is determined by point size, a very small form of vertical measurement having about 72 points to an inch. The point size of a letterform deals more with the physical space the letterform occupies than its actual measurable size. Size is also affected by the length and height of the face's ascenders and descenders, as well as the type's x-height (or height of its lowercase "x").

Text size should go hand in hand with the job it has to perform. Large text, for example, stops attention with its bold shape and message. Medium-sized text lures the reader into the small copy or body copy where the sale is made. If using an overline subhead as an announcement device, make sure it does not compete with the headline. Any secondary subheads placed in the body copy should be set in bold and be at least one and one-half to two times larger than the body copy.

Additionally, the paper, printing process, and the age of the targeted audience affect the choice of text size. Text appearing on uncoated paper stocks such as newsprint or some packaging surfaces will bleed or move on the page when printed; it must be thick enough and large enough so delicate lines do not disappear or fill in, affecting quality and readability.

For older audiences with less than perfect eyesight and young children just learning to read, text should be set in 12- to 14-point type. Depending on the typeface and whether a coated or uncoated paper stock is being used, 10 to 12 point is usually sufficient for general audiences.

Common Type Mistakes

Although it is common for designers to create type in the brand's image, it should never be manipulated to the point that it cannot be read and understood at a glance. The most common mistakes include (1) using large blocks of all capital letters, (2) setting white type on a dark or black background, (3) overusing italics to highlight text (the use of italics should be limited to a single word or quotation), and (4) using overly decorative faces containing gothic swirls or scripted flourishes.

The color and direction of type can also affect readability and legibility. Black type is not the only headline option available to the designer. Other dark colors, such as navy, dark green, or brown, are readable and say more than the commonly used black type. Light or pastel colored text lacks contrast, making it hard to read against the white of the page. Small text is always easier to read when reproduced in black.

Type direction can make type difficult to read, as well. Words printed vertically on the page or tipped on their side often slow the reader down and should be used for announcement devices only.

Type Design for Multiple Media Vehicles

There is no formula for choosing a typeface that will work across all media vehicles—just experience gained from many successes and a few more failures. When choosing type for a campaign, it is important to know which face or faces competitors are using. Which face, style, and weight will best represent the brand's image and conceptual direction? Which promotional mix will be employed? What is the age of the intended target? Is the brand new, an old reliable, or in need of a facelift? Without the answers to these questions, you will not be able to create a unique and coordinated visual/verbal look or message across the media mix.

Type choices should not be made quickly. The time spent finding the right personality match for both the brand and the target is an important step in defining image. Design issues, readability, and legibility play a huge role when determining the right face(s) to represent the brand. Ask yourself, Can this face be used on the web, in print, as mobile text, in a catalog, a brochure, an e-mail, or on out-of-home? If not, keep looking.

It is also important to know where and how type will be used. Will it be used in headlines, body copy, or both? Will it be placed on top of a colored or screened background? Used in any reverses? Will it be set in a color or only in black? What type of paper stock will it be printed on? How will that affect the typestyle chosen?

Each face has a story to tell and an image to project. There are hundreds of faces out there to choose from; many are overly familiar, and some will work great for print but look dreadful on the web or as small text. It is the art director's job to narrow down the options to a select few and test them for both readability and legibility when viewed on diverse screens and paper stocks.

As a rule, the best all-purpose faces will come in multiple weights to ensure a diverse range of contrasts and some kind of individualistic appearance. A face might have unusually tall or squat ascenders or descenders, be full bodied and sensuous, or be endowed with a more dangerous, edgier look because of its pointed edges or geometric appearance. Be sure to keep away from the trendy face of the day: Its popularity will not last, and often it will not be a good fit with the brand's overall image. In the end, when selecting the voice of the brand, pick the faces that have the best appearance and are the most readable and viewable when used across a diverse range of media vehicles.

Remember, type should be more than just functional; it can bring beauty and character to a design. Diverse shapes tell a story and project an image graphically. What a typeface says gives an ad movement, energy, or humor. Each face awaits the individualized personality and expression given to it by the copywriter and designer.

Choosing the Best Verbal Look for a Multimedia Campaign

It is beyond the scope of this book to look at every kind of piece that might be used in an advertising campaign, but we can offer a few samples of the most commonly used vehicles in order to isolate certain commonalities and individual characteristics. Let's examine some of the unique aspects of choosing the best typefaces, styles, and sizes for a multimedia campaign.

Print

Print's job is to inform both visually and verbally, so it is crucial that type choices be easy to read but still project the brand's image. Any vehicle falling under this heading will usually incorporate headlines, subheads, and body copy into the design. To assure unity and readability, the typestyle chosen should blend in with the motif—not draw attention to the intricacies of its own design. Research has proven that serif faces are not only more elegant

Figure 5.3 **Sample Ad: PetSmart**

Source: Created by Kate Gustafson, The University of Tennessee, Knoxville.

in appearance but easier to read. However, sans serif faces are acceptable alternatives for body copy when displayed with increased kerning and leading to ease readability. Ultimately, when deciding on whether to use a serif or sans serif typestyle, keep in mind many sans serif faces appear larger than serif ones, so pick 10 to 11 point for sans serif faces and 11 to 12 point for serif faces.

Print enjoys the attention of the reader. Each vehicle is read up close and straight on. This allows headlines and subheads to be tightly kerned and leaded, often giving a familiar face an individualized personality. Smaller text or body copy is more affected by paper stock than size or overall design. Newspapers,

newsletters, and direct mail are most commonly printed on uncoated or dull, ink-absorbing paper stocks. Because of this, these vehicles require faces that ensure they do not bleed together or lose delicate lines when printed.

Magazines, brochures, catalogs, and posters are most often printed on a coated or shiny paper stock, allowing the ink to set on top of the paper. This surface is optimal when more delicate or decorative faces are employed.

Text sizes for headlines and subheads will vary depending on the vehicle; body copy, on the other hand, is relatively uniform, usually appearing around 10 to 11 point. As a rule, body copy leading will be open, measuring at least one point size larger than the text size, and have no kerning.

Other similarities extend to both the column width and line length. The text used in any vehicle can be set in one or more columns. This uniform look often requires multiple subheads to divide the body copy into more easily readable, or scannable, chunks. Copy-heavy pieces can easily gain strong visual contrasts on the page by alternating a solid-looking subhead with a lighter-weight body copy.

Multiple columns will be divided by a quarter-inch gutter or the amount of white space that appears between columns. Open gutters help the reader to recognize that the copy should be read from top to bottom rather than across the page. Alignment set flush left and ragged right creates much-needed white space; brochures or newsletters will appear more standardized when the text is set flush left and flush right.

The most popular and easiest-to-read body copy faces used in newspaper and magazine ads are Times or Times Roman. Newsletters, brochures, and direct mail often employ Garamond, Palatino, Times or Times Roman, and Century Schoolbook. These are only a few of the dozens of faces available to designers, but each one offers a good selection of weights for contrast. Brochures and direct mail are typically more creatively designed, often employing multiple typefaces or styles, reverses, italics, and weights.

Posters are unique, and of all the print vehicles we will look at probably employ the most inventive use of type with the least amount of text. Because most posters have to be read from a distance, it is important to use a large type with a small amount of open kerning. Be careful—letter spacing that is too open can cause the reader to focus on individual letters rather than recognizable words, thereby slowing down the delivery of the message. The typestyles used on posters will vary, often employing both serif and sans serif faces. Many of these faces will need to be set in bold in order to overprint a block of color or some type of image. Be sure to choose a contrasting color to increase readability.

The choice of face will depend on where the poster will be seen. Will it be viewed in a quiet place where a more decorative face can be used, or a busy

place where visual noise requires a simpler set of faces that can be sought out and understood more easily? The diversity in poster design and use makes it impossible to determine a rule of thumb for poster type design. The visual amount of copy, the placement, the color, the angle at which it will be viewed, and the size will all have to be taken into account when choosing text for any kind of poster.

Out-of-Home

Because both outdoor and transit are moving targets, they require increased kerning and word and line spacing to be readable. Too little spacing renders the message unreadable. The best faces for out-of-home vehicles are sans serif faces. Any ornate or decorative faces should be avoided, because they drastically affect the readability of the message at greater distances and speeds. If placing text on top of a color, be sure there is a noticeable difference in contrast between the background and the typeface. Many out-of-home vehicles can be gaudy and overdesigned, so this is a good time to reiterate the importance of working with no more than two faces, preferably in the same type family or font. Remember: When using multiple sizes, weights, caps, italics, reverses, and so on, tacky is only a design choice away, so control using excessive type "accessories."

Broadcast and Electronic Media

Broadcast and electronic media all have special requirements that distinguish them from print. These vehicles require additional space between letters and words. When set too close together, it becomes difficult to discern between individual letterforms and words. The solidity of sans serif faces are best displayed when viewed on a television screen, as opposed to a serif face that will often lose detail or blend into the background.

Type on the web is affected by resolution; therefore, online ads should make use of faces with distinctive shapes. Designers disagree on whether sans serif or serif faces work best online. Sans serif faces project a stronger and more distinct letterform that does not bleed together or pulsate on low-resolution screens. Gill Sans, Helvetica, Verdana, and Ariel, all of which are sans serif, are the easiest faces to read at any resolution. Some of the better serif faces include Lucinda, Rockwell, and Georgia. Each of these faces sport very solid serifs that offset any screen distortions due to resolution.

Web designers also need to consider the effects of different computer platforms and screen sizes on readability. The web is one of the few media vehicles that is not viewed equally by everyone who sees it. Type measuring

anywhere from 10 to 14 point will be easiest to read, as will line lengths of no more than four to five inches. Faces that are rounder with larger x-heights are easier to read than taller, more wiry faces. Type sizes will vary, but a good sizing rule of thumb allows headlines to cut across columns, with subheads measuring at least two points larger than the body copy.

E-mail messages can be visually boring when too copy-heavy. Consider adding subheads that are not only great stopping points but also an effective way to build awareness and curiosity that could mean the difference between a target's actually reading a message or simply deleting it. Attention can also be generated with italics, or by placing a word, comment, or quote in bold text. Never underline anything unless you want the piece to look old-fashioned; underlining harks back to the age of the typewriter. Most e-mail messages are set in at least 12-point type and often use Arial or Verdana for best readability.

6

Copywriting and Layout Nuances

Figure 6.1 **Sample Ad: Knoxville Zoo**

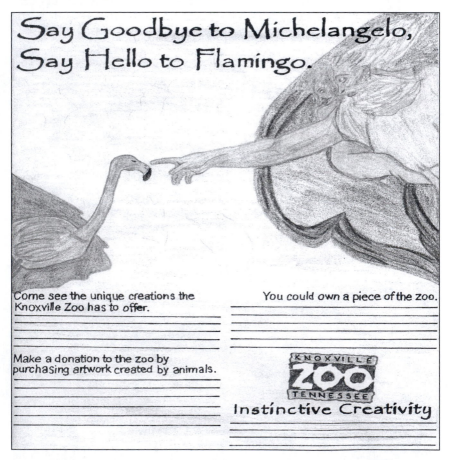

Source: Created by Justin Cooter, The University of Tennessee, Knoxville.

Determining What Kinds of Images Will Work with the Key Consumer Benefit

A successful IMC campaign must promote a single idea across multiple media vehicles. It must be recognizable whether promoted on television, in direct mail, in a mobile text, or viewed at a guerrilla-marketing event. No matter how short or long its content, a campaign's imaging and messaging must be strong enough to identify the brand wherever it appears.

A good campaign will find a way to create a relationship between what is said and what is seen in order to build the brand's identity and encourage purchase. The creative team has an array of images and text-based options at their disposal. The choice of which to use should be based on the target, the key consumer benefit, the strategy, the brand's image or perceived image, and the media vehicles used in the campaign.

In order to create a memorable campaign and a memorable brand beyond the current key consumer benefit, consider using diverse color combinations that are different from competitors; in addition, use headlines that not only highlight the key consumer benefit but also engage readers by asking a question or attaching a memorable simile or metaphor to the brand. Use visuals that showcase current users; use demonstrations; appeal to the target with sexuality, animation, fantasy, or humor. Consider using a catchy jingle or unusual noise to engage the target in the message. Pick a logo, packaging, and a slogan or tagline that not only scream the brand's image but are so individualized they stand out from competing products on the shelf. Any time you can create a memorable phrase like Wendy's "Where's the Beef?" that becomes a part of mainstream conversation, you have established a trend that can be further developed into an image, that says reliable, dependable, sophisticated, rich, or decadent, to name just a few possibilities. Speak boldly and say it creatively and consistently, and the campaign will be recognizable anywhere.

Sometimes the product or service being advertised is not blessed with any features that differentiate it from competing products. In that case, a creative and unique approach that sets the product apart based on ingenuity, status, or reputation will aid in defining its image. Another way to offset product parity is to promote a universal feature as unique. Perhaps every microwave has a turntable, but yours might be set to music that matches the flavor of the food. Perhaps the carrots break dance, the broccoli two-steps, and the onions do the twist. If it is creative enough, the target will sing the songs and do the dance every time they fix a microwavable meal. The visual/verbal message should clearly point the way to memorable, informative, and imaginative visual/verbal solutions to the target's problems, needs, or wants.

The Visual/Verbal Message Defines a Campaign's Identity

The concept or idea developed from the creative brief tells the creative team what needs to be said and shown to make the key consumer benefit stand out across all media vehicles. The idea should catch the target's attention both visually and verbally by tying both elements to the target's self-image and lifestyle.

A brand's image or personality is defined by the advertised message. Is it cool, expensive, rare, affordable, or cutting-edge? Whatever it is, the image will be legitimized by what is repeatedly said and shown. Each element will create a tone or style that must be used cohesively and consistently throughout the campaign. For example, if a headline asks a question in one place, there must be another question asked in each successive media vehicle. Body copy will also address the question each time it appears. If images of animals are used in one place, they must be used everywhere; they don't have to be the same animal or the same headline or the same body copy, just the same repetitive style. Other elements such as layout styles, color or color combinations, typestyle, and any spokespersons or character representatives will be represented everywhere the message is seen or heard.

These types of cohesive properties require a campaign to have one continuous visual/verbal thought from one ad to another. If the goal is to push a one-dimensional key consumer benefit, then showcase it in all media; however, if you want to tell a continuous story, let the key consumer benefit develop slowly across the promotional mix. For example, consider introducing varied uses if the brand is technologically diverse, presenting a new feature in each different media vehicle. The campaign's message should lead the target to the next step in the promotional process, such as visiting a web site, downloading a direct mail coupon, participating in a trial event, or making a purchase.

Determining what visual/verbal element or combination of elements to be used will depend on the media mix employed, the brand's lifecycle, and the complexity or simplicity of the overall campaign strategy. Whether the campaign will be a complex introduction or reintroduction of a brand or a simple reminder, the creative team needs to isolate a multipurpose creative direction.

Let the Choice of Media Vehicles Point the Visual/Verbal Way

It is important to know which media vehicles will be used before deciding on the overall creative direction. Certain ideas require a concentrated media mix; others require a more diverse mix. Media choice is fundamental to telling the product's or service's story: The right choice depends on whether the key consumer benefit requires a lengthy verbal message, a combination

visual/verbal message, or a simple concentrated look at the product alone. For example, many media vehicles are informative and employ a large amount of copy. Others require the use of all the essential visual and verbal elements to attract attention. Still others rely on large amounts of white space, small headlines, simple visuals, and little or no body copy to develop or maintain a brand's image. These latter techniques work particularly well when making a simple statement or setting a more elegant mood. Dominant visuals can also influence image by allowing the consumer to hone in on any intricacies in the product's design, or merely focus on the product alone, either in use or in an appropriate setting.

The proper combination of essential visual/verbal options assists in strengthening the key consumer benefit, creates a more memorable campaign, develops a stronger tie to the target's needs, attracts the target's attention, encourages comparison, and assists with the creation of a visual/verbal image that will easily adapt to multiple media requirements.

The Essential Verbal Design Elements of Copy

The story the copy will eventually tell is part creative brief, part brainstorming solution. Once the idea or concept is solidified, the design team has to determine what will be said and shown, the tone of voice employed, and whether the copy will support the visual or play a starring role in the telling of the brand's story. Copywriters have a diverse arsenal of verbal design elements to choose from, including headlines, subheads, body copy and detail copy, slogans or taglines, and jingles. Each of these copy elements needs to tell the product's or service's story cohesively while advancing the target's knowledge about the key consumer benefit. Let's take a look at each of the verbal design elements.

Headlines Scream the Key Consumer Benefit

A headline is a large vocal forum for an ad's main idea. It has a lot to do: It must capture the reader's attention by connecting in some meaningful way with the target, scream out the key consumer benefit, enhance the visual/ verbal relationship, and lure readers into the body copy. A headline is the largest and boldest piece of copy on the page; the reader will often notice it before any other design or copy element. The length and size of a headline will be dictated by what needs to be said and the brand's lifecycle stage. As a rule, most will measure anywhere from a five- to seven-word statement to two complete sentences. A headline answers the target's most important question, What's in it for me?

A headline for a new or reinvented product will have a lot more to say than one used by a brand in its maintenance phase. The type of headline style used is dependent on the overall length of the statement being made. For example, a problem/solution headline will require more words to make its point than a command headline style will need. The media vehicle employed will also regulate headline length.

If the first thing the reader sees does not inspire, the target will just flip the page or toss the piece in the trash. It is important the headline be easy to read, educational, and beneficial. Lengthy headlines usually announce something new or present a study or alternative use. Shorter, less informative heads are usually associated with a mature product or service that already has a strong established brand image and is advertising to remind consumers about the brand. Every headline—regardless of length—should project a unique style all its own.

A headline's tone or style depicts how the advertising message is expressed; will it use humor, a question, or perhaps a pun? The type of style used should support the message and the brand image. It should talk to the target in a tone of voice or language they will understand about an issue that matters to them. Since the headline's job is to inform the target about the key consumer benefit—the one fact research has guaranteed the target to be interested in—it should be cleverly and concisely written to seduce the reader deeper into the ad. Here are the most commonly used headline styles:

- Direct Benefit. This headline style offers one specific benefit important to the target.
- Reverse Benefit. A reverse benefit headline leads the reader to think their lives will be incomplete without the advertised product or service.
- Factual. Factual headlines are very interactive and usually offer some type of trivia question important to understanding the product or service.
- Selective or Flag. A selective or flag headline clearly names a specific audience group. For example, if you want to reach back pain sufferers, mention them in the headline.
- Indirect or Curiosity. Gives the readers enough information to pique their interest and make them want to learn more about the advertised product or service.
- News or Announcement. This type of headline features current events in the news or focuses on a current trend.
- Command. A command headline politely but directly tells the reader what they should do. It is great at creating involvement.
- Question. A question headline is a great way to create engagement. Just be sure the question is thought provoking and cannot be answered with a simple "yes" or "no" response.

- Repetition. If it's worth saying, it's worth saying two, three, or four times.
- Puns. A pun headline is a "play on words." A pun can take similar-sounding words that have more than one meaning and use them to make a point. Always an attention getter.
- Similes, Metaphors, Analogies. One way to describe the product is to compare or link it to another similar or "like" image. A *simile* uses the words "like" or "as" to describe something, as in "the engine purred like a kitten." A *metaphor* takes two dissimilar features and compares them without using like or as. For example: "It's raining cats and dogs." An *analogy* equates two features based on similarities, such as comparing dry skin to an alligator hide.
- Rhyme. Rhyming headlines use the repetition of similar sounds to point out a feature or prove a point.
- How To. "How to" headlines explain how the product works and how to use it.
- Product Name. Using the product name in the headline is great when launching a new product or reinventing an old product. These types of headlines do not project a strong consumer benefit beyond its level of brand equity within the product category, so this strategy is best used only if the product owns the category.
- Major Benefit Promise. This type of headline can promote studies by doctors, engineers, scientists, and so forth. The promise is usually the key consumer benefit.
- Reason Why. Just as the name promises, this type of headline gives the consumer a reason(s) why they should use the product or service.
- Testimonial. A testimonial headline uses a positive quote from a member of the target audience about his or her experience with the brand. There is no better word of mouth than that of a happy consumer/user.
- Personal Benefits. This type of headline promises something such as less pain, longer lashes, prestige, safety, and the like.
- Practical Advice. A practical advice headline does just that—dispenses practical advice. For example, it might tell the target how to get clothes cleaner or teeth whiter.
- Problem/Solution. This type of headline mentions the problem but spends its time selling the solution.
- Warning. A warning headline suggests the target pay attention so "this will not be you," or offers a "once in a lifetime" chance at something the target wants.

Although the choice of headline style will normally depend on the target, objectives, key consumer benefit, and strategy, there are those rare times—

usually in newspaper—when the focus is on price. Price-based headlines are not always a good choice when used across multiple media vehicles. If price is a reoccurring issue, consider putting it in a callout box. A callout box is a graphic box that is usually placed within a block of copy and often uses bullet points to highlight important facts like prices or details about a product or service that set the brand off from competing products.

Whether the headline screams the key consumer benefit or is being used as support for a dominant visual, the headline and visual are inseparable. They show and tell the product's or service's story in one cohesive unit. Some of the most engaging headlines can both show and tell: "Shirts you can: Throw in, pull out, and slip on. No Wrinkles." At its best, show and tell not only educates but also visually shows and tells the target about the key consumer benefit.

Aesthetically, show and tell is also important in how larger verbal elements are shown on the page. When deciding how to break a multiple line headline or subhead, be sure the lines are not of equal length and that each break has a rhythm or clarity of thought. The best breaks often mimic a conversational pause or act like a period ending a thought. Do not abandon the rules of proper grammar when creating breaks, and be careful not to hyphenate a word or break a proper name.

It is important to remember a good headline is also a multipurpose sales device. Not only does it open most print vehicles, but it can also be used in any broadcast or digital media vehicle or in a presentation. Rejected ideas often make great slogans or taglines.

Take It Away, Subheads

A headline should lead logically to a subhead. A subhead is the second largest piece of copy on the page and can be used as an announcement device, as a support for the headline, or to break up long blocks of copy. There are three basic types of subheads: upper, under, and copy breaks.

An upper subhead appears above the headline. Its job is to make an announcement boldly rather than have it buried in the body copy. These types of subheads are usually a statement that shouts out a grand opening, a new location, or even special sales or store hours. Upper subheads are often reversed out of a solid block of color to attract attention.

A subhead that supports the headline is known as an under subhead or a main subhead. Usually one or two complete sentences in length, it explains the headline in more detail. For example, if the headline is "Get Your Free Tickets Now," the subhead will tell the reader how or where to get the tickets.

Copy-heavy pieces use subheads or copy breaks to section off long blocks of gray copy with a strong black or pop of color. Copy breaks help divide

copy up into multiple discussion points. These types of subheads work like chapter heads, informing the reader about the subject matter in the subsequent paragraphs. Because they are used as announcements or informative devices, they are usually statements running anywhere from three to seven words in length.

Copy Tells the Brand's Story and Makes the Sale

A main subhead's secondary job is to seamlessly lure the reader into the body copy. Copy is the product's or service's story. It is the copywriter's job is to make sure the reader follows each verbal element through to the body copy, where the actual sale is made. The writing must appeal to the senses so the target can experience how the product works, tastes, or feels when being used. The body copy utilizes the same tone as the headline to unite the verbal elements. The target uses the copy to learn more details about the key consumer benefit and any supporting features and benefits such as sizes, colors, uses, and studies or testimonials that confirm or simplify claims.

Body copy is constructed like a novel: It must have a clearly defined beginning, middle, and end. The beginning finishes the thought begun in the headline and expounded upon in the subhead. The middle paragraphs of text are where supporting points are used to strengthen the key consumer benefit and highlight how the brand can enhance the target's overall lifestyle. The closing paragraph is a call to action: It needs to tell the target what they should do next, such as go to a website, call for more information, or come on down to a brick-and-mortar store. To make it more urgent, give the consumer an incentive to respond right now or within the next 30 days.

Body copy should not be an endless list of facts; rather, it should be an entertaining and informative story that is tied to the target's lifestyle. Each product's storyline needs a strong plot (key consumer benefit), which is advanced and colored by events that affect the brand (features and benefits). These event(s) must somehow affect the characters (target), moving them to some kind of climax (call to action).

The best copy does not repeat itself but builds upon each preceding point. Personalize the copy by writing to a single individual using "you" instead of "them," "they," or "we." Use short sentences and multiple paragraphs to make both reading and comprehension easier. Be sure copy uses a personalized and conversational style that talks to the target in a language they will understand about events that are important to them.

Informative copy will concentrate on a product's or service's benefits rather than its features. Benefits can be made unique when tied to the target's needs, wants, and lifestyle. Most competing brands have the same or similar

features and so are not inherently special or unique. However, if a distinctive use can be isolated, copy can carve out a niche for a brand, setting it firmly apart from the competition. In his book *Bill Bernbach Said . . .* (1989), William Bernbach summed up getting the target's attention with copy in this way: "You can say the right thing about a product and nobody will listen. You've got to say it in such a way that people will feel it in their gut. Because if they don't feel it, nothing will happen."

Because copy is often being written at the same time the art director is designing the ads, it is important for both the copywriter and the art director to understand what the copy should say and what the visual elements should show in order to create an idea that is visually/verbally unified.

Don't Forget the Detail Copy

Some of the most important copy on the page is the small detail copy located near the logo at the bottom of the page. Detail copy includes one or more of the following: store address or addresses, hours, web address, phone number(s), credit card information, and any maps that will help locate the product or make using the service easier.

Slogans: The Voice of the Company

Generally located above or below the logo, a slogan should reinforce the brand's image and represent the company's mission statement or overall philosophy. Slogans are usually a statement of no more than three to seven words. A good slogan may last the life of the product or until a company is sold, reorganized, or the brand is changed in some meaningful way.

Taglines: The Voice of the Campaign

The only difference between a tagline and a slogan is longevity. A tagline may appear above or below the logo and is tied to a current campaign theme: It changes with each new campaign direction. Tags associated with brands having a strong brand identity can last a little longer when tied to lifecycle stages.

Jingle a Catchy Tune

One way to make a key consumer benefit memorable is to attach it to a "catchy" tune. Anything is memorable if we can't get it out of our heads.

Figure 6.2 **Sample Ad: Ray-Ban**

Source: Created by Allison Schepman, The University of Tennessee, Knoxville.

It's considered "catchy" for a reason. For example, can you hear the original FreeCreditReport.com song right now? Some of the best stay with us decades after the ads have ended, such as with Alka Seltzer's "Plop, plop, fizz, fizz, oh what a relief it is!" or the Oscar Meyer Weiner song. Each example tells us all we need to know about the featured product.

The Essential Visual Design Elements

Sometimes you can talk a product to death: there's a better way to bring a feature to life. An ad's visual identity—whether whimsical, dramatic, classical,

or sophisticated—can be expressed through varied types of visuals, layout styles, character representatives or spokespersons, and color(s). The typeface and style can visually represent the brand with its soft curves, harsh edges, delicate lines, or solid appearance, as we learned in the previous chapter.

The essential visual design elements include layout styles, visual images, typeface and style, spokesperson or character representative, color, and logos. With few exceptions, every campaign device will use one or more of these image identifiers in every ad or promotional piece employed in the campaign. The choice of visual used will depend on the key consumer benefit, the target, the brand's overall image, its current positioning, the choice of verbal style, and the media vehicles that will be featured throughout the campaign. It is important that a brand's visual/verbal identity moves easily between media vehicles without a loss of identity.

Layout Styles

The choice of layout style used helps define the brand's personality by arranging essential design elements on the page. Let's take a look at the most commonly seen layout styles.

Big Type

When you have a powerful informative headline, scream it out by making it as big as you can to attract the reader's attention. Visuals, if they exist at all, are usually small and play a secondary role. The beauty and appeal is defined by the unification of the typeface chosen with what is being said. Break the headline up into varying line lengths to create visual interest. It is important that visuals do not get in the way of what is being said. Body copy is usually minimal in this case. If you love the shape, texture, mood, and movement of type, the opportunity to use it as a verbal graphic element makes this layout style as fun and interesting as the brand.

Circus

A circus layout could be described as organization run amuck. Anything and everything from the designer's visual/verbal arsenal is up for grabs. It is not unusual to see multiple typefaces in a multitude of sizes, colors, and/or tints. Additional elements usually include assorted snipes, banners, and bursts of all sizes and shapes announcing grand openings, sales, and special events in bold reverse type. The key to a circus-style layout is to control placement.

Consider grouping visuals together when possible and focus on one dominant element, creating as much white space as possible. The more structure you can create on the page, the easier the ad will be to follow.

Copy-Heavy

A copy-heavy layout style is informational. Headlines are typically lengthy and visuals are small, usually focusing on the product, the packaging, or the logo. This approach is great for new product launches or reinvented products, where lengthy explanatory copy is required to educate the target. While this type of layout style can look very flat due to the amount of copy present, working multiple subheads into the copy or adding a dash of color to the headline and existing subheads helps the ad pop off the page and increase readability. This is also a great time to incorporate spot color into the design.

Frame

This layout style showcases the border around the ad. Most often used in newspaper advertising, a frame is great for isolating an ad on a busy page. A frame can be used two different ways: (1) to define the size of an ad, or (2) to appear as a graphic box that is inset or slightly smaller than the size of the ad. Inset borders are often graphic in design and are most often used in magazine and direct mail. The size and design of these frames can vary from thick or thin lines, can include graphics, or can sit upon or enclose a shaded background.

Mondrian

This abstract layout style uses multiple geometric shapes such as squares and rectangles in often-vivid colors or neutral tones to section off an ad. The purpose of each form is to strategically guide the reader through the ad. By isolating the headline, visuals, body copy, and logo within these shapes, the designer pulls the reader in and ensures that each component will be viewed independently.

Multi-Panel

This layout style features multiple panels or boxes placed either side by side in a pattern or randomly arranged on the page. It is often used to tell a product's story, highlight features or product uses, or bring a storyboard to print. Each panel has a visual with an accompanying caption underneath or a copy

bubble placed within the panel; these captions frequently replace body copy. Panels can be uniform or vary in size.

Picture Window

This layout style features a large visual, usually taking up about two-thirds of the ad's available space. The headline is printed on top or reversed out of the visual. The picture window layout style is excellent at drawing the viewer into the image. For example, the photo might show a wet dog shaking off the rain on a living room carpet with a headline reading, "Does Your Carpet Smell Like One of These?" Type that appears on top of a visual must be bold enough to be read easily. It should be placed over a solid color or quiet portion of the photograph, that is, the lightest part of the wall. Or, if furniture or other decorations dominate the background or wall, the designer may have to enlarge the headline or use a bulkier typestyle. The key to this layout style is not allowing the text to upstage the visual and vice versa. This union should be viewed as a partnership, not as independent components.

Rebus

This elegant layout style places multiple small or alternating-sized visuals within a large block of copy. The rebus style is great for showing and telling how a product works or illustrating varied product features. Wrapping text around images helps to isolate copy points and simplify overly detailed blocks of copy. Another option is using pictures to replace words in a headline, creating the ultimate visual/verbal statement.

Silhouette

This layout style works great when there are a lot of related visuals that need to go into one ad. By grouping them together in pleasing and irregular shapes, the designer can increase both white space and eye flow by creating one large, dominant image. Body copy or callouts are often placed around the images, usually highlighting price and individual product features. Be sure type is evenly balanced around the visual to unify the visual/verbal components. Items that are not related may need to be isolated into a grid or multi-panel layout style. The silhouette layout style may appear overly posed or symmetrical if visuals are too close in size or color. Consider having the visual interrupt, or overprint, the headline to increase the visual/verbal relationship. Another option is to allow visuals to be cropped along the sides of the ad in alternating or varied spots.

Type Specimen

This layout style breaks all the rules by using multiple typefaces in one ad. Most often used in large, often lengthy headlines, it is not unusual to see each letter in a different face. If your product does not lend itself to a witty advertising approach or if it lacks an exciting key consumer benefit, the type specimen layout style can draw the reader's eye. Because there is so much going on, be careful that readability and legibility are not adversely affected. The success of this layout style depends on the careful selection and combination of the varied styles and sizes of typefaces used. This is a great way to define a playful, elegant, or spirited product personality.

Ultimately, the layout style chosen will project the brand's personality and style while organizing where each of its visual/verbal components will be placed within the design. Choice of style will depend on the ambiance desired and whether it will tell a detailed story or show an experience.

Visual Images

The visual design elements play a large role in advertising design. They can be featured alone, placed within body copy, interact with the headline, be grouped together, appear large or small, be a simple black-and-white image or full of color. Content can be realistic and detailed, representational or abstract. Designers have a rich palette of visuals to choose from, including photographs, illustrations (line art or clip art), and graphic design. Let's take a quick look at each one.

Photographs

Photographs are a great way to feature the product alone in an appropriate setting or in use. The reality of photography can help the target experience the product or service vicariously, highlight specific features, and focus on important details such as textures, patterns, and uses. Photographs can be used to set a mood, dramatize an activity, or show the juiciness of a burger or a freshly cut piece of fruit. However, using photographs in any ad is both expensive and time-consuming.

Photographs can be black-and-white halftones or four-color separations. They can be altered by cropping or combining images. They can also be customized by changing a black-and-white shot into a duotone, or giving the photo one additional color that adheres to the lighter tones in the black-and-white image. A spot of color will draw attention to a specific area of a visual.

If the budget is tight, black-and-white images are less expensive than color. Stock photographs, or photos that have been used before or purchased from a commercial site, are the least expensive photographic option.

Illustrations

Illustrations have tonal qualities but lack the realistic quality inherent in photographs. However, that does not mean that they cannot set a mood or add some panache. Perception is based on the manner of illustration used. Think of the diverse styles of Toulouse-Lautrec, Marc Chagall, Henri Matisse, Pablo Picasso, Beatrix Potter, and Norman Rockwell.

If the goal of an ad campaign is technical in nature, illustrations are a good choice. They can range from analytical depictions such as pie charts and graphs to character representatives like Snap, Crackle, and Pop of Rice Krispies fame. The price of illustrations depends on the reputation of the artist and the time required to complete them. A less expensive and quicker option is the use of line art or clip art. Line art is a simple black-and-white drawing. Tones are created with stippling, crosshatching, or the addition of solid areas of black. By varying the drawing's line weights, the illustrator can create strong black-and-white contrasts for emphasis, depth, and interest. Clip art is an existing line drawing that can be used for free. There are several clip art books and Internet sites where designers can search for just the right image.

Graphic Design

Graphic design is a form of artistic expression using abstract or geometric shapes, color(s), and type to represent a company, product, service, or social cause. These images can be of any shape or size and may feature a single solid color, a simple outline, many different colors, or overlapping images. A simple single line used to divide the page is also considered a graphic, as are callout boxes or plain graphic bars used to highlight copy. Graphic design images have been used to launch and maintain some of advertising's most iconic brand images, including McDonald's Golden Arches, the Nike swoosh, and the Pink Ribbon breast cancer awareness campaign, to name just a few.

Spokespeople and Character Representatives

When you want to assign a face and personality to a product, consider adopting a spokesperson or character representative to be the visual/verbal voice of the product or service.

Spokespeople

The choice of spokesperson should be based on their relationship with or resemblance to the target, their overall style, or some aspect of their personal lives or professional accomplishments. Athletes are great for any kind of activewear; personalities involved in entertainment, social events, or politics are great for representing more expensive or image-based product lines. Celebrities are chosen for their tone of voice, their sex appeal, their success, or their political or charitable affiliations. Preferably, their particular attributes will match both the product and target's self-image.

Celebrities and athletes do not give a product credibility—they give it mainstream acceptance and status. For technical, new, or reinvented brands, you may want to consider using scientists, engineers, doctors, CEOs, or company presidents to give a product credibility. Current users can serve as desirable and believable spokespeople, as well. Testimonials can be delivered by actual users or by paid actors repeating their words. This latter approach allows the message to be delivered with more personality, believability, and flawlessness. However, any time an actor is substituted for an actual product user, it must be stated or shown in the ad. A spokesperson's popularity or importance is often fleeting. If they are no longer playing, acting, in office, or holding the job title that made them famous, they run the risk of becoming yesterday's news.

The use of unknown talent is a great choice when promoting universally used products or services. The larger pool of talent makes it easier for the creative team to find models that represent the target's self-image, demeanor, and style.

The choice of spokesperson should not be taken lightly: Any problems in their personal or professional lives will reflect negatively on the brand. If you must use celebrities, a less expensive option is to use the celebrity's voice (not his or her likeness) to promote the brand. This is known as a voice-over. The problem with this idea is that a voice cannot be carried over to print media. Most celebrity endorsers are paid to infuse their image into the brand.

Character Representatives

Character representatives like the Energizer Bunny or the GEICO Gecko represent the voice and face of the brand. Animated character representatives are a lot cheaper and a lot more reliable than real people. A character image is created specifically for the product and will not be seen in a courtroom or promoting another product. Character representatives also have a longer life

span than celebrities. Their popularity does not rely on a single game, show, concert, or movie. Because they speak exclusively for the product, we trust them and we like them. The Green Giant, Mr. Clean, and the Keebler Elves have survived for decades because they are lovable, reliable, and have never succumbed to a passing fad or been involved in a scandal.

It is easier to match the target's personality or self-image to that of a character representative, since animated spokespersons are created in the animator's imagination and developed with the product and intended target in mind. A character can take on the attributes of the product, like the doughy-looking Pillsbury Doughboy. The connection may also be made with simple word association, like the Aflac duck quack or the tiger's roar that lets us know Frosted Flakes are "grrreat!" Or, the association can be less obvious, as in the toy that "keeps going and going" with Energizer batteries. If the creative team chooses the wrong personality to endorse the product or service, it can adversely affect how the target views the brand.

Choosing a real or imagined character depends on the key consumer benefit and overall strategy. Although most creative teams do not brainstorm with the overall budget in mind, an animated character will cost more upfront to design and much less over time than a live spokesperson. When a client wants a campaign to last indefinitely, updates will need to be made periodically to keep the brand fresh. Character representatives will guarantee a longer life span than celebrities and their professional personas. Longevity and social trends are good reasons to develop and use character representatives: They never age, they can change with the target, and they are exempt from the ever-changing trends in the marketplace. McDonald's and Kellogg's regularly update their character representatives: Ronald McDonald no longer simply pushes burgers; today, he touts burgers and exercise. And Tony the Tiger has transformed from a shapeless cat to a buffed-up, healthier-looking tiger over the years.

The Symbolism of Color

Verbal discussions about color send a visual to our brain, which in turn elicits some kind of emotion. The symbols we assign colors are rooted in our cultural beliefs and in our natural surroundings. Color stimulates feelings on a subconscious level, ignoring reason and intellect. We may be drawn to or repulsed by a color's brilliance or drabness. Color can tell a product's or service's story, help build brand image, and even determine the brand's voice. Bright colors are generally seen as youthful and exciting, while darker colors are more peaceful and elegant. Color can make us feel warm, cold, excited, restless, or relaxed. We reflect our emotions with color references such as

Figure 6.3 **Sample Ad: GNC**

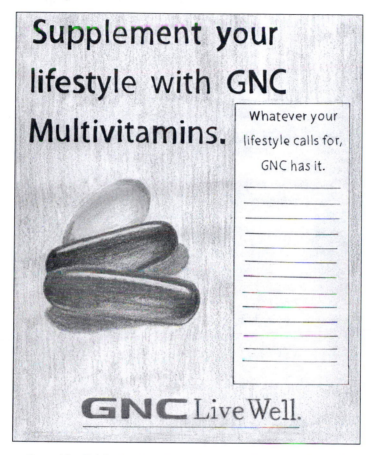

Source: Created by Caitlin Bradley, The University of Tennessee, Knoxville.

"having the blues" or being "so angry I saw red." Advertising uses colors to evoke these same meanings, and emotions can often be identified by their color scheme alone.

Color also can be used to set a mood or draw attention to a specific product feature. Unusually bright or unique color combinations on packaging, for example, can make a product stand out from competing products on store shelves.

The choice of color should complement the key consumer benefit and the emotion or attitude it reflects. Elegance is portrayed with white or black rather than with bright colors. Red, yellow, and orange are hot. Blues and purples are cool, and greens and browns reflect nature. When deciding to use color,

be sure it has a point or reason to appear on the page. Too little color will make an ad look dull and uninteresting; too much will make it look childish and/or gaudy.

A Look at the Color Wheel

First developed by Isaac Newton in 1666, the color wheel can help a young designer understand color theory. Basically, color theory is a set of rules for combining colors. Let's take a closer look at how it works.

A color wheel consists of twelve colors. Beyond the three primary colors of red, blue, and yellow, the other nine colors are made up of varying percentages of those original three. Secondary colors are one color away from the primary colors on the color wheel and are created by mixing two primary colors together: Yellow and red make orange, yellow and blue make green, and red and blue make violet.

The remaining six colors are known as intermediate or tertiary colors. Intermediate colors are found between the primary and secondary colors on the wheel and are created by mixing one primary and one secondary color together. The resulting colors are blue-violet, red-violet, red-orange, yellow-orange, yellow-green, and blue-green.

Mixing one primary, one secondary, and one intermediate color together creates what are known as analogous colors. They appear next to each other on a color wheel and work well when one is used as a dominant color and the others are used as highlights or shades. When used together, they can create a restful or relaxing feel.

Colors that are directly opposite each other on the color wheel are known as complementary colors. Clashing colors bring excitement to the page. Be careful, however, because when used in large blocks, clashing colors can often overwhelm the message; therefore, it is best to try to separate them with another color, a visual, or type.

The primary colors of red, yellow, and blue create a rainbow of color choices. The concept of mixing colors is used in modern-day printing, and with the addition of black is known as CMYK. (C)yan, (M)agenta, (Y)ellow, and (K)black are the four colors that, when used together, make up every color that appears in a printed photograph or illustration.

Let's take a quick look at the implied emotions or symbolism associated with various colors. The overall reaction the target will have toward a color will depend not only on the color itself but on its overall intensity (the strength of a color), its value (the amount of lightness or darkness in a color), the tone (any color with the addition of gray), the tint (any color with the addition of white), and its shade (any color with the addition of black).

Red: This dangerous color denotes aggressiveness, strength, heat, passion, violence, and revolution. Red is an action color.

Blue: This cool earthy color denotes water, comfort, loyalty, security, calmness, stability, unity, relaxation, conservativeness, truthfulness, and is considered refreshing.

Yellow: This energetic color denotes caution, heat, brightness, happiness, cowardice, deceit, and cheerfulness.

Green: This cool, relaxing color denotes money, health, food, environmentalism, movement, growth, renewal, health, jealousy, envy, and inexperience.

Brown: This nature-related color denotes eccentricity, neutrality, wholesomeness, simplicity, friendliness, dependability, and health, and is also a good appetite stimulant.

Orange: This warm autumn color denotes warmth, excitement, energy, vibrancy, and good health while being considered stimulating and friendly.

Pink: This soft cool color denotes health, youth, and femininity.

Purple: This color denotes royalty, sophistication, and religion, as well as wealth, opulence, peace, mystery, and spirituality.

Black: This strong color denotes drama, elegance, seriousness, self-confidence, power, conservatism, conventionality, and mysteriousness, and is also considered sexy and sophisticated.

Grey: This diverse color denotes business, coldness, distinctiveness, stability, conservativeness, moodiness, formality, and sophistication.

White: This ethereal color denotes purity, cleanliness, simplicity, elegance, and innocence.

When choosing color combinations, play it safe. Warm colors like red, brown, orange, and yellow are appealing when placed on lighter, warm backgrounds. Similarly, cool colors such as blue, green, grey, and pink work best when paired with contrasting cool colors.

The Visual/Verbal Uses of Color

Readability and legibility of the brand's message are affected by how colors are used on the page. Color should not compete with what is being said. Headlines, not color blocks, need to capture the reader's attention. When placing type on top of a colored background, make sure the depth or intensity of color does not overpower the type. A background should be subtle and calm, not heavy and distracting. Body copy or other small text can lose detail if placed on a background that is too busy or too dark. There are four major ways to display color on the page (beyond the use of color photographs): using reverses, screen tints, spot color, or the Pantone matching system (PMS).

Reverses

If choosing to use a reverse, or light-colored copy placed onto a dark background, be sure the contrast between the background color and the text is severe. Reverses are great at catching the reader's eye and drawing them into the ad, but use them sparingly: Bold contrasts can overwhelm the rest of the ad's message. Reverses are most easily read when type is large and bold. During printing, depending on the paper stock used, the background color can bleed or run into the text, severely affecting readability and legibility.

Screen Tints

Screen tints are an inexpensive way to offer depth to any color. For example, a screen tint can ad multiple shades of gray to a simple black-and-white ad. The computer allows the designer to lighten or tint any solid color into varying shades, thus giving each shade the appearance of a new color.

Spot Color

Color photographs are everywhere in advertising. If you want an ad to stand out and increase memorability, consider using a black-and-white photograph with just a spot of color. Spot color is an excellent way to spice up a black-and-white photograph by calling attention to a small area that has been singled out to receive color. This method is guaranteed to draw the viewer's eye and is a great way to highlight the product, the packaging, or the logo. The key is to keep the color section small.

Pantone Matching System

Once the art director knows the specific color or color combinations being used in the campaign, they must be assigned Pantone numbers in order to print the exact color needed. The Pantone matching system (PMS) is a numbered color system used in printing and most desktop publishing software. An art director who needs a specific color can choose one or more from over 500 different coated or uncoated colors and shades offered.

Logo

A logo represents the company, brand, or service's name, image, or use. It will realistically or abstractly represent the brand's personality, reputation, and its successes or failures. A logo can consist of a graphic symbol with or without type or be represented by a type alone. To help the target retain the

information, it should be placed either above or below the slogan or tagline and in either the lower right hand corner of the ad or at the bottom, making it the last visual and/or verbal message the viewer sees.

Logos do not need to match an ad, packaging, or campaign's typestyle. The logo is a separate voice from that of any advertised message. Logo design and the accompanying typeface(s) associated with the design are unique to the product, service, or company and help create an individualized identity and relationship.

It is important, however, that any face used for the slogan or tagline complements the appearance of the logo design. For example, if the logo is bold and round, choose a lighter, slightly less rotund face. A modern-looking logo design should be coupled with a slogan set in an equally modern typeface. Each design should be able to maintain its clarity whether appearing on a business card, the web, or an outdoor board.

Whatever visual/verbal element or combination of elements are used, great advertising is memorable because its images and copy take the reader or viewer on a creative, informative journey. In an online logodesignlove.com article, Sol Sender, the team-leading designer for the Obama 2008 logo, described the importance of a logo this way, "The strongest logos tell simple stories."

Placing the Essential Design Elements on the Page

The design elements in an ad vary in importance. It is vital to determine what you want the viewer to see or understand first. How the designer places the essential design elements on the page should show the reader exactly what the product is, how it works, when and where it will be available, and who is selling it. This order can be strengthened by making sure the most important point is the largest visual or verbal element on the page.

A designer can either show or tell the story of the brand's key consumer benefit: the former is accomplished through the main visual, the latter with a strong headline. Either way, this one dominant essential design element will immediately draw the viewer's eye and attention because it is the largest visual or verbal element on the page. Once it has the target's attention, it needs to entice him or her into the body copy or, if nothing else, to the logo. If it screams visually, it must also educate verbally. If it screams out verbally, it must show the features, benefits, and/or results visually.

Another way to make the visual or verbal design element stand out is to surround it with white space. White space refers to the white of the page. The more white space available, the cleaner or more elegant the ad will appear. The more cluttered the design, the less white space there is to evenly frame each essential element. A cluttered ad, or one lacking white space, sends a negative message to the target, no matter how much quality is discussed in the copy. If the ad looks

junky and crowded, it reflects poorly on the brand. It is important to keep in mind that perception can outweigh a million words and a dozen visuals.

Too much white space appearing between items can be distracting as well. Use the white of the page to frame the design and lead the reader from design element to design element. Judicious use of white space allows the designer to control when and how each essential design element will be seen by gently and informatively moving the reader through the ad from left to right and from top to bottom.

Part I: Campaign Development Exercises

1. Pick a product or service of your choice and develop a creative brief. Be sure to carefully research the product, the choice of target, and the competition to ensure as much is known about each as possible.
2. Next, come up with 15 to 20 ways to promote the brand based on the creative brief. Just write them out on paper for this step.
3. From the list above, write 5 to 10 headlines for the best ideas that will help to push the key consumer benefit.
4. For each headline, make a list of the types of image(s) you want to represent the brand. Keep in mind how you want the target to think or feel about the brand. Be specific.
5. Out of the 5 to 10 ideas, develop 10 thumbnails for each. Be sure no two are alike. Test the ideas against the creative brief. Are all on-target and on-strategy? If not, then rework a few.
6. Once you have three to five thumbs you like, write body copy of at least 50 to 100 words (this will depend on vehicles chosen) to flesh out the key consumer benefit in a creative way. Be sure copy strategically talks to the target, accomplishes the objectives, and stands out from the competition.
7. If you do not have a logo, slogan, or tagline, design one now. Be sure it clearly represents the brand's image.
8. Present thumbs, visual(s), and copy ideas to the class for critique.
9. From the critique, pick the three best to further develop into a rough or super comp. At this stage, test the overall look or image by trying out varied layout styles, typefaces, color combinations, and so on before you begin laying out the final design.
10. Pick the best rough or super comp from the step above and develop two or more additional pieces into a campaign that follows the look and style of the original idea.
11. Be sure to use the campaign essentials list (see page 26) to ensure the campaign is on-target and on-strategy.
12. Present the final campaign for critique.

Part II

Campaigns Speak Through
Numerous and Diverse Media

7

Public Relations

Figure 7.1 **Sample Ad: K•B Toys**

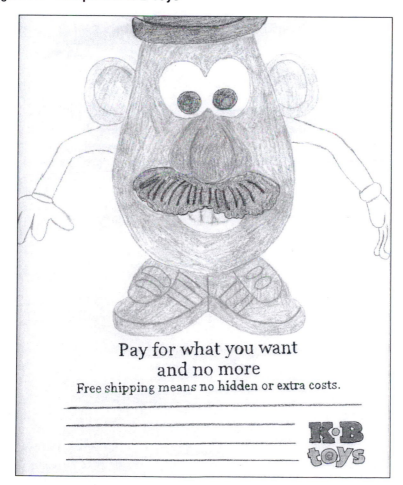

Pay for what you want
and no more
Free shipping means no hidden or extra costs.

Source: Created by Rachel Kennedy, The University of Tennessee, Knoxville.

Defining How It All Works

Let's begin our media discussion by defining the differences between marketing, advertising, promotion, publicity, public relations, and sales with a few examples.

Marketing is about making a profit and producing products that target needs and wants. *Advertising* is about creatively bringing attention to a product or service in order to make a sale. *Promotion* encourages purchase and keeps the brand top-of-mind. *Publicity* deals with media attention. *Public relations* is about creating relationships and improving a brand, corporation, or organization's image. *Sales* is the ultimate goal of a campaign. If that didn't help you to differentiate between these terms, managementhelp.com points to a quote from a *Reader's Digest* article entitled "Promoting Issues and Ideas" by M. Booth and Associates, Inc.

> . . . If the circus is coming to town and you paint a sign saying "Circus Coming to the Fairground Saturday," that's advertising. If you put the sign on the back of an elephant and walk it into town, that's promotion. If the elephant walks through the mayor's flowerbed, that's publicity. And if you get the mayor to laugh about it, that's public relations. If the town's citizens go to the circus, you show them the many entertainment booths, explain how much fun they'll have spending money at the booths, answer their questions and ultimately, they spend a lot at the circus, that's sales.

This example shows IMC at work—how it uses various media to reach the public with a message that informs and excites and will ultimately result in the sale of both goods and services. We will begin with a look at public relations.

Public Relations Speaks Out in an IMC Campaign

The Public Relations Society of America (PRSA) defines public relations this way: "Public relations helps an organization and its publics adapt mutually to each other."

More specifically, public relations is a mostly nonpaid source of news that is all about building, maintaining, or reinforcing the relationship between a company and its key external audiences or *publics,* or key internal audiences or *shareholders.* Public relations gets consumers thinking or talking about a product or business in a positive way. It can encourage action by reporting studies or by using CEOs, scientists, or engineers to explain uses or outcomes. PR is a great way to reach the target with new or breaking news or address any crisis immediately.

As part of the IMC promotional mix, public relations has evolved from a supportive role to one with a strong, legitimate, promotional voice. To understand public relations' role in an IMC campaign, it is important to understand the differences between advertising and public relations and how each one is employed.

Public Relations Promotes; Advertising Sells

Traditional public relations most often deals with issues surrounding a product or service, such as negative publicity, or the announcement of upgrades or improvements to name just a few, rather than specific product or service attributes; advertising, on the other hand, is all about a product's or service's individual attributes. Public relations is relatively cost-free, credible, and good at influencing public opinion, and it effectively creates a one-on-one relationship with the target. Advertising is an expensive, persuasive, creative image builder that talks *at* the target rather than *to* the target.

Choosing advertising or public relations to launch a campaign or create a buzz depends on the designer's objectives. If the aim is to create awareness or build a brand's image, advertising will be a more successful vehicle. If the aim is to announce changes, build interest, create news, reinforce an image, or rebuild a damaged reputation, then public relations is the best promotional choice.

Specifically, how does public relations differ from advertising?

1. In advertising media, space is paid for, thus guaranteeing message delivery. Public relations does not have to pay for any coverage published through a mass media vehicle.
2. Advertising controls message content. The message public relations sends to the media can be rewritten and/or reinterpreted.
3. Advertising focuses on promoting a single brand to a single external target audience. Public relations focuses on building a relationship with multiple target audiences.
4. Traditional mass media outlets such as print and broadcast deliver a one-way flow of information. Public relations, on the other hand, interacts with the target, creating a dialogue between buyer and seller.
5. Advertising controls the publication date of its messages. Public relations relies on whether or not its message is considered newsworthy enough by local media groups to warrant coverage.
6. Advertising focuses exclusively on selling a brand's feature and benefits. Public relations promotes a brand through informative articles and events.

7. Advertising's goal is to make a sale by informing, reminding, educating, or persuading. The goal of public relations is to make a brand mean more to the target than its packaging by promoting good will, influencing public opinion, igniting interest, and building and maintaining its reputation.

8. Advertising is considered obvious, intrusive, and manipulative. Public relations, because it is endorsed by a third party (the media), is considered more reliable.

9. Advertising is great at creating and maintaining image. Public relations is great at creating news about new product launches or reinvented products.

10. Advertising copy is creative, insightful, and persuasive. Public relations copy is straightforward and full of news.

11. Together, advertising and public relations are great for generating excitement, building both awareness and brand equity, and maintaining brand loyalty.

Learning to Work Together

The biggest bone of contention between advertising and public relations deals with timing—who should launch, who should inform, and when and how the promotional efforts should occur. When using public relations in an IMC campaign, all members of the promotional mix should be on the same page, regardless of personal differences. Timing and message content must be coordinated to support the key consumer benefit.

When used in a campaign, public relations may serve to build curiosity before a launch or to introduce a new or reinvented brand. The rest of the promotional mix will reinforce, build on, or maintain the message throughout the campaign. For instance, a successful, long-running campaign may continue to employ public relations to report successes and keep the brand name in the press by promoting testimonials or arranging press conferences for varied appearances, upgrades, and events.

When public relations tactics are used to promote a brand in conjunction with advertising and promotional efforts, it is known as *marketing public relations*.

Marketing Public Relations in an IMC Campaign

Marketing public relations (MPR) works hand in hand with traditional advertising efforts to specifically promote a company's product or service. Like traditional public relations, MPR often uses nonpaid media vehicles or tacti-

cal guerrilla events that support existing advertising efforts. One of MPR's jobs is to address consumers' cynicisms and distrust of advertising by giving it a sense of credibility. When a credible third party talks about a product, whether it is the press or via word of mouth, MPR has legitimized its place in the promotional mix. Any events sponsored by public relations are great for differentiating products in a crowded category; such events also help renew visibility or interest in existing products and generate enthusiasm for new product launches or for the reinvention of brand images.

MPR deals with the selling of a product, service, or corporate image to a specific target audience. Creative teams sometimes fail to fully utilize the marketing potential of public relations. Traditionally, public relations was used as a corporate mouthpiece that frequently ignored external messages and resulted in ill-timed, conflicting messages that were both off-strategy and off-target. This type of approach could effectively erode brand image, dilute message strength, and taint corporate reputation. In an IMC campaign, public relations uses the same tone of voice as other vehicles in the promotional mix. As the brand's media mouthpiece, it is great for creating interest in varied media events, building curiosity for new product launches, or maintaining or strengthening the brand's image. Because of its close ties to the media and direct one-on-one contact with the target, it helps endow the rest of the media mix with credibility.

As a member of the IMC promotional mix, public relations brings a long history of experience in creating a lasting relationship between the product, service, company, or organization and its target audience. Public relations ensures that inside shareholders understand the message external publics are receiving, thus guaranteeing that the two-way dialogue between these two important groups is both on-target and on-strategy. Employees are a brand's best source of public relations: They are the initial and ongoing brand representative that links buyer and seller and reduces negative word of mouth.

The role of public relations is to keep its finger on the pulse of consumer sentiment and address any bad press—product recalls or damaging technical issues—that directly affects customer satisfaction. Should any negative publicity arise, they can interact directly and immediately with both their internal and external publics. Negative publicity of any type not only affects morale internally but also can affect consumer loyalty and, eventually, equity. Companies that handle negative publicity proactively—before it becomes an issue—greatly reduce the need for enacting defensive tactical steps.

Companies that fail to communicate directly with their publics risk losing their trust. It is very expensive and time-consuming to gain back loyal consumers. In today's fast-paced digital age, a minor blemish on a brand can turn into a devastating loss of both consumer confidence and revenue if claims are not addressed and resolved without delay.

Building Relationships with Public Relations

Public relations delivers an immediate result. Its job is to manage relationships by creating a positive perception about a brand, a corporation, or an organization. It can use social networking sites, the news media, and any traditional media vehicles to address any unverified information or comments with corrected information by referencing relevant policies and/or outlining immediate solutions. Public relations is a great vehicle for engaging the target in discussion on use or any problems or concerns they may have, thereby making them an active part of the immediate and long-term solution.

Externally, public relations is responsible for maintaining good will, initiating feedback, and actively developing or maintaining brand loyal consumers. Every contact point with the target—whether in a brick-and-mortar store, online, or with a delivery driver—must be a positive one. They must actively work to solve problems as quickly and painlessly as possible; educate the target with facts about the product, service, or corporation; and dispel image-eroding rumors.

Internally, public relations is responsible for enhancing employee morale and leading educational programs to ensure a positive seller-to-buyer experience. Education also includes keeping employees informed about policies and offering channels of communication to upper-level management. Additional communication channels might include a company blog, newsletters, access to annual reports, suggestion boxes, company magazines, and optional brown bag lunches headed by department heads or corporate leaders.

When used as a moderator between the target and the corporation, public relations can educate both technical and customer service representatives on current advertising and promotional efforts, any brand or corporate identity changes, logo redesigns, slogan or mission statement alterations, sales promotions, or any new product announcements. This ensures internal communications are in sync with what external communications are saying. PR will also coordinate any public appearances, sponsorships, and endorsements to keep the visual/verbal message cohesive.

Public relations representatives work with the local, national, and international news media to promote sponsorships, relevant community or national projects they are involved in, and any upcoming guerrilla marketing events to increase attention, attain public support, or favorably increase public opinion.

In the end, MPR is an excellent and inexpensive tool for building curiosity, supporting advertising efforts, creating differentiation or reinforcing reputation, maintaining a two-way dialogue between buyer and seller, creating and maintaining brand image, generating viral or word-of-mouth discussions, and handling negative publicity.

Of all the media vehicles available in the promotional mix, public relations is the most consumer-centric: It focuses on building and maintaining a positive, long-term relationship with the target and enhancing public opinion. Public relations excels at generating buzz on new and existing products, handling scandal and monitoring public opinion, developing community relationships, managing niche markets, and maintaining brand image. As the brand's promotional mouthpiece, it is important that all public relations efforts mimic the tone of voice used within the media mix and employ databases to actively build or maintain a two-way dialogue with the consumer. Let's take a quick look at each one.

The Buzz on Brands

It is now easier to generate buzz or encourage further discussion through word of mouth than ever before. Blogs, viral videos, and e-mail campaigns can create excitement or anticipation for a new product launch, establishing a sense of need, entitlement, and exclusiveness even before a product hits the market. Social media sites like Twitter, Facebook, and YouTube continue the dialogue as users or potential users share their excitement and experiences. Beyond the Internet, public relations practitioners can generate buzz through sponsorships; celebrity endorsements; newspaper and magazine articles; press conferences; via talk shows and trade shows; product placement in movies, on television, or in video games; and through guerrilla marketing events.

Scandal and Public Opinion

When faced with a scandal, public relations representatives must understand the factors that are influencing public opinion. Negative publicity can come from anywhere—a disgruntled customer or employee, a bad product, or a string of accidents. Practitioners must be prepared to respond to any negative situation and promptly tender a solution. PR specialists must be able to comment intelligently and professionally on any rumor, scandal, negative news coverage, or government investigation. In addition, they must keep a watchful eye on blogs and any social media sites to analyze, address, and respond to any changes in the marketplace that may negatively affect the brand. Knowing what the target is saying and how they feel about a product or service is critical to a brand's continued success. Immediately addressing both the press and the target about any kind of damaging news coverage is imperative to controlling outcome. Remaining silent or allowing misleading information to spread is the quickest way to damage a corporate reputation and eat away at both brand loyalty and brand equity. The cost to repair a damaged image and revive consumer trust is both expensive and time-consuming.

Community Relations

Working within the community is a good way to project corporate responsibility and achieve visibility. Programs might include supporting the arts, children's programs, local clean-up projects, or social and educational programs. Smaller but more personal programs might include sponsoring a charity event or a local sports team.

Corporations can also gain favorable publicity by supporting environmental efforts, participating in community beautification projects, offering summer jobs for local teenagers and college students, and supporting recycling programs. Any type of community involvement requires meeting, greeting, and working within the community to improve the quality of life and interact with the surrounding public in a positive and supportive way.

Managing Niche Markets

High-quality public relations is the key to managing multiple targets or specialized niche markets effectively. Creating a two-way, consumer-focused dialogue is the foundation on which public relations was built. IMC has brought the mindset of creating long-term relationships with the target to traditional advertising practices. Public relations ensures this contact is effective at all levels of customer contact, whether internal or external. When the role of each market segment is defined, it can assist internal customer and technical service representatives to engage the target in a two-way dialogue about customized needs, problems, or concerns. This one-on-one interaction gives the target a personal stake in product development via feedback on the brand and/or customer or technical-related services.

Image Management

Crisis communication is another of public relations' image-management responsibilities. Anybody without public relations in their promotional mix will feel the crunch not only financially, but also emotionally, as consumers react to every piece of bad news by switching or bad-mouthing brands. A good public relations crisis campaign can calm the waters and encourage positive thinking based on a brand or company's security.

Because IMC is consumer-centric, how a brand and its image are managed is more important than ever. The target must be recognized as a loyal customer, and the brand must consistently deliver the same quality and/or experience with each successive purchase. Any problems or needs that should arise after the sale should be dealt with immediately, courteously, and

expertly. Unhappy employees, government recalls, or industry investigations can affect brand image; the role of public relations is to respond proactively and protect the product's image internally and externally before it can affect brand loyalty and equity.

When used in the IMC promotional mix, public relations exudes trust and credibility with both the press and the target. Since delivering dialogue and maintaining relationships is PR's strong suit, it is a good vehicle for building and retaining a brand's image and developing a strong rapport between a brand, a corporation, and its stakeholders and publics to keep the brand's image strong.

Tone of Voice

Because public relations often leads off an IMC campaign or works in tandem with a brand's introduction, reintroduction, or varied promotional strategies, all public relations communications and events will use the same key consumer benefit and visual/verbal tone of voice as other media vehicles used in the campaign. This reflects the spirit of consistency and repetitiveness needed to maintain the overall concept not only internally but also externally with the press, customer and technical service representatives, sales personnel, and suppliers. Internal practice of what is preached externally is important to maintaining image, consistency, and brand loyalty.

Databases

Database use in IMC plays a huge role in developing a relationship with the target by personalizing messages based on past purchases and known needs and wants. Public relations uses this information to personalize any one-on-one interaction and further that relationship by educating and informing the target about upgrades, additional purchase options, and first-to-own opportunities.

Understanding Public Relations' Strengths and Weaknesses

The versatility of IMC's voice requires a thorough understanding of what each media vehicle brings to the campaign. Let's take a look at the strengths and weaknesses of public relations.

Strengths

1. Building Credibility. Public relations' use of the local and national media gives a brand instant legitimacy and credibility.

Figure 7.2 **Sample Ad: Hills Science Diet**

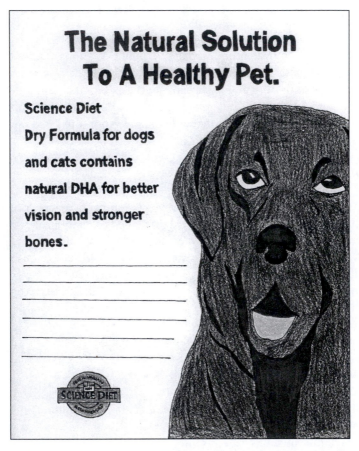

Source: Created by Robby Cockrell, The University of Tennessee, Knoxville.

2. Two-Way Dialogue. Direct contact with the target is the best way to build a lasting relationship. Giving the target a voice in the brand's growth helps build loyalty.

3. Multiple Media Vehicles. Vehicles are numerous and varied and include news conferences, feature articles, sponsored events, lobbying, infomercials, speeches, and public service announcements, to name just a few, all of which can reach both internal and external audiences with a highly targeted message.

4. Free Press. Media vehicles such as broadcast, print, and the Internet allow public relations to deliver an IMC-coordinated message free of charge.

5. Research. Public relations is further legitimized when technical or scientific studies can back up a brand claim.

Weaknesses

1. Twenty-Four-Hour News. Mass media coverage typically lasts no longer than twenty-four hours.
2. Lack of Repetition. Loyalty is based on a long-term repetitive message changing the target's behavior. Public relations cannot repeatedly reach the target with the same message without the support of other members of the promotional mix.
3. Measurement. Since public relations rarely asks the target to do something (like make a purchase), it is difficult to tell whether the objectives were carried out successfully or if the message was received.
4. Content. News releases are not guaranteed to be reproduced or delivered as written.
5. Publishing. Since public relations is not paid for, there is no guarantee the piece will be printed or aired.

Public Relations as Part of the IMC Campaign Promotional Mix

So why have public relations as a part of the promotional mix? Because it is a credible and believable way to deliver the key consumer benefit to the target audience with an informative, fact-based message. Before any articles are written or sponsored events are held, public relations must understand (1) its place in the promotional mix, (2) the target audience to be reached, (3) the objectives to be accomplished, (4) the key consumer benefit to be promoted, (5) the strategy and tone employed, (6) the overall timeline the campaign will cover, and (7) the message other members of the promotional mix will be using.

An IMC campaign is more than the visual/verbal message; it is also about creating a cohesive environment both internally and externally. A successful IMC campaign requires change throughout an organization. The campaign must deliver an internal response for the external message. The multiple publics with whom public relations must interact require the visual/verbal message be adaptable to each group. Each message must deliver the key consumer benefit in a language they understand and present a solution to a problem they have at work, at home, or in their social lives.

Public relations' consumer-focused approach makes it a powerful element in

the promotional mix. One of its many roles in an IMC campaign is a strategic one—to keep an eye on what is happening in the marketplace and anticipate how it can affect the product or service. It is an excellent vehicle for managing viral campaigns, monitoring blogs or other social media outlets, overseeing external projects and events, and responding to media or community concerns—anything that can positively or negatively affect brand image.

Strategically public relations manages the campaign's visual/verbal message by dealing directly with the press through vehicles such as press releases and press conferences and with the target and community through sponsored events, customer service initiatives, feature articles, and various online initiatives. Internally, public relations representatives will strengthen the visual/verbal message by soliciting feedback and/or holding seminars or workshops to ensure the external message is delivered to the target with the same clarity at every contact point—customer service, technical advisors, and/or sales or delivery personnel included. Its watchdog tactics make it ideally suited to capitalizing on any opportunity and handling or overcoming any threats encountered in the marketplace. Its inherent credibility and virtual no-cost promotional opportunities make it a great vehicle for continually keeping the brand's name in the press. Receiving a third-party endorsement allows the cynical consumer accustomed to ignoring the puffery of creative executions to get directly to the "meat and potatoes" of the brand and the facts as related in an editorial message.

In order to be an active member of an IMC campaign, public relations must be more than a passive media liaison or relationship manager: It needs to find ways to make the brand newsworthy and ensure that its image stands out from competing brands. Practitioners must understand that reacting to events can damage a brand's image, whereas creating events strengthens both the brand's image and the brand's relationship with the target. Unsubstantiated claims or rumors as well as legitimate ones can pop up at a moment's notice, so it is imperative that the brand's image be monitored constantly, both internally and externally.

Public relations does not have the strength of other media vehicles to build a brand image or repeatedly remind the target about the varied attributes of a product or service. Its strengths lie in creating excitement, coordinating existing messages, reinforcing or changing public opinion, and its ability to build a lasting relationship with the target.

The goal of any IMC campaign is to coordinate all efforts in order to bring an understandable, repetitive, reinforceable message to the targeted audience. Each member of the promotional mix must know what the client wishes to accomplish in order to strategically accomplish the objectives, thereby ensuring a trackable return on investment (ROI). Because public relations does not require the target to buy or do anything measurable, it is difficult for it to

show ROI for its efforts unless it is the sole member of the marketing team, paired with social media, or actively involved in a sponsored event.

Lobbyists Talk the Government Talk

One area that is stepping up advertising efforts in this sluggish economy is lobbying groups. This form of public relations, known as *issue advertising,* is used to highlight important issues such as health care, pharmaceutical reform, and energy concerns to legislators or other members of government. Issue advertising is usually spearheaded by a *lobbyist,* or the designated person who is paid to present an organization or corporation's point of view; lobbyists use their personal contacts to influence government officials to vote in their favor.

Publicity Is All About Making the News

Actor and comedian George Carlin aptly compared publicity to metamorphosis when he said, "The caterpillar does all the work but the butterfly gets all the publicity." More specifically, publicity is the result of sustained public relations planning. It is publicity that makes a brand, service, cause, person, or organization newsworthy. Publicity makes a product or service's claims credible through an objective third party, who writes or talks about the brand in magazines, feature stories, and news articles, or discusses them on radio or television talk shows. Blogs and other social media sites are powerful influencers as well, since current users often comment on products, customer service, or performance issues.

Design and Copy Options

Public relations has many ways to reach its publics, its shareholders, and the local, national, or international press. Although most vehicles are directed at a small, very specific niche market like the news media, message content is specifically targeted to either internal or external audiences. These mostly large copy-heavy pieces, such as annual reports or press kits, are full of news and are often colorfully designed. Other vehicles, like press releases and fact sheets, verbally push the key consumer benefit and overall concept used in the IMC campaign. Let's take a look at a few of the possible options public relations uses to communicate with the media and interact and engage the target.

Press Releases

A press release is the best way to garner interest from the news media by informing them about a product or service. Basically, a press release is a

news article that is sent unsolicited to a newspaper editor or reporter. If found newsworthy, it may be presented in local or national news outlets, either in its original form or slightly altered to improve content. This free form of publicity is a great way to increase interest in a new product or to report on the new and improved status of a reinvented product.

Press releases must be well written to stand apart from the hundreds of releases editors and broadcast news directors receive each day. To be noticeable for the right reasons, they must be properly formatted and free from any spelling or grammatical errors.

Paper press releases are almost a thing of the past. Today, most press releases arrive via e-mail. Each release should be tailored to a given publication's audience. For example, a trade journal would want to know how news on a brand affects business, while a consumer magazine or local newspaper would want an explanation of the features and benefits customers can expect from the product or service.

Although press releases employ the same verbal copy points as advertising body copy, it is essential to remember that a press release is a news announcement, not a sales pitch. The style of writing, therefore, should rely less on creativity and more on factual information. Overall, press release copy should (1) reflect the newsworthiness of the product, (2) maintain an educational tone, and (3) use the third person "it" to refer to the company or product.

Each release should contain at least one usable quote, and when possible two or more. Since news sources are also visual/verbal vehicles, be sure to include a headshot (head and shoulders) of the person most often quoted in the release. If you take out creative storytelling and replace it with who, what, when, where, why, and how facts, writing a press release is not that different from writing advertising copy. See Figure 7.3 for an example of a press release.

Requirements for writing a press release consist of:

1. Personalizing the release. Be sure to spell all editors' names correctly and never address editorial staff by their first names unless they are known to you. Match the release's key consumer benefit with the appropriate editor.
2. Opening with the statement "FOR IMMEDIATE RELEASE" to promote its timeliness. If it cannot be published immediately and is being sent as an advance release, clearly state in all caps the appropriate time and date of the release. This type of early warning release, known as an *embargo,* is usually reserved for large events or announcements.
3. Using an opening salutation. Contact information usually includes no more than a name, e-mail address, and phone number.

4. Having an interesting opening headline of five to seven words featuring the key consumer benefit. Be sure it mimics the style used throughout the campaign.
5. Including in the opening paragraph the name of the city and state in which the release originated. Copy will discuss the importance of the key consumer benefit.
6. Including in the middle paragraphs the supporting features and benefits and any testimonials or quotes to promote the key consumer benefit with verifiable facts.
7. When possible, including at least one to two quotes from reputable people who can comment intelligently on the key consumer benefit.
8. Keeping sentences and paragraphs short to make isolating facts and overall reading easier.
9. Refraining from the use of run-on sentences, slang, or technical jargon, unless writing a release for a technical or scientific journal.
10. Using the closing paragraph to tell the target what to do, the date of an event or launch, the location of a grand opening, and any important times, websites, or other relevant information.
11. If more than one page, placing the word "more" centered at the end of page one.
12. Closing each release with "-###-" centered at the end of the final page. The points mentioned in numbers 11 and 12 are small courtesies that inform the editor where the text ends.
13. Being sure the piece has been checked for any errors, such as incorrect dates or misspelled names, to ensure accuracy.
14. Trying to keep the release simple, direct, and at or below 500 words in length.
15. Trying to avoid the use of e-mail attachments. There is always the chance attachments will not open. Instead, include links to additional information in the body of the release.
16. When complete, e-mailing a copy to the client for final approval.

Finally, if there is nothing new, of interest, or of value to the target, do not create news. Save the press release for information the competitors cannot compete with or quickly match.

Press Kits

Press kits or media kits are used to promote a company's products and services or to announce new product launches or special events to the press. These

Figure 7.3 **Sample Press Release**

FOR IMMEDIATE RELEASE

<u>**CONTACT:**</u>
Mary Doe, Marble Springs State Historic Home
E-mail: mdoe@xxx.org
Phone: 555–555–5555

<div align="center">

COME CELEBRATE HISTORY
DURING "JOHN SEVIER DAYS"
and South Knoxville Arts & Crafts Festival
3rd annual event to highlight 18th-century games, entertainment, and education

</div>

Knoxville, Tenn.—Marble Springs State Historic Site, in conjunction with the South Doyle Area Homeowners Association, will be hosting the third annual John Sevier Days Arts and Crafts Show, Sept. 19 and Sept. 20, from 9:00 a.m. to 5:00 p.m. Sponsored by the South Knoxville/Seymour Times newspapers, the event provides an opportunity for the Knoxville community to experience history in an interactive environment.

The festival will feature tours of the historic site, along with 18th-century entertainment such as spinning, woodworking and open hearth cooking demonstrations. Participants can also watch a weapons demonstration showcasing tomahawks and period-appropriate firearms. Attendees will have an opportunity to participate in special contests, including a Bonny Kate look-alike contest, a hat race, cast-iron frying pan tossing, and a tomahawk throw. Children will enjoy face painting and various hands-on arts and crafts projects. Regional artisans and crafters will be showcasing their wares; arts and crafts will also be available for sale. Various musical entertainers will perform throughout the weekend.

"John Sevier Days is a wonderful opportunity to showcase the rich history we have in the South Knoxville area, and it allows us to highlight and commemorate the accomplishments and memory of John Sevier," said Lisa Fall, board member for Marble Springs State Historic Home. "This event is all about bringing the community together."

Admission is a donation of $1 per person, which will go toward the fund to repair the Trading Post roof; parking is free. Contest participation will also include a small fee. All activities take place at the Marble Springs state historic site: 1220 W. Governor John Sevier Highway, 37920.

<div align="center">- ### -</div>

Source: Created by Professor Lisa Fall, University of Tennessee, Knoxville.

comprehensive packages are usually presented in a pocketed folder and will often include editorial and/or promotional material on a product or service, company, person, or program, as well as a company biography, customer testimonials, research or testing materials, black-and-white photographs of the product, or headshots of CEOs, presidents, spokespersons, and so on. The kit might also include a press release, fact sheet, CDs, or audio or video material. Be sure the visual/verbal voice from the campaign is evident on the cover, in press releases, and throughout newsletters and/or fact sheets.

Fact Sheets

Part of the press kit, a fact sheet is a simple outline that lists in a brief and succinct way only the most important data or facts, usually taken from the original press release, about a company, brand, individual, or event. Fact sheets are a great resource for members of the press and for the delivery of live on-air commercials by local DJs.

Pitch Letters

Good pitch letters are creative vehicles that immediately capture the editor or journalist's attention. The main purpose of a pitch letter is to get the press to read the attached press release, media advisory, fact sheet, or press kit. Like advertising copy, pitch letters tell the product's or service's story in a way that entices the reader to find out more. A good pitch letter for a product should use the same tone of voice used in other pieces within the campaign. Be sure it is personally addressed and is no more than one page in length.

Newsletters

A newsletter is a powerful marketing and communications tool, making it a great way to inform both internal and external targets about what is going on in a company or with a product or service.

When deciding to use a newsletter, be sure content is both interesting and relevant to the reader. Keep the style light and entertaining: This is not the place for hard news. Today, most newsletters are distributed via e-mail rather than printed and distributed via the U.S. mail. For external audiences, find an interesting way to encourage participation, such as giving those who opt in to receive the letter some kind of reward—a coupon, a gift card, advance sales notices, and so on. Be sure to make signing up as quick and easy as possible. Ask only for the information you need such as name and e-mail address, and perhaps gather information on latest purchases or interests so the letter can be catered

to the target's interests. Newsletters are a form of permission marketing—the receiver must "opt in" or sign up to receive any correspondence. Most newsletters today creatively mimic the look of the company website.

Although newsletters appear informal, they are a part of the IMC campaign and should use the same visual/verbal voice as the rest of the campaign. Consider using the same typeface as well as the same headline style, slogan or tagline, and logo. If a spokesperson or character representative figures prominently in the campaign, perhaps the newsletter's content could be written in their voice, or it might include an anecdotal section that keeps the reader informed of their latest brand-related activities.

Most traditional newsletter design is copy-heavy and regimental in appearance, so consider using multiple subheads to break up long blocks of copy and add a dash of color, even if it's just black. Another good way to break up the page is to use photographs or callout boxes that break the monotony of the typical two- or three-column format used by most newsletters. Some of today's most attractive newsletters look more like beautifully designed posters than informative copy. These online newsletters use multiple buttons or links to inform and connect without making the page look like a jumbled mess or a typical newspaper page.

Newsletters should carry a repetitively used masthead that identifies the company responsible for the piece, including a date and volume number. Any articles or sales promotion offers should be relevant to the audience. Create contrast between visual and verbal elements on the page by varying the size and weight of type. Create white space by using a "flush left, ragged right" page layout, and increase the width of the gutter. Single vertical graphic lines between paragraphs or around photographs offer a touch of organization. Allowing headlines, visuals, callout boxes, and charts or graphs to overprint these lines breaks up the stoic, cylindrical appearance of the page. Wrapping text around a visual is an effective way to keep the eye focused on the informative copy. Also, be sure to maintain a consistent size for all headlines, subheads, and body copy across all pages.

So what is the point of a newsletter? Is it to promote a product, solicit feedback, praise employees, announce special sales, or list changes in the current benefit packages offered? Whatever the topic or content, if directed at an external audience, be sure it is informative and includes a link to some type of sales promotion such as coupon offers or the opportunity to enter a contest or sweepstakes. To keep them actively involved in the product consider offering a link to a blog where they can visit to ask questions, share news, and so on. As an additional reward, offer something special to existing brand loyal customers not available to those who have newly opted in.

Research shows the average time spent with a newsletter is only 51 seconds,

Figure 7.4 **Sample Ad: Knoxville Museum of Art**

Enjoy intellectually stimulating entertainment
at Knoxville's only art museum.

The KMA continually hosts many new artists' exhibitions.

The KMA provides sophisticated Knoxville residents with
various forms of culturally enhancing entertainment.

www.knoxart.org | info@kmaonline.org km Sophisticated Entertainment

Source: Created by Josh Cantrell, The University of Tennessee, Knoxville.

so make sure that recipients can pick up informative headlines, subheads, and visuals with a quick scan of the page. Be sure any buttons or links in online newsletters are color coded to match the design, and surround them with white space to make them easy to spot. Newsletters directed at an internal audience must include links to sites that will help manage benefits or highlight any current advertising messages or sales promotions. When targeting an external audience, keep in mind that too many coupon offers or percent-off tags can junk up the page; stop the reader with a headline and some copy to whet the appetite, use a graphic or photograph to show the product or services attributes, and let a button whisk the reader to another site or page where the offer is isolated. Above all else, be sure the piece is well written and well designed;

the fact that it is transmitted via e-mail does not exempt it from meeting strict advertising quality standards.

Annual Reports

An annual report is a comprehensive, formally presented yearly report produced by a company, corporation, or charitable foundation for its shareholders. Required by law of all publicly held corporations, annual reports cover the previous fiscal year and report on a company's activities and financial status.

These high-end reports are often printed on a coated paper stock allowing for good reproduction of photographs and type. Although full of very dry copy, the pages with the most design potential are the front cover and page runners. Layout is usually set up in three or more columns and uses a very copy-heavy format featuring charts, graphs, and varied photographs.

As a rule, most annual reports contain the following sections:

1. A cover featuring a visual, the company name, and date and year of the report.
2. A content page featuring the varied sections and their corresponding page numbers.
3. A performance section that focuses on the year in review, such as any new product launches, significant research reports, testimonials, and even stock reports.
4. Future projections for the coming year.
5. A financial section showing profits and losses or stock prices.
6. An appendix with the names of corporate leaders, any relevant stockholder documents not covered elsewhere, lists of products and services, affiliates, subsidiaries, and so on.

An annual report is very technical in nature: Liven up the front cover with a visual/verbal message that strongly reflects the previous year's advertising efforts. Consider showcasing a single ad or spokesperson or a collage of images from various pieces. For the sake of consistency, reuse the same typeface and style used in the campaign, as well as the same color or color combinations. Match the headline style when appropriate, and consider using any spokesperson or character representatives as a runner from page to page. For example, an annual report from Energizer might show the pink bunny walking across the bottom of each page. Every time a page is turned, the bunny will appear to have taken a step or moved closer to the right-hand side of the page. Aflac, on the other hand, could place the duck near every page number. For added

interest, the duck's wings might appear in a different position from time to time. The least expensive option is to show the character—say, the GEICO Gecko, for example—simply standing next to each page number. Finally, many annual reports have copy placed on top of a lightly screened background, so be sure the type is readable no matter what size it is.

Layout of the page should be as repetitive as possible. Think of it as a template: Be sure all repetitive graphics and copy appear in the same place from page to page and all headlines, subheads, and body copy are the same size throughout. Don't be afraid to run headlines, charts, or photographs across columns to attract attention and break up space.

Because public relations is responsible for such a diverse range of both internal and external promotional pieces, it is important it maintain a repetitive look and tone of voice no matter where it is seen or heard. Additionally, its close ties with the press, shareholders, and their publics help to give both their message and those associated with the advertised message a sense of credibility.

8

Traditional Advertising

Figure 8.1 **Sample Ad: K•B Toys**

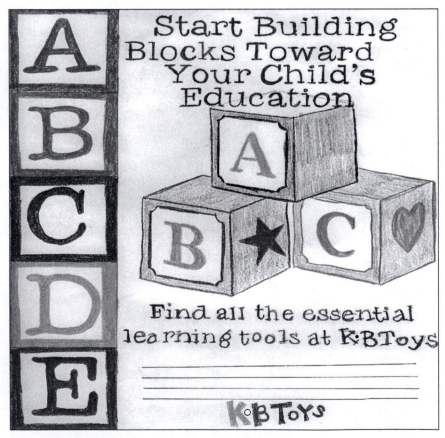

Source: Created by Kristen Eddleman, The University of Tennessee, Knoxville.

Traditional Advertising in an IMC Campaign

Advertising is a nonpersonal, paid form of one-way communication that uses persuasion to sell, entice, educate, remind, and/or entertain the target audience about one specific brand. Traditional mass media uses print (newspaper and magazine) and broadcast media (radio and television) to reach an undefined mass audience. While traditional advertising is not the best choice for building a relationship with the target, it is great for creating brand awareness and building or maintaining brand image. Because of its immense reach, it is often used to launch a new or reinvented product or as a reminder for commonly used products such as condiments, milk, soda, toilet tissue, aspirin, cold medicines, and the like. The fact that the message can be repeated helps position the brand in the mind of the consumer, build brand loyalty, and over time gain brand equity.

One of the main drawbacks of any traditional advertising vehicle is that it is not consumer-centric. It relies instead on a passive yet informative one-way flow of information that delivers an impersonal message. Its main job is to inform and attract attention, not build a relationship or initiate dialogue between buyer and seller. However, when traditional vehicles offer interactive opportunities, they can become a temporary substitute for one-on-one interaction. For example, newspapers can include coupons, list web addresses, or announce a "limited time only" sale. Magazines can hold the target's interest longer when they feature scratch-and-sniff cards, pop-ups, or multiple folds. Including a website address allows the target to seek out additional information, sign up for contests or sweepstakes, and chat with other users. Covers have also gone interactive by using unusual folds, pockets, movable parts, and even three-dimensional designs to attract and hold the reader's interest. Radio is interactive when participating in remote broadcasts or when promoting a locally sponsored contest such as a call-in trivia game. Interactive television allows viewers to vote for a contestant or order products seen on television commercials or in their favorite shows via their computer, remote, or telephone.

Although it may not have the power it once did, traditional media is adapting, making it unlikely we will see its demise any time soon. Research has shown that consumers are more receptive to advertising in traditional media because they view it when relaxing and engaging in entertainment opportunities. Research also indicates that ads seen in traditional media vehicles are more likely to generate buzz based on a memorable visual/verbal message than advertising seen elsewhere.

Advertisers must pick and choose media vehicles that match the brand's image and the target's needs. Because advertising is only a one-way monologue that delivers an impersonal message, it needs to work with relationship-

building vehicles to create interactive opportunities. For example, when any traditional vehicle is paired with public relations, it is a great way to promote an event or launch a promotion. When paired with social media, traditional media can lay the foundation for the message consumers share online, increasing the buzz and the frequency with which the message is viewed or heard. Add a website into the mix and consumers can locate additional information, talk directly to a customer service representative, or place an order.

The role of traditional media in an IMC campaign is to ensure advertising efforts:

1. Capture attention.
2. Increase sales.
3. Make a product or service stand out from the competition in a creative and informative way.
4. Develop and maintain both brand identity and image.
5. Announce updates or improvements to existing products.
6. Launch new products or services.
7. Address the target's needs and wants.
8. Encourage buzz.

When you understand the strengths and weaknesses of advertising, it is easier to launch an IMC campaign that has an integrated media mix—one that maximizes exposure and eliminates the costly guesswork involved in finding the target.

Understanding Advertising's Strengths and Weaknesses

The versatility of IMC's voice requires a thorough understanding of what each media vehicle brings to the campaign. Let's take a look at the strengths and weaknesses of advertising.

Strengths

1. Buzzing and Branding. A great ad gets noticed and creates positive word of mouth and viral sharing.
2. Guaranteed Exposure. An ad is paid for, so it is guaranteed to run or be seen.
3. Guaranteed Placement. If the space is bought, the ad is guaranteed to run.
4. Image and Awareness. Ads are great for building awareness and launching or maintaining brand image.

Weaknesses

1. Reliability. It takes a long time and frequent exposure before the consuming public will act on the advertised message.
2. Visual/Verbal Control. Standards and regulations keep certain types of advertising (such as cigarette and alcohol advertising) out of certain publications or off broadcast networks.
3. Expense. Buys in major media outlets are often expensive to produce and run.
4. Reach. It is often difficult to target and personalize advertisements.

In the course of this chapter, we will look at newspaper, magazine, radio, and television advertising. Each of these embattled vehicles is fighting to keep up with new media and define its place among them. The art and science of reaching the correct target with the correct message—at the right time and place—is getting more and more difficult. Let's take a look at what each one has to offer. First up, print: newspaper and magazine.

Defining Newspaper Advertising

Currently, newspapers are fighting for their publishing lives. Many have closed their doors due to a decline in readership, circulation, and advertising revenue. Others have increased subscription rates, downsized their staffs, and reduced the size of the paper in order to survive in a tough economy and compete against the newest technology-driven news vehicles. As newspapers struggle to define their place among twenty-first century technology, their role in retail advertising remains the same: to make a sale and encourage action on the part of the consumer.

One of the oldest and least targetable forms of mass media advertising, newspaper ads were once the only way to get local, national, or international exposure. Newspapers now compete not only with 24-hour televised news channels but also with the Internet and social media sites.

Newspaper advertising is typically divided into two main types: local and national. Local advertising promotes local businesses and events and includes both classified and display advertising. National advertisers like Apple, Target, or McDonald's, for example, feature products that can be purchased locally, online, or by making a toll-free call. It is difficult for both local and national advertisers to reach any one particular target audience. Specialized products that range from lawnmowers to fine jewelry to investment ads are more likely to reach the intended target when placed in a feature section they are sure to read. Therefore, the target audience is often tied to the sports, lifestyle, or

business section of the paper. Knowing whom you are trying to reach and what media vehicles they frequently use will help determine whether newspaper is the best media vehicle to reach the intended target. For example, newspaper is a great choice if advertising to baby boomers, who are regular readers, but a poor choice if advertising to millenniums, who favor new technology sources over traditional ones.

As a rule, newspaper advertising is credible, informative, and relatively inexpensive to use. It must have a sense of urgency, must boldly inform the reader about the key consumer benefit, and provide them with an incentive to buy now. What it lacks in beauty and targetability it more than makes up for in loyal readers looking for a sale or a coupon. The ability to localize a national brand, increase store traffic, build awareness, generate excitement for a new product launch, and build or retain brand-loyal customers makes newspaper advertising an effective vehicle in any IMC campaign.

Retail Sales Announcements Move Products

Because newspaper advertising usually advertises current sales, it's easy for many advertising efforts to look and sound alike. To ensure compatibility among vehicles within the IMC campaign, the creative team must decide which visual/verbal devices they will use to grab the reader and how to make the key consumer benefit unique and action oriented. Sales should not reflect the current holiday, overstock, or special events. The visual/verbal tone of voice used should take an approach the competition would never use: mirror the personality of the target, and vigorously promote the key consumer benefit, overall strategy, and persona of the product or service.

To attract attention, this timely medium must promote one-time-only sales, limited time offers, trials, test drives, and the like, or include coupons that encourage action and engage consumer interest. Keeping ads fresh is another way to sustain interest. Newspapers printed on a daily basis make it easy to update or change out current advertising to avoid stale or repetitive offers.

Retail Ads Push Price

Since newspaper advertising is all about making a sale, it is important to high-light price. Pricing sets the product or service apart from competing brands, simplifies comparison shopping, and makes informative buying decisions easier. There are three main areas where prices can be displayed: the headline, the subhead, and as a callout near a visual(s). Headlines are a great place to feature a specific price prominently. Subheads are better suited for displaying a range of prices. Callouts are a good choice when an array of prices need to

appear near individual images. These small blocks of descriptive copy usually include a bold product-identifying headline, a small amount of descriptive copy, and a slightly larger and bolder price point than the callout headline.

Avoid hiding the price in copy blocks; if it's really a good deal, as all sales are assumed to be, display it boldly. Scream it out, make it big, make it bold, italicize it, let it stand alone, or tie it to a copy point—it doesn't matter where it appears, as long as it's there and easily recognizable.

The only time price is not prominently displayed is when promoting exclusive products that focus primarily on image. These types of ads often eliminate prices and concentrate instead on features and benefits that will enhance the target's lifestyle; special sales and financing packages may also be mentioned.

The Visual/Verbal Voice of Newspaper and Magazines

Each ad, no matter the vehicle, must develop and maintain a visual/verbal identity that (1) features the key consumer benefit, (2) speaks directly to the target audience's needs, wants, and/or lifestyle, and (3) cohesively reflects the visual/verbal tone of voice used throughout the IMC media mix.

Because print vehicles are informative both visually and verbally, they can define an image, highlight a price, or explain a task, idea, or use. They can use colorful or black-and-white images, project both simple or complicated concepts, and encourage action. Print ads use one or more of the essential design elements to tell a story with words—through headlines, subheads, body copy, descriptive copy, and slogans or taglines. Visually, they demonstrate the verbal direction with photography, illustrations, graphics, type and layout styles, and frames or borders.

Newspapers incorporate strong black-and-white contrasts in their ads, use a single dominant visual or verbal element, and highlight prices to make the ad stand out on the page. Body copy should flesh out the key consumer benefit and let the target know what the product looks like, highlight any special features, and describe how it works, how it will enhance their lives, and where to find it.

Clutter is often a problem when working with newspaper design, so eye flow and placement of each essential visual/verbal design element must be controlled. If using multiple related images, consider grouping them together and using callouts to highlight individual product descriptions and price. Unrelated images can be organized into a grid, with copy and price discussed independently. If the ad does not have a lot to show, make sure the headline has a lot to say. Consider using graphics, illustrations, line art, or a border to increase the black-and-white contrast on the page.

Framing a Print Ad

Although not a required design element, borders are often used as a decorative element, tying an ad together and setting it off from surrounding copy or other ads.

Borders define the dimensions or edges of a newspaper ad. They can be fat, thin, and double ruled, or defined by graphic images. Most high-end stores peddling expensive merchandise will use a thinner, more elegant-looking border. Advertising for discount establishments is often more cluttered, so a heavier border is required to stand out. A good rule of thumb suggests that the overall weight of a border should reflect the weight of the typeface. Borders need not be consistent in size. Consider making the top and bottom slightly thicker than the sides. This disperses the weight away from the center of the ad, creating the illusion of additional white space and making the ad appear larger. Whatever the look or size employed, be sure the border does not interfere with the visual or the verbal images used in the ad. Borders can also be used inside an ad, particularly around photographs or callout boxes to emphasize an image or any copy points that require special notice.

Frames are not exclusive to newspaper. When borders are used in magazine ads, they are known as *inset graphic borders.* Graphically, they mimic those used in newspaper; instead of defining the edges of the ad, inset graphic borders in magazine ads guard against the accidental loss of some of the ad when the magazine is trimmed to size during printing. These decorative borders can be outlined in any color or tint; background colors may be confined within the border or bleed beyond it. Although borders can grab a viewer's attention, magazine ads typically rely on the white of the page or some type of light-colored background to set off the product or provide additional emphasis.

Cooperative Advertising Divides the Exposure

Commonly used throughout all traditional media vehicles, a cooperative or co-op arrangement takes place when two or more compatible advertisers divide the cost of advertising. Co-op advertising ventures allow advertisers to get more advertising exposure for less money. When products are consistently paired together, the target begins to think of the two as inseparable, or as a two-for-one offer. This type of joint venture is often utilized by national brands in order to get their products exposed in local or regional markets. Wholesalers, manufacturers, distributors, and retailers usually offer cooperative programs. Popular alliances might include airline and cruise ship packages, or the pairing of the Apple iPhone with AT&T or Verizon service.

Defining Magazine Advertising

Magazines chronicle our times with detailed narratives and colorful images. They define a lifestyle built on the target's personal interests, political beliefs, and overall values. Strategically speaking, a magazine can customize the key consumer benefit to directly meet the needs and wants of the target.

Unlike newspaper advertising, which pushes sales and prices, magazine advertising focuses on image—specifically, how a brand will affect or interact with the target's perceived self-image. This type of advertising requires a substantial knowledge of the target and their overall lifestyle. All advertising associated with image must visually and verbally inform the target about the ways in which the product will enrich, change, or improve their lives.

Image-based products such as jewelry and cars are known as high-involvement products, meaning the target's self-image is tied to the brand's self-image; therefore, it is important that the brand's message reflect this image both visually and verbally. Placing sales tags on high-involvement products is discouraged, as it can emasculate both the brand and the target's perceived image. In such cases, the focus should be on the benefits or prestige of ownership.

Magazines are highly targetable and engaging when informative copy, gatefolds, inserts, coupons, order forms, a scratch–and-sniff panel, pop-ups, business reply cards, samples, or three-dimensional enhanced images are included in an ad. Although they cannot evoke a two-way dialog with the target, they can encourage them to take the next step by logging onto a website, calling a toll-free number, or visiting a showroom.

Unlike any of the other traditional media vehicles, magazines have a long life span. The special interest content and exclusive target involvement encourages the target to either retain and/or reread content, or pass it along to others interested in the topic. This increases the advertisement's reach, as new readers give the advertising a second chance to make a first impression.

Magazines connect with the target by focusing on their leisure pursuits, interests, or business concerns. Readers expect and look forward to multiple advertising messages that appeal to their likes. A magazine is read by a target that is interested in its editorial content, so it makes sense for advertising to match the editorial style of the magazine. For example, a do-it-yourself magazine might feature advertising for paint, wallpaper, appliances, or tools. Fashion magazines typically advertise designer clothing, jewelry, and other accessories. Such ads focus more on lengthy fact-based copy that not only educates a receptive audience but also encourages trial or additional research. This targeted medium is an efficient way for advertisers to reach a very specified or niche market. Like all traditional media, magazine advertising needs

Figure 8.2 **Sample Ad: Rooms to Go**

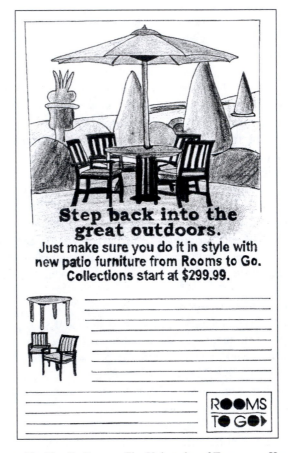

Source: Created by Natalie Rowan, The University of Tennessee, Knoxville.

to be supported by vehicles that are better at building and maintaining a relationship with the target and creating an interactive dialogue with the reader. To make ads more personalized, consider using sales promotions, intercept marketing, or direct or e-mail marketing.

Magazines work well with other members of the media mix by establishing image or by making purchase or research far easier. They can direct the target to additional information or include varied interactive enticements such as coupons, order forms, small samples (of, say, lotions or fragrances), or even CDs.

The choice to use magazine ads is an expensive one; consider it only if the product is geared toward a specific niche market, is a generic or rational

purchase, or is an image-enhancing emotional purchase. Magazine advertisements are best suited to educate with lengthy copy or by visually showing the product in use in a particular setting, or to portray status or elitism.

The Visual/Verbal Voice of Special Interest Magazines

There are three basic types of magazines: trade, consumer, and farming. Each can be subdivided into special interest categories such as gardening, dog lovers, fashion, and business, to name just a few. These categories can then be further divided into local, regional, or national coverage. Each diverse category presents the advertiser with a very exclusive group of targeted consumers.

Special interest magazines have very loyal readers who repeatedly pick up or have their favorite magazine delivered directly to their home or office. Knowledgeable readers demand a creative idea that is new, different, and relative to their personal experiences.

Magazine advertising should be informative and visually create a mood or define a demeanor or attitude. The choice of visual/verbal imagery will ultimately develop and define the brand's image and overall personality. Copy should reflect the target's interest in, and/or experience with, the product or service being advertised.

When the message is one of exclusivity, sophistication, or education, prices should be minimized or altogether absent. Few image-based ads feature prices or lengthy copy; rather, they let the visual(s) sell the product, the benefit, and the overall visual/verbal experience. Ads that do feature lengthy copy have the ability to hold the reader's interest longer, making it a great vehicle for developing and maintaining a storyline or plot that can be carried across multiple media vehicles. In addition to its educational function, copy that is written creatively will sustain interest and create excitement in the target.

Testimonials are another great way to give copy credibility and build a brand's reputation. How-to ads attract attention by involving the consumer's imagination and skills in the visual/verbal message. If the brand is a food product, consider using a recipe or a coupon for a complimentary item, such as coffee with a coupon for creamer.

Since magazine advertising defines, reflects, and projects image, it is important, that the advertised message be striking and visually appealing. This is the time to use bold colors and graphics to make the ad stand out from competing advertising. A creative idea with a unique visual/verbal expression is more engaging and persuasive. If the ad's image reflects both the brand and the target's image, an exclusive relationship is formed between the buyer and the seller.

When the key consumer benefit focuses on image, it is easier to show it than to talk about it, so visuals will take center stage. Copy plays a more dominant role if the product is new or newly reinvented. Use visuals to create an image and copy to define its importance. Each enticing visual and paragraph of informative copy should define the brand's image, ooze elitism, and define the target's personality profile; these goals are best achieved by mirroring the target's self-image, interests, and lifestyle. Magazine advertising can be whimsical, sophisticated, sexy, trendy, informative, and visually/verbally stimulating. It is an excellent vehicle for new products with a truly unique selling proposition, as well as for rebuilding brand image or maintaining an established one. Copy that speaks directly to the target's personal experiences allows the message to focus squarely on situations where the product can be used to solve a problem or enhance an experience.

Advertising in magazines must be planned for months in advance, so any last-minute creative changes resulting from current publicity, scientific findings, or current events should utilize a more frequently published or digital vehicle. Unlike immediate publicity outlets or daily newspapers, magazines may be published as often as once a week or as infrequently as once per quarter.

Consider using magazines to support sales promotions, public relations, event marketing, or direct marketing in publicizing local, regional, or national events. The same visual/verbal design influence used in magazine ads to define image or enhance prestige will influence the visual/verbal voice used throughout the event. Once the visual/verbal tone of voice is established, it will be reflected in press releases, packaging, direct mailings, outdoor boards, pledge or thank you cards, posters, flyers, banners, and bumper stickers. Any sales promotion vehicles such as totes, T-shirts, caps, or water bottles will be easily recognizable as a member of the IMC campaign media mix.

Sizing Up the Ad

A magazine ad can be divided into three important design-influencing parts: *live, trim,* and *bleed.* Trim is the size of the ad after being printed, trimmed, and bound. The live area, located inside the trim, safely confines type so it is not accidentally cut off during printing. A full-size ad measuring 8½ × 11 inches would have a live area around 7 × 10 inches. All images and color blocks can extend beyond both the borders of the live and trim area to the bleed. Bleed is the area beyond the trim. An ad has bleed when an image or block of color extends to the edge of the trim on one or more sides. Bleed assures that no white space will show around an ad's edges when the magazine is trimmed to size.

Interactive Folds Give the Reader Something to Do

One way to engage a reader is to incorporate a gatefold into the design. Varying in size, a gatefold refers to one or more folds that face inward toward the magazine's center or spine. Folds can be attached to a single-page ad, to a spread, or to a two-page ad. Most ads employ a single full-page panel. In order to fold without rumpling or creasing, the panel is usually one-quarter to one-half inch smaller than the original page size. Partial page panels are also an option, with a single fold measuring anywhere from two and a half inches to four and a half inches. Although single panels are the most common, there is no limit to the number of gatefolded partial or full-page foldouts used in a magazine ad. Pieces with multiple folds might use a fan or accordion fold that allows the panels to be stacked back and forth on top of one another, or a roll fold, in which multiple panels are repeatedly folded or rolled toward the center. A two-page spread will have a roll fold or gatefold that is placed on both the left and right sides of the spread and folded inward toward the spine.

Gatefolds can extend the advertised message, invoke curiosity, and engage the reader. When the target interacts with the ad by opening the panels, their interest is focused on the message for a longer period of time. Most panels show accessories or alternative uses for a product; they can also inform the reader about coupons, contests or sweepstakes, upcoming offers, or even a promotional offer such as a product sample. Since gatefolds overlay the bottom photograph, it is important that the images align exactly during printing.

The next section looks at radio and television's role in the traditional media mix. Broadcast vehicles rely on the listener's or viewer's imagination to capture attention. Radio must attract attention with sound only, while television can creatively use sight, sound, and motion to drive home the message.

Defining Radio Advertising

Radio reaches a broad and often captive audience through our phones, in our cars, in restaurants, in grocery stores, even in waiting rooms. Often relegated to background noise, it is a medium that rarely holds our complete attention. Because of this, advertising has to work harder to snap targets out of their self-imposed comas with interesting and attention-getting devices—a task made harder when competing against personalized music options such as iPods, MP3 players, and satellite radio.

An imaginative media, radio has the burden of creating a visual/verbal message out of copy alone. Its "sound only" format must draw the listener in by creating a visually stimulating product narrative. The more colorful, informative, and personalized the message, the easier it will be for the target

to imagine the product or service in their lives or solving their particular problem. Catchy jingles are a great way to keep the product or service alive for hours or even days after exposure, as the target audience repeatedly replays the lyrics in their heads or shares the bouncy tunes with others.

Like newspaper, radio is timely and adaptable to the latest political, social, or seasonal trends. It is a great vehicle for creating action by announcing sales, publicizing events, or promoting remote broadcasts from local area retailers. Because it is action oriented, it is great for building awareness and creating excitement. Local merchants will find it a relatively inexpensive primary vehicle; larger brands will find it a great cooperative opportunity. In a campaign, radio is often used as a support or secondary vehicle to reinforce the IMC message used elsewhere in the media mix.

Advertisers must decide whether the radio spot will be 15, 30, or 60 seconds in length and what time of day the spot will air. The two most listened to time slots are the morning and afternoon drive times from 6:00 to 10:00 A.M. and 3:00 to 7:00 P.M. These primetime slots guarantee listeners; once people leave their cars, however, listenership drops off dramatically, as do advertising rates.

The production of radio ads is relatively inexpensive. Typical costs include hiring talent and incorporating sound effects (SFX) or a musical score or jingle. Total media costs depend on how often the ad will air and the number of stations on which the ad will be placed. Other considerations include the choice of using AM or FM, or a music or talk format. Programming can be broken down further into music types such as rock, hip-hop, country, and so on. Each specialized category allows the message to be personalized to match the target's interests.

Radio challenges the creative team to engage the listeners' minds with information and their imaginations with verbal stimuli. This is made somewhat easier because of its highly targetable format. The ability to produce numerous spots for a relatively low cost can keep the message fresh or allow for an ongoing storyline.

As a viable member of the IMC mix, radio is a great medium for reinforcing the verbal message used elsewhere in the campaign. A good example is to start with the spokesperson or character representative, sound effects, and/or a jingle from television, and then mix it with the slogan, tagline, and/or headline style from print. Radio can also inspire immediate action, localize a national brand's message, and increase brand awareness. Like other traditional advertising vehicles, radio talks *at* the target. Promotional events such as remote or on-site broadcasts are a great way for radio advertisers to interact with the target.

Most commonly used in local markets, radio is a cost-effective way for

local merchants to reach their target with a relevant message that reflects what is going on in the community. If used nationally, radio has enormous reach. Most national ads will use the same generic message in all markets, but typically, advertisers prefer to exploit radio advertising's hometown, highly targetable, uniquely personalized, special interest format.

For a radio ad to move from background noise to the conscious mind, it must engage the listener through startling sound effects or catchy jingles. Promotional opportunities abound when tied to call-in trivia games or remote broadcasts that allow for on-site trials and unsolicited testimonials. Slice-of-life vignettes and ongoing storylines can be used to promote the brand while involving it in dramatic or comedic scenarios that feature local area establishments. This is not only a great way to build curiosity but also to tell an ongoing story listeners can tune into regularly. Consider tying it to a sponsored broadcast such as news, weather, or traffic updates that are "brought to you" ("you" being the listener) by a specific product. This gains repeated exposure and increases brand awareness.

Radio is not the best image-building medium; if the message needs immediate action, consider pairing it with newspaper, the web, texting, and out-of-home advertising to reach a broader swath of public quickly and inexpensively. Public relations can use radio effectively to deliver public service announcements, solicit volunteers, promote blood or food drives, or announce new product launches. If the goal is to educate with detailed copy or promote multiple price points, radio is not the best vehicle. Radio's fleeting message is rarely memorable unless repeated frequently.

Listening to What Radio Has to Say Visually

There are two basic ways to deliver an advertising spot on the radio: live or prerecorded. Simple spots can be written, produced, and aired in as little as a few hours or days and quickly delivered on the air by popular, local DJs. Their involvement in the message can be tantamount to a personal endorsement. Listeners trust their opinion, giving the brand a boost of credibility. Popular radio personalities do not read from a prepared script, but are instead provided with a fact sheet. The dialogue is delivered in their own words, without the benefit of sound effects or music, as might be present on a prerecorded version of a radio spot. Depending on the personality, live presentations can be risky because they are not controlled. However, a DJ who has actually used the product can often talk about its benefits longer than the purchased airtime allows, inadvertently offering a reliable testimony in the mind of the listener.

Radio ads should use a conversational style and have an upbeat and friendly tone. The voice that is chosen to deliver the commercial (announcer or talent)

will depend on the strategy and tone of voice used throughout the campaign. Be sure the voice chosen represents the target's personality and voice. Radio copy should be short and full of urgency to encourage a prompt response to the message. Build a visual picture of the product or service's features and benefits and how they can change the listener's life for the better. A radio ad is particularly engaging if a game or a suggested trip to the website will sign up the listener for a contest or sweepstakes, or if a trip to a brick-and-mortar store will get them a sample or promotional item. Let's take a look at a few of the diverse ways a radio spot can be scripted and delivered.

• Music and Jingles. A consistent sound is more than just the spoken word or readable copy. It can also be projected in the music played or jingle sung. Music sets a mood without the need for words or visuals. Depending on the genre or tempo, music defines emotions, creates a feeling of nostalgia, and excites or relaxes the listener. Use music to help the target imagine a visual and emotional scene.

Catchy little jingles stay with us long after a commercial message has ended. Consider tying jingles to the key consumer benefit, slogan, or tagline. Every time the target sings or hums a bar, the brand gets a second, third, or fourth shot at delivering its message. A few bars can say as much as a page of dialogue. Jingles not only set a mood but can place boring dialogue to music, making it more memorable.

• Narrative Drama. This type of message uses dialogue to tell the brand's story.

• Straight Announcement. This no-nonsense type of message delivers only the brand's features and benefits. An excellent option when delivered by an on-air personality.

• Celebrity Delivery. This message format is a great way to feature the campaign's spokesperson or character representative.

• Live Donut. A live donut is half prerecorded and half live read. The opening and closing are prerecorded, usually with music that fades when the center portion (the ad) is presented live by an on-air personality.

• Dialogue. This delivery format is a great way to use testimonials or discuss a brand's features and benefits.

• Multiple-Voice Delivery. A multiple-voice approach features a character or characters who speaks directly to the listener, usually asking questions and providing answers.

• Sound Effects (SFX). Sound can be a visual stimulant. Visual actions shown in other media vehicles can be recycled and visualized on the radio. Sounds such as a ringing doorbell, a belch, or screeching tires can help make a point or solve a problem.

• Vignette/Slice-of-Life. A vignette is like a TV sitcom or drama that has an ongoing storyline. The key to recognizing a vignette is the use of repetition—whether characters, sounds, music, slogans, or taglines—to tie the multiple storylines together.

• Interviews. Remote broadcasts are a great way to incorporate man-on-the-street interviews into the advertised message.

It is not uncommon to see one or more of these techniques used to deliver a brand's message, create awareness, build curiosity, or entice immediate action. The only rule is to make sure it will engage the target.

Visualizing the Verbal-Only Message

Radio must be able to successfully deliver the key consumer benefit verbally. Reusing devices such as spokespersons, character representatives, music, jingles, or headline devices helps the listener tune in and "visualize" the verbal-only message. In order to reach the target, the message must attract the listener with the brand name and key consumer benefit within the first three seconds. To be successful, radio advertising must:

1. Tune the Listener In. The message has three seconds to engage listeners before they tune back out.
2. Cleverly Identify the Brand. Each spot should open by clearly identifying the brand and key consumer benefit. If the brand is hard to pronounce or has an unusual use, consider incorporating it into a jingle, a rhyming scheme, or through repetition.
3. Have a Consistent Tone. Each radio spot must adapt the tone of voice used throughout the IMC campaign.
4. Be Chatty. Dialogue that is written in a conversational style is easier to understand and relate to. Punctuate points through short sentences rather than rambling dialogue.
5. Describe the Product. Give the listener's mind something to do, perhaps by describing the product, its packaging, or the outcome of its use.
6. Remind. When listeners are not totally tuned in, copy must repeat the brand name and key consumer benefit often before it is remembered.
7. Be Timely. Tie the brand to local events.
8. Give the Features Real-Life Uses. Don't bore with endless facts; entice with results.
9. Sound Out Carefully. Sound effects work only if they advance the message and are easily recognizable.

A Quick Look at Radio and Television Scripts

The script is where the copywriter goes to give the product or service a voice. In radio, straight dialogue or conversational copy must describe the brand in visual terms in order to stimulate the listener's imagination. Television can employ sight, sound, and motion to create image, showcase colors, or show the product in use or in a particular setting. Traditionally, both radio and television scripts follow a standard format to ensure readability. Most are double-spaced documents that are set up in multiple columns.

A simple radio script focuses on three things to punctuate the action: dialogue, SFX, and/or music. All dialogue is set in caps-lower-case and enclosed in quotes. To stand out, all SFX are underlined with a dashed line, and all music is highlighted with a solid line (see Figure 8.3). SFX and music reinforce the tone of voice, attract attention, and set a mood. Do not be afraid to use one or more in both radio and television to reinforce the visual/verbal message. All instructions to the talent or production crew will be set in all caps and enclosed in parenthesis.

Beyond dialogue, SFX, and music, the more complex television script will include camera shots (or specifications regarding how much of the visual will be shown); camera instructions (describing where the camera needs to be placed during the shoot); and transitions (or how the camera will move between scenes—see Figure 8.4).

To be remembered, both radio and television ads require a hefty amount of repetition. Do not hesitate to repeat the key consumer benefit and product name frequently throughout the spot. Remember, the target is initially unengaged; for the message to be remembered, it must be repeated in a new and creative way each time it is mentioned. Be sure to close the ad with a call to action or with the repetition of the slogan, tagline, or logo. In television, when possible, be sure to also show the product and any packaging if unique. Let the target know how to find the product with more than just an address. For locally produced ads, the address becomes visual when attached to local landmarks. Don't give a phone number in radio unless you're lucky enough to be able to use a mnemonic like 1–800-FLOWERS, since the target is unlikely to have a pencil handy at the pool, in the park, in their car, or on a couch. Be sure to cross promote by including a web address in both radio and television; they are relatively easy to remember since they usually include the product's or service's name.

Defining Television Advertising

Television advertising creatively shows and tells us what will clean our clothes, the best ways to entertain, and what to drive or wear. It uses sight, sound, and

Figure 8.3 **Sample Radio Script**

Advertiser:	Target:
Run Date:	Strategy:
Length:	KCB:

SFX:	STRANGE STOMACH GROWLING SOUNDS.

ANNOUNCER:	"Hey Thompson you going to lunch?"
	Dialogue is always typed in caps/lowercase and enclosed in quotes to distinguish it as spoken dialogue. Any speaker who will not be reused anywhere else in the campaign can be labeled as "announcer."
THOMPSON:	"Uh (MORE GRUMBLING SOUNDS) no. Too much to do, this contract is due by the end of the day." (YAWN) "And besides, it takes too long to go out, and it's just too darn expensive to have it delivered. So it's starvation again for me." (SIGH)
	Quick sounds can be placed within the dialog. Introduce any reoccurring characters to the target by calling them by name.
ANNOUNCER:	"Go out! Don't go out." (EXCITED) "Floozies will bring you anything from their list of 125 hot or cold dishes within 30 minutes for only $7.99."
SFX:	(SMALL LITTLE CLAPS OF EXCITEMENT)
	Hold the listeners attention with some type of noise to help them envision what the speaker(s) are doing.

THOMPSON:	"125 (GROWLING) menu items?"
ANNOUNCER:	"Yep."
THOMPSON:	"In 30 minutes for only $7.99?"
ANNOUNCER:	"Yep."
MUSIC:	"WHAT A WONDERFUL WORLD" PLAYS IN THE BACKGROUND.
	Music can help set the scene without the need for additional dialogue.

THOMPSON:	"Who do I call?"
SFX:	HAPPIER SOUNDING GROWLS.

ANNOUNCER:	"It's easy, just dial 555-FOOD-FIX or visit www.foodfix.com to order ahead for dinner tonight or immediate delivery."
SFX:	SOUNDS OF THOMPSON DIALING THE PHONE.

ANNOUNCER:	"For those of you with a little more time, stop by and see us at 1234 Chop Shop, next to Barney's Golf Accessories. We're open seven days a week from 11 to 9 Monday through Saturday and 12 to 7 on Sundays. See ya soon, and Eat Up."
	Be sure to close with the product name. If applicable, the location where the product can be found, including landmarks, a phone number or Web address, if easy to remember.
THOMPSON:	"Yeah." (POLITE BURP) "Oh excuse me, Eat Up."

Figure 8.4 **Two-Frame Sample Television Script**

Frame 1:	OPEN:	Open on a deli with a long line of frustrated looking customers.
	MCS:	
	CAMERA:	STILL.
	SFX IN and UNDER:	IN (A lot of stomachs growling and people mumbling in background) UNDER.
	WOMAN 1:	"There has to be an easier and faster way to order lunch!"
	SFX OUT:	(Of people mumbling and stomachs growling in background).
	CUT TO:	Floozies, where a woman is picking up her "to go" order.
Frame 2:	MFS:	
	CAMERA:	PAN (restaurant customers eating to a customer picking up her call-in order to the delivery driver picking up his to go orders) LEFT AND RIGHT.
	CAMERA:	STILL.
	MCS:	
	OWNER:	"Here is Mr. Thompson's delivery order, Dave. This is his fourth order this week."
	DAVE:	"I'm on my way."
	WOMAN 1:	"Yes! Finally, freshly prepared food I don't have to wait in line for."
	MUSIC IN and UNDER:	IN ("What a Wonderful World") UNDER.
	ANN:	"Dine in, carry out, or delivery. At Floozies, you'll never have to stand in line again. Come by and see us at 1234 Chop Shop, or call 555-FOOD-FIX, or visit us on the web at www.foodfix.com. We're open seven days a week from 11 to 9 Monday through Saturday and 12 to 7 on Sundays. See ya soon, and Eat Up."
	MUSIC OUT:	(What a Wonderful World)
	SUPER:	(Floozies logo with address, phone number, and Web address. Deli in background.)

motion to bring a brand's personality to life in a way and in a language the target will identify with and understand. As a primary media outlet, television is an excellent venue for building or maintaining image, creating brand awareness, launching new products, or repositioning or reminding the target about mature ones. Like other traditional vehicles, advertising sales on television are slumping. An ailing economy, a disinterested target, and newer, more popular alternative media options on the Internet are keeping marketers from investing heavier in the medium.

Television's ability to show and tell, demonstrate, educate, and entertain allows the creative team many options for solving their client's advertising problem. This mass media vehicle makes isolating a niche market a little more difficult than magazine and radio. However, national and cable stations do offer some targetability based on programming. Today's jaded consumer often sees a commercial but doesn't really hear it or process it unless it's visually stimulating, unusual, and/or solves a problem or fulfills a want. Advertisers using television bombard consumers with approximately 18 minutes of advertising per 60 minutes of broadcast programming, leaving them disillusioned, overwhelmed, and uninterested in most advertised messages.

Because television can reach a mass audience, it is perfect for selling generic products such as shampoos, window cleaners, insurance, or furniture polish. For the advertisement to be unique, it must possess or reflect some type of inherent drama or a feature or characteristic that can be used in a subtle but dramatic way to make a point. Leo Burnett, a mid-twentieth-century advertising giant, defined *inherent drama* this way in his book *100 LEO's:* "You have to be noticed but the art is getting noticed naturally, without screaming and without tricks." Subtle today is a little more about being clever or taking a unique approach to solving or addressing a problem; three brands that have utilized inherent drama to the fullest are Apple, GEICO, and Aflac.

Television, like all the other traditional advertising vehicles, talks *at* the target. Any interactive component added to television turns a monologue into a dialogue by holding the target's attention longer and making the message more memorable. Creating interactive opportunities is a great way to engage the target in the message and create a situation that encourages discussion. Consider having the target visit a website for coupons or enter a contest or sweepstakes, visit a showroom, take a test drive, call a toll-free number to request additional information, or contribute to a blog. Direct response marketers often use price incentives or free gifts to encourage interaction and/or immediate purchase. Not only is this a great way to make a sale, but it also meets the target on a one-to-one basis, encouraging loyalty and repeat purchase.

144

Figure 8.5 **Sample Ad: Knoxville Museum of Art**

Source: Created by Victoria Drew, The University of Tennessee, Knoxville.

The Visual/Verbal Voice of Television

Television has a short message life and a distracted audience. To make television advertising work, a message must express the key consumer benefit creatively and educationally. Because television incorporates sight, sound, and motion, products advertised on TV can be seen, demonstrated, shown in use, or used to set a mood or spark an emotion. Television ads make the product real and allow the target to imagine the brand in their lives. It is important to show and tell the target how they will look or appear to others using, wearing, or driving the featured product and how it can make their lives more fulfilling. Seeing is believing.

The visual/verbal messaging used in television should match the tone, color choice, and overall style used throughout the IMC campaign. For example, a jingle like the one used by FreeCreditReport.com is catchy, tells us everything we need to know, and works well on both radio and television. Additional uses might include using the actor's image in print, direct response, out-of-home, and in sales promotion materials, to name just a few ideas.

The high cost of production, editing, and media makes television a very expensive mass media vehicle. Even the simplest television shoots are stressful and exhausting. A few seconds of footage can take hours to achieve. Because of this, a heavily scripted and detailed storyboard is required.

Creatively, a television commercial is made up of two parts: a script and an accompanying storyboard. The audio portion alone is known as a *script,* and the video portions are known as *scenes.* The combined audio and video segment of a commercial is the *storyboard.* Its job is to relate both the visual and verbal message in a detailed way. This very detailed document can also include information on music, SFX, camera shots, scene transitions, and any special instructions to the talent.

Because there are so many people involved in a television shoot, the script must be detailed enough not only for the client and talent to follow, but for the director, editors, camera operators, and any lighting and sound people to follow, as well. The script explains what is going on when, and it spells out exactly where and how each shot will be carried out. Anything less explicit than that can quickly affect both the budget and shooting schedule. Changes at any step along the way are costly.

A typical brand-based commercial will last anywhere from 15 to 30 seconds. When the brand has a lot to say, advertisers will often purchase a single 30-second spot and break it into two separate but related commercials. This "more bang for your buck" buy is known as *piggybacking. Direct response* ads are longer than the typical commercial, usually running around 90 to 160 seconds. The extra time is used to show features, benefits, and uses of the product in question. The granddaddy of all direct response ads is the *infomercial.*

Infomercials Are Just Long Commercials

Infomercials are long commercials that last 30 to 60 minutes. Most infomercials are endorsed and delivered by a celebrity or an accepted professional in the field. Like direct response commercials, infomercials often feature demonstrations, testimonials, and studies backed by scientists, physicians, or engineers. It is important for the target to get a thorough rundown of how the product works and, if they choose to make a purchase, what's in it for them. Since the goal is to get the target to act, the toll-free number, web address, and payment options should appear on screen continuously or be referred to often by the presenter.

The same basic sales techniques used in traditional commercials—educate and inform—are equally important to the success of an infomercial. This type of direct response commercial has to make both ordering and purchasing fast and simple. With an accepted credit card, the target can easily order from the comfort of their home or office by clicking a few keys or pushing a few buttons. Advertisers who offer 100 percent satisfaction guarantees and make returns easy will ensure customer satisfaction and repeat business.

A Television Shoot Is Hard Work

Most television commercials are painstakingly planned out before the shoot begins. If not, what is already a very expensive and lengthy process can easily go over budget and disrupt the production or media scheduling. A television shoot can take anywhere from a couple of days to several weeks to complete. Add in any computer-generated work or voice-overs and the process can extend to months. Once the art director and copywriter finish the storyboard, the team must (1) hire a director, (2) hold auditions, (3) work with costume, hair, and make-up professionals, (4) decide on a location, (5) find a crew to shoot, edit, and produce the spot, and (6) commission a musical score or perhaps a jingle for the product. The brand's target is matched with programming: Talent must look, act, and sound like the target; lighting, music, wardrobe, and props all must be chosen to project a mood or mimic the target and brand's image.

Finally, the creative team must find an adequate location to shoot the commercial. Locally shot and produced commercials will most often use a straightforward announcer-delivered spot, making them a relatively inexpensive option for small businesses. Established brands, on the other hand, will often shoot in larger markets or in remote locations. A shoot that takes place outside of the controlled environment of a studio is referred to as an *on-location shoot.* This type of production is great for defining image or cre-

ating a realistic environment that allows the target to see the product in use and in a definitive setting.

In order to reach the target with a meaningful message, an effective commercial must:

1. Scream out the key consumer benefit in a way that is relevant to the target.
2. Talk to the target in a language they can understand, about problems and situations they can relate to.
3. Ensure the visual/verbal message matches the tone and overall visual appeal of other pieces used in the IMC campaign.
4. Get to the point quickly. Music, sounds, and repetitive statements can help make that point in the allotted 15 to 30 seconds.
5. Address target issues, problems, or interests both visually and verbally to ensure the viewer's connection with them.
6. Define the product identity and that of the target through dialogue, character selection, music and/or sounds.
7. Solve a need or want through the use of testimonials, product demonstrations, and computer-generated images—anything that will build curiosity, entertain, excite, or have some type of personal or social ramifications.
8. Make the key consumer benefit the obvious focus of the commercial.
9. Engage the target by showing how the product works and how it will make life easier, or more satisfying, by focusing on the benefits the product or service offers.
10. Create some type of interactive opportunity.
11. Ensure all speaking parts are accurately timed to easily fill the time allotted.
12. Make sure the final frame shows one or all of the following: the product, the packaging, or the logo to help with memory and brand recognition.

Traditional media vehicles continue to play a large part in consumers' lives and are still favored by advertisers working with new technology options. As each medium adjusts to its new role, advertisers will find new ways to adapt the vehicles of old into their new media mix.

9

Out-of-Home

Figure 9.1 **Sample Ad: Bennett Galleries**

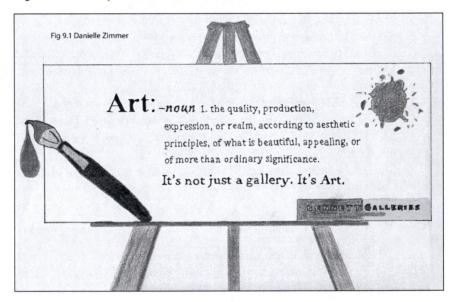

Source: Created by Danielle Zimmer, The University of Tennessee, Knoxville.

Out-of-Home Expands the Campaign Message

Aptly named, out-of-home advertising is any advertising seen outside of the home. Vehicles included under this mass media umbrella include outdoor boards, as well as transit vehicles, shelters, terminals, and stations.

The diversity of shapes, sizes, and designs give these varied vehicles an interesting array of looks. Brief, simplified, colorful messages characterize all forms of out-of-home advertising, the job of which is to catch the attention

of often tired, distracted, and irritable commuters who are either on the move or watching the message pass by their location.

All types of out-of-home advertising are growing in popularity due to the increasingly creative options available to designers. Placement of out-of-home is usually concentrated in larger cities and surrounding areas, in or on public transportation, and along interstate highways. It is not unusual to see out-of-home at shopping malls; in downtown areas, airport terminals, and bus shelters; and on or in subways, buses, and taxis. Messages appearing inside public transportation reach a captive audience, as this type of advertising cannot be missed, thrown away, muted, ignored, clicked off, or minimized. This great reminder vehicle is most often used by local businesses selling locally available products and services, and by local media companies and entertainment providers.

Considered a mass medium, the typical out-of-home vehicle is not consumer focused and must rely on advertising used elsewhere to build a relationship with the target. Most out-of-home vehicles offer a great way to create interest, build or maintain awareness, direct traffic, and reinforce other messages used throughout the IMC campaign. Without any one-on-one contact, these ads must have some type of viral component to get and keep the target talking about the brand.

Because it is limited in what it can say and show, out-of-home advertising is not a great canvas for image-based products. It is, however, an effective vehicle for advertising mature products or promoting events. Most out-of-home vehicles can be changed out easily, making it a great option for campaigns that have an ongoing theme.

Out-of-home's supporting role among other more traditional or even alternative media makes it ideally suited for teaser ads, new product launches, the maintenance or reinforcement of existing advertising, or as part of a highly visible cooperative opportunity. Creatively, these vehicles have a lot more to show than say. To maintain campaign consistency, consider repeating a color(s) scheme, headline style, and character representative or spokesperson. Visuals are usually limited to one image, so keep it simple but bold if budget and restrictions permit.

This is not the venue to show and tell a detailed story. Copy will be limited, focusing on the key consumer benefit, slogan or tagline, logo, and perhaps an exit number, directions, or address. Each message must be expressed in no more than five to seven words. Do not consider this a handicap: Remember, one carefully crafted visual is worth more than a page of copy. The typeface should be readable from a distance of up to 500 feet, so letterspacing should be increased slightly. Avoid using all caps and reverses, as these tactics may decrease readability and legibility.

Understanding Out-of-Home's Strength and Weaknesses

The versatility of IMC's voice requires a thorough understanding of what each vehicle brings to the campaign. Let's take a look at the strengths and weaknesses of out-of-home.

Strengths

1. Unavoidable and Repetitious. Commuters and pedestrians can't turn it off or delete it. They are a captive audience who will repeatedly see the message on a daily basis as they travel back and forth to work or other destinations.
2. Location. Messages that are placed in high traffic areas are sure to be seen.
3. Creative. The diversity of size and creative options make out-of-home eye-catching and inherently interesting.

Weaknesses

1. Limited Message. Consumers are on the go, so the message must be limited to no more than five to seven words.
2. Preservation. Ads are vulnerable to weather conditions, vandalism, dirt, and pollution that could damage brand image.
3. Location. High traffic locations are expensive.
4. Availability. Both outdoor and transit need to be reserved months in advance and often require lengthy commitments, making out-of-home a poor choice for short runs and time-sensitive advertisements.

Determining the Visual/Verbal Voice of Outdoor Ads

Outdoor boards, also known as *billboards,* can be found along any street or highway in America, directing commuters to local establishments and reminding them about (or perhaps even introducing them to) local business establishments, news teams, or events. Creatively, outdoor boards have come a long way over the past several decades, making them much more interesting to travelers and commuters. Talented creative teams have elevated outdoor boards from ugly blights upon the landscape to an art form. Key consumer benefits scream off of boards sporting bright colors, cut-outs, 3-D additions, and electronic movement. In pedestrian areas, some designs have added or dropped pieces down to the sidewalks below, helping to draw attention upward. Three-dimensional additions like those used by the chicken eatery Chick-fil-A

Figure 9.2 **Sample Ad: Ruby Tuesday**

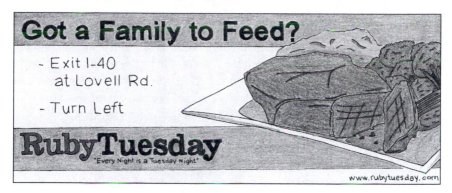

Source: Created by Brandon Tillman, The University of Tennessee, Knoxville.

are a creative, eye-catching curiosity device that can be continued in print, on a website, on television, or as part of an event. Additional attention can be gained by including an *extension,* where a part of the design extends beyond the main surface of the board by five and a half feet on top and/or two feet below and on either side.

Outdoor has to make a noticeable impression in six to eight seconds, when not located in a pedestrian area or by a stoplight. Brief messages must be memorable to be successful. With more size and design options available than ever before, this unusually shaped and verbally stunted vehicle should not be considered limiting to the creative team, but an imaginative and creative challenge.

Visible for quite a distance, billboards are an effective advertising device for an array of products or companies. Typically, large highway signs will measure 20 × 60 feet, while most boards placed within city limits measure 14 × 48 feet. Because advertisers can pick a specific location, outdoor can be a fairly targetable vehicle; however, high traffic areas have a cluttered visual arena. Designs that are clever, unique, or interactive will grab the viewer's attention and stand out from the surrounding visual/verbal noise.

Today, all outdoor boards are easy to change out and are made of tough nonfading material that can stand up to daily wear and tear. They cannot stand up to extreme weather conditions, vandalism, or extreme pollution, though, so they should be constantly monitored by the outdoor company for any necessary repairs.

No longer a painted surface, the majority of outdoor boards are digitally printed or silk screened onto vinyl, which can be secured by wrapping the vinyl around the board or gluing it into place. Boards may be opaque or translucent, and they are often illuminated externally by lights. These lights are mounted

on the front of the board or lit by a light box located between two translucent panels, allowing the image to be seen from both the front and the back.

Campaigns that use multiple boards placed in strategic locations along a main artery can display several different messages or repeat a single message for emphasis. Out-of-home as a whole is a great teaser vehicle for gradually increasing interest in a new product and keeping a brand or company name in the public eye. There are several types of outdoor boards, but the most popular today include vinyl, mechanical and digital LED, and wallscapes.

Vinyl Boards

Vinyl boards are the simplest and most common type of outdoor board. These no-nonsense boards point the way to local businesses and events. The focus is on who is doing the advertising, what they are promoting, and where they are located.

Mechanical Boards

A mechanical outdoor board uses three multi-message or tri-vision views that rotate continuously. Panels are triangular in shape, and as they turn, three different flat-surfaced ads are revealed. Each rotation lasts around five to ten seconds. Often illuminated, these boards make a memorable impression on the target. One board can deliver multiple messages for a single brand or a single ad for three entirely different brands.

A scrolling board is another type of mechanical board that can display up to 30 messages as it scrolls between images. Usually backlit on vinyl, these boards are easy to view both day and night. Mechanical boards are usually placed in heavily trafficked areas like transportation terminals and malls.

Digital LED Boards

Largely regarded as the boards of the future, digital LEDs can be changed with the click of a mouse and rotate every few seconds. Currently, several companies are working on technology that will allow the board to send messages—a coupon or, perhaps, a sales announcement—directly to motorists' cell phones as they pass by. Other boards are finding ways to be interactive, as well. Several years ago, one such board in Times Square advertised a phone number to cell-phone-carrying pedestrians, allowing them to play an interactive game with other viewers in real time up on the board.

Each of the technologically advanced boards is large and can be seen from long distances. However, for safety reasons, they are most often located in

high traffic areas where drivers must stop for lights, or routinely sit in traffic, or in areas with a heavy amount of pedestrian traffic.

Wall Murals or Wallscapes

Wallscapes are basically large outdoor boards that are hand painted on the sides of buildings or printed on vinyl and hung off the side of the building. These highly artistic and targeted murals usually feature bright colors, a bold image, and an eye-catching logo.

Transit's Visual/Verbal Message Gets Around

Transit advertising is any advertising that appears in or on buses, taxis, subway cars, commuter trains, ferries, transit stations, platforms, terminals, bus stops, or even on benches.

Transit is a great vehicle for reaching an audience of all ages, backgrounds, and incomes. Reach goes beyond riders to pedestrians, other drivers, and people at work who can see them from their office windows. It is a highly effective direct response vehicle and a great way to encourage immediate or impromptu purchases. The enormous range of shapes, sizes, and technological enhancements make transit advertising a very creative vehicle. Typical of all out-of-home vehicles, transit ads have limited space; therefore, images must be powerful and meaningful, colors must be bright, and messages must be short and sweet. The small amount of copy often limits the designer to showcasing no more than the key consumer benefit, a slogan or tagline, and the logo. Transit advertising's to-the-point message is an excellent reminder and great support vehicle, especially when teamed up with outdoor boards. Let's take a look at a few options.

Interior Cards

Some of these canvases are big, and some are small; however, all are limited in their capacity to deliver a detailed message. Interior cards found on buses, trains, or subway cars are not the most creative vehicles we will look at, but captive commuters have the time to read the message—repeatedly—on a daily basis. Many interior cards have a double-sided message that can be changed out regularly. Copy space is limited, although it is not unusual to see tear-off order forms or applications known as car-cards. Passengers can use these direct response cards to place an order, request additional information, or receive a discount on a product or a service. Interior cards come in a number of different framed sizes and are usually placed above the windows of mass transit vehicles.

Figure 9.3 **Sample Ad: Wasabi Steakhouse**

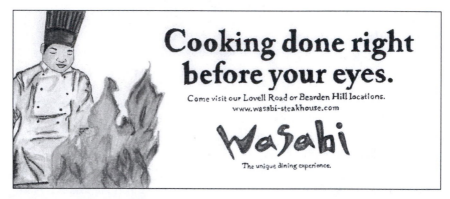

Source: Created by Madhuri Jagadish, The University of Tennessee, Knoxville.

These interior and bulkhead advertisements can range anywhere from 11 inches high by 24 inches wide to 30 inches high by 144 inches wide.

Exterior Transit Advertising

Companies that have something big to say use exterior bus, train, or car advertising to attract attention and improve brand awareness. These bold, colorful, weather-resistant designs can be airbrushed directly onto the vehicle or printed on self-adhesive vinyl, foam board, or corrugated plastic.

There are four basic kinds of bus advertising: king, queen, bus backs, and full bus wraps. King-size ads or posters are the most common. Used by both local and national brands, these designs can be placed on either the driver's side or the curb side of the bus and usually measure around 30 inches high by 144 inches wide. Smaller queen-size posters are usually placed on the curbside only and measure 30 inches high by 108 inches wide or 30 inches high by 96 inches wide.

Bus backs, as the name implies, are placed on the backside of a bus. These very popular, creative, "in your face" designs have become a special way to highlight a brand or cause. For example, the Dutch government launched a promotional awareness campaign for the Keep Holland Clean Foundation by placing a back wrap on city buses that replicated two sanitation workers clinging to either side of a garbage truck. The realistic-looking stickers were used to remind commuters not to leave their trash on the bus. To strengthen the visual, a bus with a raised backside was used to more closely resemble a garbage truck. The message worked: Litterbugs thought twice about leaving their trash on the bus.

Vehicle wraps are another form of exterior bus advertising. This type of wrap is a relatively new creative option introduced little more than a decade ago. As

the name suggests, a vehicle wrap takes a design and wraps it around a bus, car, or truck. A colorful, self-adhesive vinyl literally molds or wraps itself around the entire vehicle or part of a vehicle. Created digitally, these wraps are weather resistant, fade resistant, and can last up to a year. Memorable and relatively inexpensive, wraps are a great support vehicle for generating brand awareness and promoting local sports or news teams and charitable and cultural events.

Wraps often include a punctured window covering that allows passengers to see out but blocks commuters from seeing in. Bus ads are a very creative, unique, and attention-grabbing way to deliver a memorable message.

Transit Shelter Posters and Bench Advertising

A great way to extend the creative message used in or on buses is to extend it to bus shelters and/or benches. Transit shelter posters consist of two identical ads placed back-to-back with a light box in between. These ads can display the same images used on other transit vehicles to reinforce the message, or they might continue an ongoing theme begun elsewhere in the campaign. The posters are usually four-color and measure around 4 x 6 feet.

The newest form of shelter ads are interactive. In Chicago, Kraft's Stove Top Stuffing Mix attracted commuter attention by pumping heat into ten local bus shelters to simulate the warmth of a home-cooked meal. The goal: to conjure up that warm, fuzzy feeling Stove Top delivers to hungry consumers. This form of guerrilla marketing—known as *experiential marketing*—is a way to encourage consumers to interact with a brand, and deliver a soft sell experience rather than the traditional hard sell commercial pitch. Not devoid of a traditional advertising pitch altogether, each shelter had a poster that read, "Cold provided by winter. Warmth provided by Stove Top." Additional campaign components included placing another 40 posters in unheated shelters and using a street team to hand out samples to passing pedestrians.

This multi-sensory type of advertising is difficult to ignore, because consumers experience the message rather than just seeing or hearing it. It is nondisruptive, and something tangible that consumers can look forward to on those often long, cold waits for public transportation.

Taxi Advertising

Taxi advertising can be bold, understated, or technologically driven no matter where it appears. Exterior taxi advertising can appear on roofs, trunks, windows, and as traditional wraps or the more unusual three-dimensional wraps. Advertising can even appear on the roof of a vehicle in the form of illuminated two-sided panels. These constantly moving canvases have a broad reach.

When fitted with a GPS system, taxi advertising can change out (depending on where the taxi stops) to highlight shopping or restaurants in the area, making it a great way for local advertisers to promote their message close to their place of business. Like other forms of out-of-home, taxi advertising is most effective when used as a support vehicle. Branding, reminder, and promotional advertising are the most effective forms of taxi advertising.

Terminal Advertising

These large, usually colorful and illuminated posters are a great way to extend a message to travelers waiting for a ride. Used by both locally and nationally advertised brands, their job is to remind travelers about gifts and food or travel options located near the station or terminal. Terminal posters are often coordinated to match advertising found inside or outside on local transport.

Kiosks are another great way to draw attention to a brand. They are usually four-sided, free-standing glass cases located outside businesses and in various terminals, and they provide the chance to actually show the brand, not just talk about it.

Bench advertising need not be limited to bus stops; it can be used on park benches, on boardwalks, at shopping malls, in restaurants, or in airport terminals. Bench signs are one of the fastest growing types of out-of-home advertising because they appear in pedestrian-heavy locations. These highly targetable, low-cost vehicles offer colorful imaging that is visible 24 hours a day.

Digital Mobile Outdoor Boards

Digitally activated outdoor boards move along with commuters in traffic. Often placed on the side of panel or semi-trailer trucks, the designs on these mobile boards may be stationary or digitally scroll or rotate several messages in the same way digital outdoor boards do.

A digital mobile ad is an excellent way to deliver a targeted message based on the prescribed route of the truck on which it is mounted, or it may be used as a promotional tool for mass-marketed brands. Moving displays change every eight seconds and can appear on both sides and on the back of the vehicle. The message may be constant or can vary with up to nine different visual/verbal options. Mobile outdoor boards are great for product launches, event promotions, and raising brand awareness.

Kiosks can also go mobile: More extravagant 3-D kiosks can be placed on flatbed trucks and driven around town or placed outside movie premieres, local festivals, concerts, sporting events, and other venues likely to draw eager shoppers.

10

Direct Marketing

Figure 10.1 **Sample Ad: Ray-Ban**

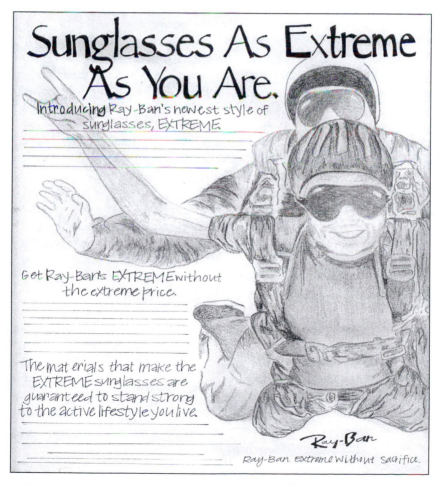

Source: Created by Nikki Reynolds, The University of Tennessee, Knoxville.

Direct Marketing Personalizes an IMC Campaign

Direct marketing is both a promotional vehicle and a direct response vehicle. A *promotional device* offers an incentive to make a quick sale as opposed to advertising that educates and entertains to make a sale. For direct marketing to work, it must induce a *direct response*—such as encouraging the target to make a call, visit a website for more information, or make a purchase. This very personalized approach initiates one-on-one contact with the intended audience.

Being able to address the target by name and personalize a message that directly addresses their self-interests are direct marketing's strongest benefits. The ability to connect with the target encourages an informative, relationship-building, two-way dialogue between buyer and seller.

Direct marketing has flourished over the last several decades, making it a successful choice for use in an IMC campaign. Product quality, the easy use of credit cards, the Internet, toll-free numbers, top-of-the-line customer and technical service teams, 100 percent guarantees, and easy return policies make buying what cannot be touched before purchase less of a risk.

Today's messages must do more than cleverly entertain (passive); they must get the consumer involved in the message by asking them to do something (active). Direct marketing turns a passive message into an active discussion by finding ways to interact and develop a two-way dialogue between buyer and seller. To further encourage purchase, many direct response offers include an additional promotional incentive to induce the target to "act now." Incentives range from free gifts and upgrades to two-for-one or limited-time offers to the exclusive chance of being the "first to own" a new item. Once a relationship is forged, other contact opportunities might include personal selling, catalogs, direct mail, websites, e-mail, trade shows, seminars, telemarketing, or any other one-on-one interactive communication technique.

Whenever advertising and/or promotional efforts are used alone or together, the goal is to make a sale. But not all sales are meant to be immediate. When used as a member of an IMC campaign, direct marketing's job may be limited to eliciting a response, creating excitement, provoking curiosity, or encouraging additional information gathering, especially if the brand is an expensive one.

Direct marketing is also a great way to launch an IMC campaign when used as an announcement or teaser device. It is very effective at building or generating interest in, say, a grand opening, a charity function, or a private sale. As a support vehicle, it functions well as a reminder, supplying promotional offers or samples, and making information gathering or purchase quick and easy.

Direct marketing campaigns must be measurable, correctly targeted, and promote a consistently reliable product or service. As a promotional vehicle, direct marketing is successful because it can talk directly to the target, in a language they will understand, about a product or service that will enhance their lives. When combined with the appropriate promotional mix, it can position a product, build both image and brand awareness, and encourage brand loyalty more efficiently and effectively than almost any other campaign approach.

The more that is known about the target's lifestyle, the more personalized the message and the easier it is to talk to the target about a brand's specific features and benefits, and how they relate to their interests. This type of intimate approach strengthens the tie between the target and the brand and is the first step to building a lasting brand-loyal consumer.

Personalized messages have earned direct marketing the moniker *database marketing,* because its success relies on a detailed list of customer names and contact information to reach the intended target. A simple database stores demographic information such as names, addresses, phone numbers, and e-mail addresses. A more comprehensive database uses psychographic information to hone in on targets' likes, dislikes, interests, hobbies, and so on; identify those most likely to purchase; and determine who has purchased in the past. Geographic information is used to determine location, use, and time of year the target will use the brand. Databases also help in identifying prospects, deciding on the type of offer needed, and encouraging repeat purchase. Generally, information is gathered from sources such as a company's own past purchase history, magazine subscription lists, the U.S. Census Bureau, warranty and rebate cards, credit card purchases, UPC scanners at the grocery store, any professional organizations the target is affiliated with, and varied corporate interactions such as inquiries for additional information.

How companies use consumers' private information is an ongoing concern. Consumers are reacting to fears about identity theft, spam, and intrusive phone calls by pressuring the federal government to tighten regulations on how companies deal with the selling of database lists. In the meantime, consumers are fighting back by joining "do not call" lists, buying subscriptions from companies that protect against identity theft such as LifeLock, and using software to block nuisance e-mails.

More and more companies feel the need to assure their patrons that consumer information will not be sold to outside businesses. Although more time-consuming, many companies are building their lists from within rather than buying outside lists; this is best accomplished by encouraging consumers to join reward programs or "opt in" to e-mail promotions. Those who do opt in to receive information are receptive to the message, making direct marketing a great primary or secondary campaign vehicle.

Traditional Advertising and Direct Response

Traditional advertising is intrusive; the message arrives uninvited to a disinterested, distracted target. Promotional database–driven vehicles like direct marketing deal with one customer at a time, usually addressing them by name, whereas traditional advertising vehicles talk to the masses about a generic problem. Although traditional advertising's reach is greater, its generic message does not always reach the intended target. Jaded, inattentive audiences do not react to a generic message as quickly as they do to a personalized, lifestyle-directed one. Traditional vehicles are employing more and more direct marketing tactics by encouraging consumers to do something, such as visit a website, enter a contest or sweepstakes, receive free samples, or sign up to receive future promotional offers.

In order for a traditionally advertised message to be remembered, it must be seen repeatedly before the target is aware of the message and acts upon it. Direct response actively involves the target with a pointed message that encourages immediate action through limited time offers or attractive incentives that encourage them to "act now" (before the commercial ends) or within a preset time limit.

It is relatively easy to determine return on investment and keep track of direct marketing's success because it is trackable. Unlike advertising, direct marketing asks the target to do something—place an order or fill out a rebate form—which allows marketers to track who responded and pinpoint where the target was exposed to the message. Consumers can inform customer service representatives where they encountered the message by giving them a marketing code (a combination of letters and numbers that appear on coupons, catalogs, and direct mail packages). This type of information helps media buyers track the success of their media buys.

Creating a one-on-one dialogue is more expensive than a singularly delivered monologue. Traditional advertising vehicles often fall victim to wasted exposure, whereas direct marketing, a more expensive option, employs less media waste. It concentrates a personalized message on a smaller number of consumers that, through research and past purchase history, have been identified as the most likely people to buy the product or use the service.

Although the response rate is often less than 2 percent, direct marketing is more effective at reaching the target with a message they are interested in than any other mass-market vehicle.

Direct marketing has a lot to say, so use it to announce a new product or event, encourage trial, or promote the relaunch of a mature product. Each of these promotional tactics offers great opportunities to attach a sample, build a relationship, and learn more about targets' needs and wants.

Understanding Direct Marketing's Strengths and Weaknesses

The versatility of IMC's voice requires a thorough understanding of what each vehicle brings to the campaign. Before we look at the diverse creative pieces that make up direct marketing, let's take a quick look at its strengths and weaknesses.

Strengths

1. Personalization. Personal information allows marketers to address the target by name and tie the message directly to his or her lifestyle.
2. Immediate Results. Toll-free numbers and website access encourage immediate purchase.
3. One-on-One Assistance. The target can reach a company representative 24/7 to answer questions or assist with a purchase. This relationship-building, one-on-one contact encourages repeat purchases and brand loyalty.
4. Interactive and Engaging. Creative writing, bright colors, testimonials, streaming video, entertaining games, scratch-offs, and samples keep the target interacting with the pieces longer or engaged in the message for an extended period of time.

Weaknesses

1. Expense. Personalized messages are expensive—even more so if a company needs to purchase a list of names rather than generating its own.
2. Junk Messages. If it interrupts programming or arrives unsolicited, it is often looked upon unfavorably.
3. Reach. One-on-one marketing limits the number of consumers the message will reach.
4. Production Time. Depending on the piece and medium used, direct marketing can be very time-consuming to produce.
5. Privacy. The unauthorized selling of consumer information is a major concern.

The Visual/Verbal Voice of Direct Marketing

Some of the more popular types of direct marketing include catalogs; direct mail; brochures; statement stuffers, magalogs, and polypaks; reward programs; and interactive television. Let's take a quick look at each one.

Figure 10.2 **Sample Ad: PetSmart**

Source: Created by Jessica Kelly, The University of Tennessee, Knoxville.

Catalogs

Catalogs can be divided into two separate categories: those selling general merchandise such as JCPenney or Sears, and those devoted to specialty goods such as Pottery Barn or Crate&Barrel. So successful are these colorful opt-in sales pieces that they create desire for a product or service. If that's so, then it is important to dazzle the target with beautiful visuals that feature the product up-close and personal.

Colors, typeface, and image quality should match the target's self-image and the product's projected image. Products should be shown alone and in four-color when possible, surrounded only by a small amount of copy featuring a descriptive head and accompanying body copy and price. Informative

body copy can detail copy points and tie the product's benefits to the target's lifestyle. Like print design, featured products should be the largest visual on the page to attract attention and encourage sales. Readers typically look first at the top right of the page, then move to the top left, so it is important to place featured products near these areas.

Catalogs, like all media vehicles, should attempt to sell more than just one featured item. Consider placing items that can be used together near the main visual to encourage companion sales. Be sure to use generous amounts of white space around items to keep the page from looking cluttered. Keeping type sizes, leading, and placement around images consistent will also create a sense of organization. Do not let type overwhelm the image; in catalog design, the image is what stops attention, not the headline or copy.

Make purchasing quick and easy by offering several ways to place an order. Options might include an order form, a toll-free phone or fax number, and/or a web address.

Catalogs can be broken down into four basic elements: the front cover, the inside front, the internal or midsection, and the back cover. The front cover should feature two or three featured products along with the logo and volume number. This is the catalog's biggest chance to make a first impression, so be sure to keep this area as simple, focused, and representative of image and content as possible.

The inside front cover typically features a table of contents, primary contact information, and perhaps a letter from the editor. It is also the first view of how products will be featured throughout the catalog. The center sections are organized into themes; for instance, a home décor catalog would have sections on outdoor furniture, kitchenware, living room furniture, dining accessories, and so on. Order forms are usually placed in the center section. The back cover includes the logo and mailing panel, as well as any additional featured items.

Direct Mail

Basically, direct mail is defined as the sending of a sales device, an announcement, a promotional device, or a service reminder through the mail to predetermined individuals. Today, direct mail is more than just a letter and an order form; it is an interactive introduction to the product or service. It is not unusual to see direct mail paired with direct response television, the web, or e-mail.

Direct mail—also referred to as *junk mail* because it often arrives without the recipients' consent—does not have to live up to its name. A direct mail package can take on a variety of shapes and sizes and contain an array of

visual and verbal pieces. Most pieces are simple promotional devices, but others can include three-dimensional pop-ups and pieces that make noise or have multiple moving parts. Still others might include some type of sample, relying on the envelope's lumps and bumps to prompt the target to open it. Each piece should keep the target's curiosity alive by adding and building on what has been previously stated.

There is no set rule as to the number of pieces a direct mail package must contain, but most standard packages will include at least an outer envelope, a personalized sales letter, a colorful informative brochure, a price list or menu, a postcard or business reply card, an order form, and a prepaid return envelope. Each piece must work together to create a cohesive visual/verbal design that compliments and reflects the message used on other pieces within the IMC campaign.

If creating a multipiece packet, consider color coding each piece, offering the target a kaleidoscope of colorful ideas and offers. Multiple pieces will reflect the same key consumer benefit, headline and typestyle, color(s), character representative and spokesperson, and (when possible) layout style. What is included in the package will depend on what the reader needs to do, such as place an order, make a donation, register for an event, or make an appointment.

To hold the target's interest longer, consider including some type of interactive device—perhaps a scratch-off card, coupons, samples, CDs, game pieces, pop ups, or some other unusual component. The only requirement is that each piece must fit into an envelope or be self-contained in some kind of self-mailer.

Direct mail's personalized approach and multiple pieces make it more expensive than most printed pieces in the media mix. However, its very exclusivity makes it a great vehicle for rewarding brand-loyal users, making an announcement, or launching or maintaining a brand's image. For those consumers not currently using the product or service, it is a great way to personally deliver some type of enticement—a coupon or free sample, perhaps—to get the consumer to try the product for the first time or to switch brands.

Do not under estimate the power of direct mail to persuade and make a memorable statement. A quality design, a targeted message, and one or more interactive pieces can turn junk mail into a creatively designed, informative jewel.

When used with public relations, the arrival of direct mail singles out the target for special attention. When paired with traditional advertising, it can build curiosity by announcing its imminent arrival or availability. E-mail is a great reminder vehicle, and a website can offer the target an alternative way to find out additional information, speak to a customer service representative, or participate in a blog discussion. Alternative media or guerrilla marketing events, for example, can make the direct mail piece interactive if used as an invitation to a special event or a ticket for a free gift.

Let's take a look at some of the more common creative devices used in direct mail.

Outside Envelope

Curiosity starts with the outer envelope. Make it as interesting as anything found inside. Give it a bright color, unusual shapes, distinctive images and/ or an attention-grabbing creative piece of teaser copy that reflect the key consumer benefit, the logo, and the slogan or tagline.

Whether the consumer asked for the direct mail package or it arrived unsolicited, it must be attractive, interesting, and intriguing enough to encourage the target to open it immediately. Be sure the visual/verbal design on the envelope mimics what is being said and seen in other pieces used inside the package. Entice on the envelope—do not educate at this point—and fill the package with some type of lumpy sample so even touch induces curiosity.

Interactive Devices

The best promotional devices intrigue and engage the target. The more interactive they are, the more time the target will spend with the piece before possibly tossing it. Big budgets or campaigns whose entire budget is tied up with direct mail should consider using some type of interactive device that is retainable and features the company or product's logo. If it can recite the message when opened, great: It has their attention. If it can be folded like a piece of origami, then it's memorable. If it can be used repeatedly, like a pen or calendar, it is constantly top of mind. If it has movable pieces that can be opened, closed, or pulled to reveal different parts of the message at a time, it's engaging. More inexpensive options include entry forms for a contest or sweepstakes; invitations to open houses, private sales, or events; and/or a scratch-off card. Interactive devices are also a great way to encourage word of mouth as the target displays or uses it at work or home.

It is important to remember that whatever the promotional device used, it can only support a sale, not make it. In the end, a clever interactive promotional piece needs an equally strong visual/verbal message to make the sale.

The Letter

Once the envelope has encouraged the target to open the direct mail package, it is important for it to include a strong, personalized letter. Usually written

by the president or CEO, it needs to clearly identify the speaker and inform the target about the promotion.

The purpose of the letter is to whet the target's appetite for additional information in a creative but educational way. The more the letter sounds like it is talking to an old friend by inserting anecdotes, possible uses, and inevitable outcomes, the better. As a rule, lower-priced items can use a more informal tone, whereas more expensive items should be more formal.

The middle paragraphs of the letter have a lot to say. Consider using an intriguing plot or benefit-driven storyline taken from other campaign pieces, which features the target as the main character and the key consumer benefit as the hero of the story. Interesting copy, even if it is long, will be read if it engages the reader's curiosity, fulfills a need, and entertains.

Asking the target to buy something sight unseen will likely promote a degree of skepticism. If, however, your letter provides information on the who, what, when, where, why, and how of your sales pitch, that skepticism will be cut in half. Boring facts do not sell and do not hold anyone's interest. Facts tied to interests and related to the target's lifestyle will enhance the copy's believability. It is important for direct mail copy to involve the reader in believable scenarios and outcomes that can be backed up with testimonials, endorsements, or some type of reliable study.

Copy should reference each piece found in the mailer, explaining its importance, uses, and so on. Remind the reader how much time they have to purchase, call, or come in before the offer expires. Short deadlines often encourage immediate action. Be sure the storyline includes as many product features as possible, including colors, sizes, manufacturing and design details, price, and ordering options.

The letter's closing paragraph should be a call to action so the reader knows what to do or how to get to the next step. Give the target as many options as possible, such as a toll-free or fax number, a web or e-mail address, and local addresses and phone numbers if the action requires a trip to a brick-and-mortar location. Be sure to include payment options and information on returns, guarantees, or warranties.

Whether the brand is expensive or not, keep the copy organized and clean. Use only three different type sizes—one for the headline, another for any subheads, and the last for the body copy; any more than that can look tacky. Depending on the strategy, price is usually prominently displayed in direct mail, so place it in the headline, the subhead, or in a callout box if more than one price exists. Use the headline to announce the key consumer benefit, multiple subheads to break up long copy, and images to visually show a solution or demonstrate a use. Try to maximize white space to increase readability and legibility. Consider using bullets to highlight important copy points rather

than discussing them in long blocks of copy. Be sure tone of voice, color(s), and headline and typestyles consistently match those used in the rest of the campaign's vehicles.

Brochures

A brochure is a colorful, informative, multipage promotional piece that comes in a wide variety of shapes and sizes. It is a great support vehicle for the primary advertisements used in the campaign and a credible way to deliver important information directly into the hands of the target. Brochures are most effective when used to break down individual aspects associated with a particular product or service. If the brand is multidimensional, consider using multiple brochures to explain each concept, or develop individualized inserts that can be customized to each target's needs.

The beauty of a brochure is its engaging look, often featuring colorful visuals, unusual folds, die cuts, and varying sizes. These usually copy-heavy vehicles should actively engage the reader by slowly unfolding the plot, or important information, as the brochure unfolds. A brochure's job is to educate the consumer with facts that can be backed up with testimonials, the results of solid scientific studies, and useful information such as pricing or a schedule of events, depending on its role in the campaign. Brochures can be broken down into four separate areas: the front cover, the back cover, the inside front left and right panels, and the inside flat.

The appeal of the front cover is important: It should be colorful, pleasing to the eye, and relevant in what it says and shows. A brochure has about three seconds to attract the target's attention. Depending on the key consumer benefit, strategy, and target, the front cover can use an enticing visual, a visual and verbal combination, or nothing more than the company name, logo, and slogan or tagline.

The back cover is the least likely to be read, so it is usually the best location to place any contact information such as phone, fax, address, and website URL. If space is at a premium, place any pricing and/or dates and times on the back, as well.

The inside left and right panels are the most read panels, so make each word count. Focus on highlighting the key consumer benefit, along with need, use, and lifestyle enhancement points.

The inside flat refers to the inside of the brochure when it is opened up and read flat. Continue the storyline here and spice it up with images, bars and/ or boxes, or graphs. Strong photographs, illustrations, or graphics command attention and can say more than a thousand words: Use them to enhance and illustrate the story, and do not forget the all-important "call to action." Text

should use short sentences and multiple short paragraphs. Multiple subheads should make it easy for the reader to grasp the main points at a glance.

While most brochures used in direct mailers are mass-produced, others can be individualized. These types of designs use a mass-produced shell that features one or more pockets on the inside, where single panel inserts can be individually changed or rotated out to meet the target's specific needs. These inserts are a great idea if the copy can be divided into individualized units that can be mixed and matched as needed. Think of each insert as a separate selling idea or ad. To deliver the message effectively, each insert needs to include at least a headline, subhead, and body copy. More elaborate designs may also include one or more visuals. Be sure to match the layout style, type size and style, placement of the logo, visuals, or any other graphic device between inserts.

If not using individualized inserts, pockets can still be used to hold game pieces, tickets, the direct mail letter, or contact information; as a more expensive alternative, emboss, deboss, or foil stamp the logo onto the inside pocket or front cover.

When used in a direct mail packet, be sure the brochure uses the same tone of voice, colors, and typeface as the letter and/or postcard. A brochure is an excellent way to visually showcase in beautiful four-color detail any copy points introduced in the letter. If the budget is tight, consider adding color by using a colored paper stock. Paper is very diverse, offering an array of colors, textures, and weights. Instead of four-color visuals, a duotone or spot color might work well. A well-designed piece doesn't need a lot of bells and whistles, just a solid creative idea.

Creativity in brochure design goes beyond the visual/verbal message. It is also about shape, size, and the number of folds required to deliver the information. Brochures are a great interactive device when cut or folded in interesting ways. The eye is attracted to unusual shapes, so if the budget allows, cut, shape, or trim the brochure in an interesting way. Designs that employ the use of *die cuts,* or a special cutting method that can partially or completely cut out or around a specially designed shape, are an expensive but attention-grabbing option. Simple straight or diagonal cuts used on the front cover, for example, are a great way to expose a visual or headline from the inside panels. The most commonly seen die cuts are the slits placed on a pocket or outside panel to hold a business card or other removable piece.

Fold It Up

How the visual/verbal message is viewed, read, and interpreted is linked directly to how the brochure is folded. The size, number, and type of fold(s)

Figure 10.3 **Sample Ad: Yankee Candle**

Source: Created by Jared Thigpen, The University of Tennessee, Knoxville.

will depend on how much needs to be seen and shown at any one time. There are seven basic types of folds, including accordions, basics, exotics, gates, posters or maps, parallels, and barrels or roll folds. Let's take a quick look at each one.

- Accordion. An accordion fold features a zigzag or back and forth type of fold, allowing for an unlimited amount of panels.
- Basic. As the name implies, the basic fold is a simple single fold.
- Exotics. These inventive and often expensive folds will commonly feature three-dimensional designs or even origami. Their unique and creative designs are sure to be memorable and lingered over.

- Gates. A brochure gatefold works the same way as folds used in magazines. A gate features a center panel sporting two or more panels that fold toward the center from both the left and right sides. Often symmetrical, a more expressive option is to feature an asymmetrical design that folds on only one side. Again, as long as you can justify it—and you have the budget for it—anything goes.
- Poster or Map. This type of fold is for large pieces. Typically, the brochure will use accordion folds that have been folded in half, thirds, or quarters and open up into a large flat area. Great for maps, games, or posters.
- Parallel. Parallel folds boast multiple folds that nest together.
- Barrel or Roll. A barrel or roll fold requires four or more panels that roll in on each other. For this to work, each panel needs to become incrementally smaller to avoid wrinkling when closed. In order for it to nest properly, the fold-in panel must be a sixteenth to an eighth of an inch shorter than the main or bottom panels.

Reply Cards and Order Forms

A reply card is usually smaller than anything else in the kit, so it must be easy to find. Consider making it a bright or unusual color, or attaching it to the brochure with perforations, making it easy to tear off and drop in the mail. The front needs to have a place for the target's name, complete address, day and evening phone numbers, and an e-mail address. If the consumer needs to make some kind of decision, be sure there is a box to check or a line to write on. Also be sure to repeat payment options and contact information. The back must have a return address and a prepaid postage stamp. Although the likelihood of people actually dropping a reply card in the mail is quite low, it can serve as a great worksheet before calling to make a purchase or ask a question. It is important that all information needed to make a purchase, receive a free sample, or request additional information be available and easy to use and read.

Return Envelope

The return envelope is one of the most expensive pieces to print. Because people are using traditional mail less often to contact a business, many packages are eliminating them all together. If it is included, keep it plain and simple and be sure to include a complete mailing address, the required postage bar codes, and a prepaid postage stamp. It is important a one-sided reply card or order form fit in the accompanying envelope easily.

Direct mail is only "junk" if it is poorly written and designed. An inventive, engaging approach can be cleverly written and unusually designed enough to entice the reader through the entire package.

Do not scrimp on printing; use bright colors and graphics when possible. Use the envelope to grab the target's attention, or if using a self-mailing piece, be sure it is die cut or cut into an unusual but relevant shape. The more visual the piece, the longer it will hold the target's attention. Always be sure the key consumer benefit is the first thing seen, and push that idea throughout the copy. Use testimonials to validate claims and make the product easy to return. Be sure each piece in the packet or package is relatable and easily leads the reader from piece to piece. If the target does not need a piece to make a choice, leave it out. Every image and color used should help set the tone and sell the product or service.

In the end, direct mail has a lot to say and—unlike most advertising vehicles—a lot of space and time in which to say it. Use each piece to highlight features and benefits, uses, prices, and solutions to specific problems.

Stuffers, Magalogs, and Polypaks

If your advertising budget is tight, consider using statement stuffers, magalogs, or polypaks to get the message out.

Statement stuffers accompany invoices, statements, or other correspondence regularly mailed by businesses and are a great way to market additional products to the customer. Stuffers usually contain a brief message and either a short-form application, web address, or toll-free number. Statement stuffers usually measure around $3\frac{1}{4} \times 6$ inches; they need to fit easily into a standard statement envelope without any type of folding or special handling. Stuffers can be used to announce new product information without incurring additional postage costs.

A magalog (magazine/catalog) is basically a multipage mail order catalog that looks like a magazine and includes both editorial material and diversified advertising.

Polypaks are a small bundle of 3×5 inch index cards that feature advertising for an array of noncompeting products. Usually arriving by mail, they are used to introduce products or to generate interest in mature products. These simple designs are typically four-color and double sided. The small size keeps information to no more than a short message, a visual, and an order form, phone number, or web address. For ease of use, the back will often include a self-mailer.

Reward Programs

Customer loyalty is fragile in the best of times. Reward programs extend customer service initiatives beyond purchase by rewarding the targets' continued patronage with additional incentives such as:

1. Priority service.
2. Follow-up programs after purchase (for example, thank you cards and e-mails).
3. New product previews, which offer an exclusive peek at a new product. Give loyal customers an opportunity to be the "first to own" before the product is launched to the general public.
4. Incentives to assist with purchase (for example, coupons or a reduced price).

Reward programs such as frequent flyer promotions often begin with one vender rewarding a customer for using a service or buying a product. These single vender offers commonly evolve into multi-vender programs or cooperatives that offer even greater incentives such as vacation packages with reduced rates at hotels and resorts.

Enrolling in a reward program requires the target to opt in voluntarily, so signing up and accumulating points should be simple and easy. Difficult to use redemption programs and policies that are constantly being reinvented damage both brand loyalty and brand image. Reward programs are an extension of a successful brand maintenance program. Any misunderstandings should be rectified using one or more of the following damage control options:

1. Offer a quick and sincere apology.
2. Offer several solutions to solve the target's problem.
3. Once the solution is identified, fix it immediately.
4. Offer some kind of incentive on the buyer's next purchase.
5. Follow up.
6. Remember: The cost to fix the problem is less expensive than replacing the offended consumer.

Interactive Television

The newest form of televised direct response is known as interactive television. If viewers like the products they see during their favorite programming, they can order what the characters are wearing or using right off the television screen, using their keyboards or remote controls to click on the link provided.

With a few keystrokes or punches, they can make a purchase or be taken to a website for more information.

Thanks to the World Wide Web, direct response can be expanded to include videoblogs, podcasts, and social media sites such as Twitter, YouTube, and Facebook.

The greatest assets of direct marketing in an IMC campaign are that it's personalized, convenient, free of hassles, and easy to use. It is also one of the best vehicles for breaking through product parity; product differentiation can be created by developing long-term relationships built around reliable, quality products and courteous and knowledgeable customer and technical service personnel.

11

Sales Promotion

Figure 11.1 **Sample Ad: Advil**

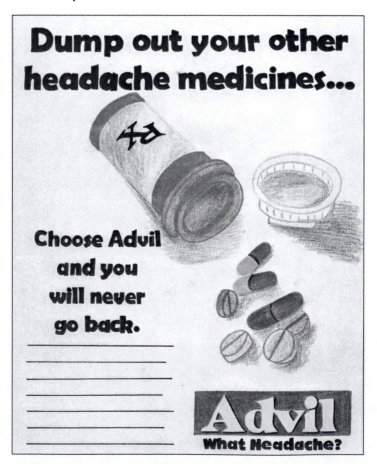

Source: Created by Carly Reed, The University of Tennessee, Knoxville.

The Incentive to Use Sales Promotion in an IMC Campaign

The AMA (resource library at marketingpower.com) defines *sales promotion* as "media and nonmedia marketing pressure applied for a predetermined limited period of time in order to stimulate trial, increase consumer demand, or improve product quality."

Sales promotion gives the target an incentive or gift in exchange for loyalty or trial. The goal of sales promotion is to immediately increase sales for the short term; this is achieved by either reducing the price of a product or service or giving the target an added incentive for the same price.

Sales promotion uses an assortment of limited time offers to persuade consumers to make a purchase. The most common types of incentives include coupons, samples, contests and sweepstakes, point of purchase displays, price off deals, rebates, bonus packs, and premiums. Incentives are most often used to encourage impulse buys or a first time purchase, or to lure consumers away from competing brands.

Promotions are often associated with traditional advertising, direct marketing, the Internet, and mobile advertising. The major difference between advertising vehicles and sales promotion is that advertising is informative and uses both a visual and verbal approach to show and tell the brand's key consumer benefit. Promotional efforts, on the other hand, engage the target in an activity—anything from downloading coupons to participating in a taste test or getting a two-for-one offer—to encourage purchase. Used together, one is a great educational device, while the other gives a hands-on view of how the product or service performs.

All of the advertising and promotional vehicles we have looked at so far deliver the message to the target. Sales promotion is less concerned with the message and more concerned with bringing the target to the product through an engaging and interactive device.

Even though sales promotion has little to say on its own, it is important the incentive offered reflects both the product and target's self-image. Logos, slogans, and taglines should be displayed prominently. Any printed incentives should reflect the color(s), typeface, and style used throughout the IMC campaign. If using a spokesperson or character representative, be sure to include them as a part of the promotional look and voice, when possible.

The increasing popularity of sales promotion can be traced directly to the slumping economy and product parity in almost all consumer goods categories. When the economy is doing well, the use of incentives goes down. When the economy is slow or weak, sales promotion efforts pick up. The lack of differentiation between products makes it difficult for consumers to distinguish between brands, causing many purchases to be dictated by price

or promotional efforts alone. To attract attention, disrupt competitor sales, and immediately increase revenue, businesses are relying more and more on sales promotion efforts to make their voices stand out from the crowd. Those brands that have a unique and effectively diverse brand image require little or no promotional effort to increase sales.

Getting the product into the hands of the target is one thing; getting them to repurchase without the use of an incentive is another. Sales promotion cannot improve on a bad product, hide product defects, overcome poorly executed advertising, or reinvent the popularity of an aging brand. It can only enhance a brand's value temporarily, not save it altogether. If the coupon, trial, or premium successfully gets consumers to make a purchase, the product must do the rest in order to make them repeat buyers.

On the down side, the repeated use of promotional efforts can hurt brand loyalty, erode brand equity, and diminish brand image. Consumers used to repeated incentives will often hold off on a purchase until the next promotion comes along. These types of users, known as *brand switchers,* are the most likely to switch from a currently used brand to a new one. Alternatively, those already loyal to a brand will not be swayed by incentives of any kind. However, it is not unusual for even brand-loyal consumers to wait for the next promotion to purchase or stock up. Another point to consider is the large amount of incentives that go to waste. Although over 90 percent of all household use coupons, only a small fraction, or less than 1 percent, are ever redeemed.

Making Sales Promotion Work Within the Campaign

What does it take to put together a successful promotion? Consider the following:

1. Bring the media to an open house or hand out samples of the product to a heavily attended event.
2. Drop off flyers, business cards, or postcards around the area; or post them on car windshields; or use street teams to deliver them outside a business.
3. Place posters on poles or in windows near the business, but be sure the location and type of product is clearly visible.
4. Place magnetic signs with the company's name, address, and phone number on the side of employee cars or business vehicles.
5. Make sure business cards, signage, packaging, and so on all reflect the brand image.
6. Print up some brochures or use the promotional car flyers and ask nearby businesses to display them at checkout counters.

7. Create a direct mail package that can be distributed to interested targets.
8. Set up a website and display its URL prominently on all advertising materials.
9. Churn up free publicity by sending out a press release to the local media to solicit a story.

Sales promotion is important to an IMC campaign because it creates dialogue and encourages awareness, trial, repeat purchase, and loyalty. It is great for reigniting interest in a mature brand, temporarily highlighting a new brand, encouraging brand switching or repeat purchase, and reinforcing existing advertising. All types of sales promotion should increase brand interest, be engaging, and require some kind of interaction between the brand and the target.

When used in an IMC campaign, sales promotion draws attention to and/or supports other messages used in the campaign. The choice of promotion depends on the life cycle stage of the product or service, as well as how it can be matched to the brand's image and the key consumer benefit. New product launches for rationally purchased products might use sampling, bonus packs, coupons, games, or contests and sweepstakes to encourage trial. Expensive, emotionally-based purchases are not likely to engage in any type of promotion outside of sponsored events. Maintenance stage products might employ the use of games or contests and sweepstakes, if any promotional efforts are used at all. Reinvented or mature brands rely heavily on sales promotion to encourage retrial through coupons, bonus packs, premiums, sampling or demonstrations, point of purchase (POP), specialty packaging, and—if it's a high-end purchase—rebates.

Since most promotions are good for only a short amount of time, many marketers are finding ways to reward longtime consumers by developing on-going loyalty or rewards programs; examples include frequent flyer rewards or the accumulation of points for a free night's hotel stay.

Understanding Sales Promotion's Strengths and Weaknesses

The versatility of IMC's voice requires a thorough understanding of what each vehicle brings to the campaign. Let's take a look at the strengths and weaknesses of sales promotion.

Strengths

1. Stimulate Sales. Sales promotion can immediately increase sales and generate income, but only on a short-term basis.

2. Interactive. Incentives ask the consumer to do something more than purchase, such as redeem a coupon, attend a sponsored event, try a companion product, fill out a rebate form, or enter a contest.
3. Trial. Promotions encourage consumers to try the brand at the point of purchase. Loyal users will stock up, and consumers loyal to the competition might consider switching brands.

Weaknesses

1. Sales Drops. The temporary increase in sales will immediately drop or return to pre-promotional levels once the sales promotion event has run its course.
2. Depleted Brand Image. Too many promotions may damage a brand's image.
3. Waste. Many incentives go unused.
4. Expense. An expensive undertaking, sales promotion may not reach the target in large numbers. Depending on the promotion, overhead can be costly.

Let's take a brief look at some of the more popular types of sales promotion.

Coupons

Coupons are great interactive devices; they bring the target to the brand and initiate a dialogue about the product or service. One of the most-used forms of sales promotion, coupons offer consumers a savings or other type of incentive on a specified product for a limited time. They are a great way to increase revenue temporarily by offering the target something in return for their purchase, or as an introduction to a new product or service. Since they have to be collected and then presented at the time of purchase, they are a great interactive device.

Coupons can take many forms, including freestanding inserts, bounce-back or on-package offers, grocery receipt backs, direct mail offers, displays, and polypaks, to name just a few. Offers can include cents or percentages off or buy-one-get-one free deals. Most coupons must be redeemed by a certain date, while others, known as *instant redemption coupons,* can be used immediately. Still others have to be used on a subsequent purchase or by varied dates throughout the month.

Some of the best ways to get a coupon into the hands of the target include:

Figure 11.2 **Sample Ad: Tuesday Morning**

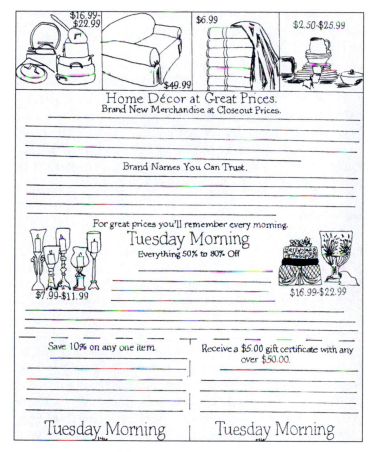

Source: Created by Kelly Bukovsky, The University of Tennessee, Knoxville.

1. direct mail;
2. bonus packs;
3. e-mail;
4. freestanding inserts (FSI);
5. magazines;
6. websites; and
7. mobile phone offers.

Coupons that are not physically attached to an ad are known as a *free-standing inserts* or FSIs. Inserted into newspapers after printing, these single sheet, often double-sided, four-color promotions usually feature coupons or

announce a sale. Also known as *supplemental advertising,* FSIs are colorful, nationally distributed pieces and may feature folds, perforations, or some type of movable or scratchable part. Sizes vary, but they most often measure no larger than 8½ x 11 inches.

One final form of coupon distribution is known as *cross-product promotion* or *crossruffing* and occurs when a coupon is placed on or within packaging or when brands share a cooperative advertising offer. A good example of a cross-product cooperative promotion was developed between Bally Total Fitness and Unilever. When women arrived to work out, Bally handed each member a sample of Unilever's Dove Body Refresher. This fast and simple alternative to an after-workout shower gave women on the go an immediate chance to try the product and initiate feedback.

Why Use Coupons?

Why are some brands placed on sale or featured at a promotional price? (1) To stand out from the competition; (2) to launch a new product; (3) to relaunch a reinvented brand; (4) to feature a brand with sagging sales; (5) to eliminate the competition; and (6) to increase brand equity. Let's take a quick look at each one:

1. Stand Out from Competing Products. Bargain buys and continual promotions bring attention to a brand. Marketers must be careful continued promotions do not damage a brand's image.
2. New Product Launch. Price reductions are a great way to encourage consumers to try a new product. Incentives such as offering a free sample, giving in-store demonstrations, offering taste tests, distributing coupons, or teaming up offers with direct mail can often encourage consumers to switch brands.
3. Reinvented Brands. Reinvented brands have to break into the product category anew when changes or upgrades have been made to an old formula. The same incentives used to launch a new brand will bring attention to a reinvented brand.
4. Sagging Sales. Oftentimes when mature products reach the end of their life cycle, promotions can hold off the inevitable, but for only a short while.
5. Eliminate the Competition. Larger companies and more established brands can keep a price lower for a longer period of time than a smaller independent or highly indebted brand. Price cuts can effectively eliminate lesser competitors.
6. Increase Brand Equity. Consumers love a deal, especially if that deal

is associated with a beloved brand. Loyal consumers will buy more from less advertised brands that consistently deliver on what they promise. Over time, this consistency helps solidify reputation and thus equity.

Coupons Really Do Need to Be Designed

It is rare for any newspaper ad to have a single coupon. The idea is to get the target to go into a store or purchase a brand more than once. To ensure this, each coupon offer will differ and offer a range of expiration dates, usually lasting anywhere from 30 to 90 days.

When coupon offers differ in length, consider alternating line lengths for balance, making sure the baselines align across the coupons. When designing more than one coupon, be sure they are placed together and have a consistent look. Coupons should be both easy to read and understand as well as easy to remove from the ad. The best placement for multiple coupons is to align them at the bottom of the ad because they have a weight to them. Coupons should never pop up in the middle of an ad, interrupting eye flow and corrupting the message.

Consistency balances multiple coupons on the page, so all offers, logos, images, expiration dates, and marketing codes should be the same size, in the same typeface, and appear in the same position on each coupon. Consider drawing additional attention to the coupons by outlining them with a dashed line, visually letting the target know where they need to tear or cut them out. Other important aspects of coupon design include:

1. Coupon Size. Coupon size is not uniform and usually depends on how many coupons will appear on the page. Be sure the coupon is large enough for the offer to be read easily.
2. Make an Offer. Every coupon needs to tell the user what they will get for using the coupon; for instance, "Buy One Large Pizza, Get the Second for a Dollar!"
3. Scream It Out. If using a percentage or cents-off deal, be sure to enlarge the offer to make it stand out.
4. Retailer Reimbursement. Grocer coupons will require a small amount of copy that tells the retailer how to redeem or get their money back for honoring the manufacturer's coupon.
5. UPC Codes. Coupons redeemed at the grocery store will need to have a scannable series of vertical thick and thin lines known as a Universal Product Code (UPC). When passed over the computer beam during checkout, the product's price is recorded.

6. Logo. All coupons need to have a logo, since the first thing the consumer will do is tear it out of the newspaper, magazine, or direct mailer.
7. Expiration Date. Coupons do not last forever. Each should display an expiration date for the offer, either enclosed in a box at the center-top of the coupon or in bold type within the coupon copy.
8. Picture It. If the product comes in more than one variety or size, make it easy for the consumer to buy the correct item by including both an offer and a picture of the product.
9. Code It. Marketing codes consist of a set of small letters and numbers and are often placed on a coupon to tell the marketer what media venue the coupon came from. This is a good way to track what media vehicles are working best.

Other Types of Sales Promotions

Bonus Packs

Bonus packs give the consumer more of the product for the same price. For example, a bottle of shampoo may include "20 percent more free" or may come with a "try me" size bottle of conditioner.

Promotional Pricing

Probably one of the most successful promotions is placing an item on sale. On-sale signage can appear on the product, on its packaging, or on a shelf or poster. The goal is to encourage trial of a new or reinvented product or to get repeat buyers to stock up. Beyond the traditional sale, promotional pricing deals can include refunds and rebates, coupons, varied discounts, bonus pack promotions, and the like.

Specialty Packaging

Creative package designs usually carry holiday or movie themes and are used to attract attention, highlight promotional pricing, or invigorate sales of a mature brand.

Package Insert Programs

Ads that are inserted into mail-order deliveries sent from the seller to the buyer are known as package insert programs (PIP). Because the ad hitches a ride with

Figure 11.3 **Sample Ad: PetSmart**

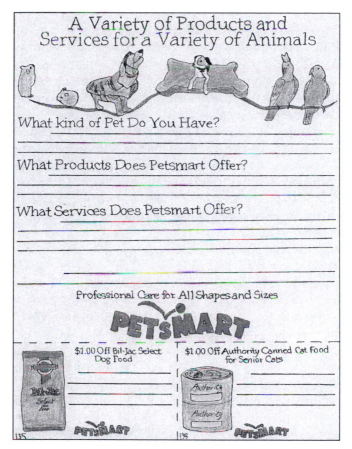

Source: Created by Kelly Bukovsky, The University of Tennessee, Knoxville.

a product the consumer has already ordered, it gets an implied endorsement from a company or brand the target audience trusts. For example, Omaha Steaks offers a PIP to vendors who want to reach their same target base. Most programs consist of no more than four to eight noncompeting pieces. A PIP is very similar to direct mail, only less expensive. This clutter-free, competitor-free vehicle is a great way to reach small, loyal niche markets.

All package inserts should feature a bold headline and a simple key consumer benefit-driven offer. When designing, think direct mail. Make sure to maximize white space, offer several ways to order, and, if possible, offer some type of incentive such as a free sample or free shipping. Any PIP that is shipped repeatedly should regularly be changed out to maintain variety and interest.

Samples and Free Trials

Two of the easiest ways to get the consumer to try a product is to offer a sample or free trial at the point of purchase. Consumers are more likely to try a product for the first time if it costs them little or nothing.

There is no better way to create interaction between the target and the brand than handing out a sample, demonstrating how the product works, or allowing the target to try the product on the spot. Today's marketers are concentrating more on advertising at the point of purchase to help differentiate products and get the brand directly into the target's hands. Reaching the consumer with a relevant message and perhaps a taste test, sample, or coupon provides an incentive to purchase "now." This is a great way to stand out from competing products and assist targets with their purchase, when and where they make a decision to buy. Small or trial-sized samples can generate immediate feedback and lasting impressions.

Another great way to get a sample or coupon into the hands of the consumer is attach it to something usable. Several Japanese businesses came up with an interactive substitute for immediately obtained samples or coupons: pocket packs of tissues that have an advertised message printed on them. It's an inventive way to send a message or attach a coupon that will be kept and reused until emptied.

Some of the other more common sampling platforms include: (1) events; (2) flash mobs, defined by dictionary.com as "a group of people coordinated by e-mail to meet and perform some predetermined action at a particular place and time, and then disperse quickly; (3) point of purchase displays; (4) guerrilla street teams; (5) nightclubs/restaurants; and (6) covert product sampling.

Point of Purchase

Point of purchase (POP) advertising includes inside and outside posters or signage, or the more commonly seen stand-alone displays found along store aisles or at the end of an aisle (the latter being known as *end-caps).*

A creative display featuring unusual or distinctive packaging, bonus packs, special pricing, samples, and shelf talkers placed *away* from competing brands can make a product step out and away from competitors. Products most often employing a POP program include candy, magazines, computers, vitamins, lawn and garden equipment, liquor, and large ticket items such as workout equipment and cars.

POP programs should not be considered an afterthought. The visual/verbal message should match what is happening throughout the media mix and not

only match the brand's image but that of the store in which it is sold and, thus, the consumer.

More marketers are looking at using POP for three basic reasons: (1) they often outperform traditional advertising efforts; (2) the dearth of sales personnel available at retail stores makes point of purchase programs interesting to retailers; and (3) along with consumers expecting less help, they are also making more impulse buys.

Refunds and Rebates

Refunds and rebates are two ways to give cash back to the consumer after purchase. Each method rewards the target for their purchase and builds brand loyalty. Many products offer a 100 percent refund if for any reason the buyer is not completely satisfied with a purchase. Rebates are a form of sales promotion that temporarily lowers a brand's purchase price. Typically, rebates are offered on high-ticket goods; they require the consumer to fill out a lengthy form, answer a series of questions, submit personal information, and/or send along some sort of proof of purchase. Therefore, the savings is not immediate.

Trial Offers

A trial offer allows consumers to try the product in their home or office for a set period of time, usually 90 days, before purchasing.

Special Events, Promotional Products, or Premiums

Sponsored events should mimic both the product and the target. Companion product pairings help achieve both awareness and recall; event sponsors often pursue these goals further by giving away some type of free gift with their logo and slogan or tagline printed on it. Types of promotional products include T-shirts, water bottles, calendars, magnets, coffee mugs, key chains, pens, and the like. Besides sponsored events, premiums can be dispensed via personal selling or attached to a product. Some premiums require consumers to cover shipping and handling or to return a proof of purchase seal.

Contests, Sweepstakes, and Games

Contests require participants to demonstrate a certain type of skill. A panel of judges usually determines winners. Sweepstakes, on the other hand, are based solely on luck, and winners are selected randomly. Purchase is usually not

required for participation in a contest or sweepstakes. One good example of a sweepstakes was the "create your own donut" contest sponsored by Dunkin Donuts: The company launched a $10 million campaign that employed radio, television, and the web, and the winning culinary pastry is available for purchase at all Dunkin Donut locations.

Games are another interactive way to engage consumers. Options might include scratch-off cards or the collection of game pieces. Unlike contests and sweepstakes, games usually do require a purchase from participants.

Product Warranties or Guarantees

Full *warranties* make any type of direct marketing a safe way to shop. If not completely satisfied, the customer can return the product for a refund of the entire purchase price. *Guarantees* ensure the lowest price: If the consumer does find a lower price, the company will refund the difference.

Trade-In Allowances

A trade-in allowance is a promotion that allows the consumer to lower the price of a new product by trading in an old one.

No matter what the incentive, if the target can taste it, touch it, or smell it, then sales promotion is a great interactive device for demonstrating the key consumer benefit at the point of purchase, especially if a product has no features that distinguish it from its competitors. It can be difficult to tie promotional offers to an existing campaign because the visual/verbal images used in other vehicles are relatively silent in sales promotion. However, these images—along with the strategy, objectives, and target—should guide the design team toward the proper choice of promotion to use.

12

Electronic and Mobile Media

Figure 12.1 **Sample Ad: K•B Toys**

Source: Created by Carly Reed, The University of Tennessee, Knoxville.

Electronic Media Sparks Up an IMC Campaign

Advertising on the Internet is a personalized way to expand a brand's message. It is a great vehicle for building awareness, developing a relationship, maintaining brand loyalty, and increasing or maintaining equity. Internet advertising uses the same visual/verbal techniques as direct mail, broadcast, and print—the only difference is it allows the buyer and seller to personally interact in a two-way dialogue.

The Internet is an extension of traditional advertising methods. It is great at continuing the sales message, interactively engaging the target, and educating them about a brand. It is also an excellent repository for information such as current promotions, studies, testimonials, product updates, and advice or tips from relevant experts. Many sites feature blogs where the target can ask questions or exchange information about the brand with other enthusiasts.

How does Internet advertising measure up to traditional advertising? (1) It has news value like newspaper; (2) it focuses product information on brand image and the target's lifestyle like a magazine; (3) it can give the brand a sense of immediacy like radio; and (4) it uses sight, sound, and motion to show the product in use or in a setting. What makes it unique when compared with traditional advertising? It encourages interaction and offers a one-on-one dialogue between buyer and seller via customer or technical assistance.

The Internet makes transacting business easier, faster, and more efficient. It is one of the strongest interactive tools in the IMC arsenal. The two primary roles of web advertising are to educate and actively interact with the target by providing 24/7 access to customer or technical service providers. The ease of use allows the target to compare products and make a purchase at any time from almost anywhere. Most consumers will begin their shopping experience on the Internet by using it as a primary source of information for products that do not require a great deal of research or can be purchased with confidence without first being seen or touched. Those seeking additional information after initial exposure to a message seen elsewhere might use the Internet as a secondary source to confirm or continue their search for information. The hours spent researching a product and its competitors make for a target that is better educated than ever before about product features, quality, price, guarantees, and customer assistance.

A website that matches the look of other pieces used in the IMC campaign will make the target's research easier and the product's visual/verbal image and message stronger and more memorable.

Destination and Informational Websites

Once traditional advertising, direct mail, or any type of alternative media has the target's attention, it should direct them to a website for more information. Independently, the target may rely on the web as a neutral source of information when researching or comparing brands before making a purchase. Others will use it strictly as a source of entertainment.

Internet surfers visit two basic types of websites: destination and informational. A *destination site* should offer activities that will actively engage the viewer and encourage repeat visits. To keep consumers coming back, it's important this type of site change out content often. It may be nothing more than an updated weather or stock market report, or it could promote contests or sweepstakes or include interesting trivia, coupons, blogs, recipe ideas, or audio broadcasts. Attaching some type of viral component is a great way to spread the word about the site with little or no advertising. Jack in the Box, for example, introduced a site after their popular character representative was hit by a car following the 2009 Super Bowl. Using the accident as a way to introduce their new website and logo, visitors to the site were encouraged to send "get well soon" wishes during his recovery. As a reward for the target's continued participation and concern, Jack in the Box planned to follow up the promotion by sending coupons to everyone who wished Jack a swift recovery.

Informational sites are where the target goes to gather product information, find tips or coupons, and get questions answered 24/7. A typical page will resemble traditional print media in its look and information. It uses broadcast techniques to demonstrate or discuss the key consumer benefit and any supporting features.

All sites should be simple and easy to load and navigate. Carry over any visual/verbal messages from print or broadcast to reinforce both the message and the image. This is a great time to feature any spokesperson or character representative used elsewhere, as well as layout or headline styles.

Educating and Interacting with the Target

Because consumers choose to use the Internet for research or entertainment purposes, it makes the interaction between buyer, seller, and brand more positive and less apathetic. Consumers determine what they look at and for how long, making it an efficient way to comparison-shop or purchase.

Once the search for product information is complete, the Internet effectively brings the product or service to the consumer. Many products allow the target not only to customize their purchase but also to participate in the development of product upgrades and the restructuring of customer or technical service components.

When the target has an active stake in the brand, they feel an affinity or loyalty that often results in a lasting relationship. Because the Internet relies on databases, it is easier to target smaller niche markets. Add in e-mail marketing, and the target can be reached at any time with a personalized message. Advertisers who match their message to these highly specialized sites will successfully reach the intended target with a message they are interested in and will respond to.

Using cross promotion in traditional mass media vehicles and/or direct mail are great ways to encourage a trip to the brand's website. It is important the creative team knows the role the Internet is meant to play in the promotional mix. Will it use visual/verbal elements to support traditional advertising efforts but serve primarily as a location for getting coupons, registering for a free sample, or entering a contest? Or will it be the only location to make a purchase? The answers to these questions will determine how the website should be cross-promoted and visually and verbally designed.

Relationship Development Opportunities

Creating opportunities to develop a relationship with the target is the goal of Internet marketing. Once the relationship is solidified, high-quality customer service initiatives are crucial to maintaining loyalty. It is as important as the visual/verbal message and overall product reliability, and it must be successful the minute the website launches. Customer service is more than people; it is policy. Representatives should be knowledgeable and courteous, and policies should (1) ensure immediate feedback, (2) make ordering and purchasing easy, (3) promise quick delivery, and (4) offer a 100 percent money back guarantee and varied ways to purchase. After delivery, a follow-up e-mail on the quality of the experience and/or a thank you note helps to maintain the relationship with the target. Future e-mails can announce sales or specials that match the target's interests.

The more opportunities a consumer has to make contact with the brand or its representatives, the better. Any attempts to contact customer service must be quick and easy. If contact is made via e-mail or instant messaging, the connection must be immediate. Any responses that will require additional time must be articulated and accurate. The goal is to create positive interactions that reflect reliability and encourage trust rather than project negativity and foster distrust.

When developing a website, it is important to take into account whether customer service initiatives will be active or passive. Active customer service includes live discussions via the telephone or electronic communication via instant messaging, blogs, or Twitter. The goal is to make answering questions and solving problems quick and easy. Passive customer service often features automated phone systems, delayed Internet responses to questions, a lengthy wait for a sample, or confirmation e-mail responses.

Advertising on the Internet

The goal of Internet advertising is to reach the targeted audience wherever they are regionally, nationally, or globally; to create brand awareness; and to pique the target's curiosity enough to make them click on the ad. Once transferred to the sponsoring website, it should be easy to navigate and gather information or ultimately make a purchase. A well-designed and informative site can simplify the seek, search, and purchase process as well as create a great opportunity to develop a database of current or interested customers.

Databases play a large role in maintaining an ongoing relationship with the target. Information is gathered based on their past purchase behavior, search topic history, demographics, permission or opt-in e-mail lists, or browser. Advertisers can also monitor the target's movements by employing several tracking devices such as cookies and click stream tracking, which leave behind an electronic trail to help track interests.

Today, advertising on the Internet is moving away from the unobtrusive simple banner and skyscraper ads to more aggressive in-your-face pop-ups and pop-unders, floatovers or flyovers, and unicast or display ads that showcase both streaming audio and video. Search engine advertising gives advertisers a broader yet targeted reach, while e-mail and mobile texting can personalize a message based on interest or even location.

It is important that a website be every bit as polished as any advertising efforts employed elsewhere. First impressions affect how a brand will be experienced and initially judged in much the same way as an initial visit to a brick-and-mortar store would. Because the Internet virtually replaces both a physical location and sales personnel, consumers need to visually and verbally recognize the brand's image in the overall layout, find the site easy to use, and find any interaction opportunities helpful.

Despite all the work that has gone into designing websites, and all the time consumers spend browsing the web, the Internet is still not seeing a practical return on investment. Since clicking on an ad is voluntary, advertising must command attention and be visually attractive, informative, and participatory. If targets don't click, they will not call to place an order or visit the store to make a purchase.

Understanding Electronic Media's Strengths and Weaknesses

The versatility of IMC's voice requires a thorough understanding of what each vehicle brings to the campaign. Let's take a look at the strengths and weaknesses of electronic media.

Strengths

1. Personalized. Sites like Amazon.com can address a returning customer by name and suggest varied products or services based on past purchase behavior.
2. Targetable. The Internet, like direct marketing, uses databases to reach those who have shown past interest or are most likely to purchase.
3. Expense. Internet sites are relatively inexpensive to maintain. Updates can be done quickly and easily as opposed to print, where any changes require reprinting of one or more pieces. The greatest expense overall is the initial design of the site.
4. Customer Service. Consumers can make a purchase, ask questions, or make a purchase 24/7.
5. Consumer-Centric. Because there is no middleman standing between buyer and seller, a relationship can be nourished starting with the first visit, continuing through the decision-making process and purchase and ending with follow-up calls or e-mails concerning the target's level of satisfaction with the experience.
6. Cross Promotion. The web address can be integrated easily into other media vehicles used throughout the campaign.
7. Engagement. The consumer visits a site out of interest and to gain information. The target chooses when they visit, how long they stay, and when and where the contact will be made. The message is accepted and digested on their own terms.

Weaknesses

1. Competitive. If the key consumer benefit is not correctly targeted and the site is not interactive or easy to use, the target can easily go elsewhere.
2. Annoyance Advertising. Internet advertising, like traditional advertising, is becoming more intrusive. It is difficult to miss and often results in an irritated consumer.
3. Niche Sites. Niche sites lower the number of consumers who will be exposed to the message.
4. Privacy. Too many sites are still selling personal data, and hackers continue to put consumer privacy at risk.
5. Technical Limitations. Not all consumers will have the newest and fastest technology. Sites should be accessible even to those with older computers and slow Internet connections.

Let's begin our discussion of the Internet with a quick look at web page design, followed by some of the varied options available to Internet advertisers. Among these options are banner ads, pop-ups and pop-unders, interstitials, permission marketing, floating ads, viral and word-of-mouth marketing, search engine marketing, social media outlets, and pay-per-click.

Website Design

When developing a website, it is important to identify the target and know what will draw them to a site, keep them returning to a site, and encourage them to make a purchase. Technically, it is also important to keep in mind the varying computer and Internet connections the target may be working with.

Before determining what a site will look like, designers must understand its overall purpose(s), among them (1) making brand research easy; (2) developing buyer-to-seller relationships; (3) selling products or services or providing entertainment; and (4) providing outstanding customer service initiatives.

Purpose dictates how a site will be used and what visual/verbal and interactive elements will be needed to meet consumer expectations. The first step in conveying that purpose is a preliminary vision of what the site will look like. Most designers will organize the site using what's known as a *wireframe*—basically, a blueprint of the site that uses labeled boxes to show the overall placement of visual/verbal elements and how viewers will navigate through the site.

Once the visual/verbal direction has been determined, the next step is to incorporate the consumers' needs into the design. The website should:

1. Be a reliable place to go for information.
2. Be easy to navigate, providing multiple paths so viewers can click their way to relevant information.
3. Not overdo technology just because you can; it is not a big leap from "techno savvy" to "creatively tacky."
4. Be clean, interactive, and educational—both visually and verbally— as well as readable and legible.
5. Keep scrolling to a minimum, provide appropriate links for users, and divide the page using headlines and subheads to highlight important points.
6. Make the purchase process easy, be multifaceted, and provide several payment options.
7. Constantly change to hold viewer interest and keep them returning to the site.
8. Be carefully proofed for any spelling and grammar errors.
9. Clearly tell the target what you want them to do.

10. Post any relevant articles or press releases on the brand, as well as testimonials, documented research results, and any pertinent links to other sites.
11. Offer interactive components such as games, music, videos, or photos.
12. Include informative blogs or forums.
13. Offer helpful services such as stock tips, weather forecasts, scores, and calculators.
14. Offer some type of unique feature that competitors' sites lack.

Aesthetically, a well-designed site mimics the current campaign, reflects the target's self-image, and directly addresses their needs and wants. Each page should use the same typeface, layout, color(s), and images to express the key consumer benefit and engage the target's interest.

Visual and Verbal Choices on the Web

Typeface

There are not as many type choices on the web as there are for other advertising vehicles we have looked at. Going with a standard face will keep viewers' browsers from substituting a typeface for one it does not have. (The substitution would change the overall look of the page.) Since you do not know which type of browser visitors will be using, it is important to understand the attributes of each one. The most commonly used browsers include Internet Explorer, Safari, Google Chrome, and Mozilla Firefox. Knowing how each browser—old and new—will display a page ensures all visitors to the site will see the same thing each time they visit it.

Once any display issues have been resolved, type use should follow the same rules as those followed in traditional print. However, text does require increased leading and kerning to improve readability and legibility online. Copy blocks should feature (1) short lines of no more than six inches, (2) multiple short descriptive or colorful sentences, and (3) multiple paragraphs. Long copy blocks will need multiple subheads and/or visuals to break up copy, increase white space, and help lead the reader on an informative journey. Specific points can be highlighted using callout boxes. To give the boxes even more importance, consider making each one a link that will whisk the reader away to a relevant site.

Layout and Color

Page layout should be consistent throughout the site. Like all campaign elements, it is a member of a family of ads and should match the existing IMC

campaign efforts. Place any elements such as navigation devices, logos, and any repetitively used graphics in the same place on every page. Any color used on type, graphic images, or as a background should appear consistent from page to page. When using a background color, be sure the contrast between it and the typeface used does not impede readability.

Images

Images on the web may be static, animated, or do double duty as a link. Just be sure they are representative of the campaign, have an obvious purpose, and work when the target interacts with them.

Body Copy

One way to engage the viewer is to have creative, interesting, and educational copy. Solid writing is still the best way to hold interest and move the reader toward the desired action. Copy should reflect the same style and tone of voice used in other print vehicles. Include only what is needed to tell the product's or service's story, and tie it to the target's lifestyle.

Sites with too much copy can be overwhelming for the target. Sprinkle the site with headlines to divide sections, visuals to illustrate copy points, and subheads to help break up long blocks of copy. Any links included in the copy should further the target's knowledge about the product or service; if they do not, leave them out. Each visual included should give validity to the copy and help demonstrate copy points; if it does not, get rid of it. When possible, use demonstrations, testimonials, and/or studies to prove a point.

Understanding Technical Limitations

Not everyone has the highest end computer, and not all computer users have a fast Internet connection, so it is important to offer the visitor options. The fastest way to lose viewers is to have too many pictures that slow down a loading page. If an image doesn't fully open within 10 seconds, reduce the visual content. Each graphic should engage the target's interest, keep them at the site longer, and fulfill their need for instant gratification, information, or assistance. Don't use technology just because you can: Technology options should be used to communicate a specific and relevant point or feature. Consider using it to demonstrate the key consumer benefit or to highlight testimonials.

Every site should offer interactive options that require the consumer to

Figure 12.2 **Sample Ad: GNC**

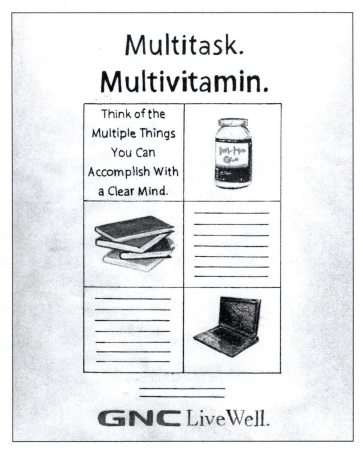

Source: Created by Caitlin Bradley, The University of Tennessee, Knoxville.

do something. Encourage dialogue and build a relationship by engaging the consumer with a customer service representative or a technical advisor, or by inviting them to participate in a blog with current users, to sign up to receive a free sample, to click on a related site, or to download a coupon.

As mentioned earlier, the size of a file can also affect the viewer's experience. Remember, simple is better, so be sure to keep each page, file, and image to 40 to 60 kilobytes at the most. And the same holds true for monitor resolution. It is important to choose a resolution that is common to both old and new equipment. Resolution is defined in pixels; the most commonly used include 640×480, 800×600 and 1024×768. A resolution that is on the higher end may not display all visual or verbal elements in the same way.

Once the site is up, make sure to check for consistency, readability, legibility, and any spelling and/or grammatical problems. If using simple links or more technically advanced bells and whistles, make sure each one is in proper working order and is easy to use and/or navigate through.

Take the time to thoroughly design and organize the site—don't just throw it together. A cluttered, unorganized look projects a lack of quality and can reflect poorly on the products sold or services offered. If including a blog or other type of online contact such as e-mail or instant messaging, be sure to monitor the site 24/7: It will pay off with satisfied and involved customers. Other initiatives might include a feature that welcomes visitors back to the site by name or that suggests current products they may find interesting based on past purchase behavior. These small but important initiatives often help consumers connect with the brand and increase the likelihood of an eventual purchase.

Types of Internet Advertising

Internet ads have the same job as traditional advertising: to make a sale by encouraging the target to do something, such as make an online purchase, call a toll-free number, or stop by a brick-and-mortar store.

In order to build awareness, encourage purchase, and create a memorable message, Internet advertising must: (1) be clutter free and to the point, since simple ideas are more memorable; (2) showcase the logo in a prominent place and be large enough to see; (3) be prominent to stand out; and (4) feature an interactive component to hold the target's interest longer. Let's take a look at a few of the available options.

Horizontal and Vertical Banner Ads

There are two types of banner ads: horizontal and vertical. One of the most common and oldest forms of advertising on the Internet is the banner ad. Horizontal banner ads are a great way to promote brand awareness, increase website traffic, and, to a lesser extent, generate sales. Targeted banners are placed strategically throughout the Internet and on related sites. Usually, banner ads are nothing more than a brightly colored bar featuring a logo and slogan or tagline. To capture attention, banners use a variety of visual/verbal images as well as animation techniques to encourage the viewer to click on the ad. Attaching some type of sales promotion device to the banner increases the click-through rate dramatically. Because of its immense reach and specialized targeting, the banner ad is the Internet's number one mass medium.

Vertical banners, also known as *skyscrapers* or *sidebars,* have a longer time to attract attention because they are larger and cannot be scrolled off screen

like traditional horizontal banners. This makes their click-through rates higher. To avoid irritating visitors, steer clear of any flashing or animated images to capture attention. Technology is fun, but too much of it is distracting and can annoy viewers.

The most successful banner ads give the viewer a choice of (1) being immediately taken to the sponsoring site, (2) participating in a game, contest, or sweepstakes, or (3) making a quick stopover at some kind of interactive streaming audio and video presentation.

Beyond use as an advertising vehicle, companies have used banners to deliver live chats. Intel for example, used technology as a way to engage customers, answer questions, and get their opinion on their new processor. To increase participation, the company advertised the chat room times online for three days prior to the event. On the day of the event, banner ads counted down the minutes one hour before the chat began. The banners also let interested viewers know they would be able to talk directly to Intel experts.

General Electric also exchanged static ads for banner ads and broadcast a live webcast discussion on health care issues with their employees.

Conversational marketing is one of the ways marketers are creating opportunities to interact with their target on a one-to-one basis. Options like these banner ads are used specifically to increase consumer interaction and build loyalty.

Pop-Ups and Pop-Unders

A pop-up is an ad that looks a lot like a regular web page. It "pops-up" over the intended website without the viewer's permission, temporarily obscuring the original site from view. Usually a bit smaller than the web page underneath, a typical pop-up features the logo and slogan or tagline of whatever is being advertised, along with a short message to encourage the viewer to click through to the sponsoring site. When not used as a sales device, pop-ups are a great way for displaying links to information, or getting visitors to participate in question-and-answer sessions without blocking content. Unfortunately, most surfers find pop-ups annoying because they have to close the window before they can view the intended site.

A pop-under looks and acts the same, the only difference being that it opens under the original web page, appearing only when the visitor leaves the site.

Interstitial Ads

A type of pop-up, this Internet ad is more like a TV commercial, featuring sight, sound, and motion. Interstitial means "in between," indicating

that the ad will open up in a separate window between pages while a web page is loading. Because they contain flashy graphics, make sure content is relevant and matches the visual/verbal look used in the overall campaign.

Permission Marketing

E-mail marketing, or *permission marketing,* is inexpensive and highly targetable. The most successful form requires the targeted consumer to opt in or give their permission to receive advertising via their e-mail.

A form of direct response, e-mail marketing is a great way to build an increasingly in-depth relationship with the targeted audience through personalized messages. The goal is to keep the brand "top of mind" and encourage repeat purchase and brand loyalty.

The most successful e-mail campaigns offer the consumer some kind of added value, such as sale or promotional information or a reason to contact the sender or visit a site. E-mail advertising can arrive in the target's inbox as a single ad or flyer or be confined within a newsletter. A good e-mail will include: (1) an attention-getting opening or head; (2) a key consumer benefit and supportive features and benefits; (3) a message that creates want by tying the key consumer benefit to lifestyle; and (4) a call to action.

Be sure each mailing includes a link to the sponsoring website and any other relevant contact information. To keep the message out of the spam folder, avoid the words "free," "order now," "click here," "call now," or "discount offer" in the headline.

Floating Ads

Floating ads appear when a website is first opened, and they "float" or fly over the page. Lasting anywhere from five to 30 seconds, they will often command center stage while blocking the site below. Many of these ads have the ability to take over a viewer's mouse for the duration of their flight. They are great at gaining the viewer's attention and are usually animated with sound options.

The job of floating ads is to mimic television commercials by "interrupting programming," which makes them difficult to ignore or get rid of quickly. Interactive options are engaging and memorable because the target is actively involved in the advertising message, as opposed to the passive nature of traditional advertising. The downside—like most Internet advertising—is that they tend to annoy the user and slow down the search process.

Viral and Word of Mouth

Viral marketing and *word of mouth* are the terms used to identify user generated marketing. The difference between the two is subtle. Viral messages are long lasting, whereas word-of-mouth messages are often short-lived. Viral messages are most often delivered via the Internet, while word-of-mouth messages typically rely on face-to-face discussions. Viral advertising on the Internet is the twenty-first century's version of water cooler gossip; word-of-mouth marketing is gossip around the water cooler.

Viral

Viral marketing is an advertising message that is passed along between acquaintances. Today, all campaigns should have some type of viral-enhancing message. Most viral messages are passed along via social media sites like Twitter or Facebook. Other than face-to-face contact, there is no more personalized place to share information. Viral marketing is also known as user generated content because users do more than purchase a product—they actively promote the product to others. Any type of viral advertising originating from a trusted friend or family member makes it more believable than a message delivered solely through sponsored advertising.

The more creative and engaging the message or event, the more likely the target is to infect their contacts' e-mails by forwarding the message. These entertaining e-mails, also known as *viral e-mails,* will usually include one or more links that will take the viewer to the sponsoring website. This type of personal endorsement makes viral e-mails a great way to launch a new product or increase brand awareness.

A good viral message engages the target's curiosity, funny bone, or intellect enough to get them to interact with it. Incorporating a viral aspect into any traditional campaign is an important way to get the target talking about the brand. Advertising agencies that create campaign slogans that become a part of everyday conversation or characters so recognizable no logo is needed to identify the brand are great ways to create buzz and some of the best ways to incorporate a viral component into the mix.

Word of Mouth

Word of mouth can be defined as one or more satisfied customers telling a friend(s) or family member(s) about their experiences with a product or service. Word-of-mouth campaigns are inexpensive and low in overhead, but they bring in a high amount of consumer loyalty if handled properly. It

is probably the best advertising money cannot buy. When word of mouth is positive it will take a brand a long way in building image and awareness. If the word on the street and on the Internet is negative, nothing can kill a brand's momentum faster.

Any type of positive word of mouth can sustain a brand's message indefinitely if it is constantly upgraded, changed out, unique, interesting, and recognizably tied to other campaign efforts.

Apple, for example, has always excelled at the use of both viral and word-of-mouth advertising to encourage buzz about a product. Always innovative, Apple was the first to create the colored computer, the iPod, and the iPhone. Not only were these cool and one-of-a-kind products at the time of launch, but Apple also made them the "must have" products of the day. The products lived up to the hype: They were exciting to own and increased Apple's reach beyond its existing niche of targeted consumers.

Search Engine Marketing and Search Engine Optimization

Search engine marketing (SEM) increases a site's rankings and helps direct interested consumers to a specific website by purchasing relevant key words on search engines such as Google and Yahoo. Search engine optimization (SEO) means making sure a site is linked to other relevant sites to attract traffic. Because search engine advertising is based on the target's specific interests, it is highly effective. SEO and SEM are proven ways to promote a business to Internet consumers.

Social Media

User generated content—the newest form of online communication—is found in wikis, blogs, and social sites like Twitter and Facebook. These new discussion sites allow consumers to voice their concerns, offer quality feedback, start a rumor, or generate buzz about a brand's features and benefits. Social media sites are also an excellent forum to promote brand awareness, enhance a brand's image, get answers to questions, and stave off any negative publicity.

Most social media ads have been experimental at best, consisting of sponsorships, ad placements, or brand applications that have not been well received by social media users. Social sites should be used less as an advertising forum and more as a viral word-of-mouth forum. Alternative ways for marketers to be socially and quietly accepted on social media sites include (1) joining in on blogs or forums; (2) openly engaging with a group that's talking about the product or competing products and adding to the knowledge of the group;

(3) designing a campaign using the target's ideas; and (4) keeping the quality of the brand and customer service initiatives up-to-date.

More and more marketers are using social media sites as a customer service outlet. Twitter, in particular, is becoming an important source that lets companies hear from and respond to their products' users. Twitter, the Internet's version of "keep it simple stupid," allows consumers to interact with a brand, service, company, or other consumers in little bite-sized discussions. This viral vehicle can make or break a brand. Twitter is all about immediacy. Information is going back and forth nonstop, allowing marketers to address questions, concerns, and potential disasters while or even before they happen. It gives marketers a glimpse of public opinion, using their insight to improve the product or service.

Social media can help marketers adapt their visual/verbal message to reflect public sentiment and overall needs. This "type to talk" social network creates buzz by letting consumers know immediately about what's going on with a product or service.

Many corporations, Comcast Cable among them, have people monitoring Twitter postings full time to address customer comments and stave off any negative discussions before they take hold and flourish. Brands like Bank of America and Apple have gone one step further, providing live customer service representatives on their sites.

Handling and solving problems before they turn negative is what customer service is all about. Helpful, practical advice builds good will and good word of mouth. Monitoring social media sites also allows marketers to exploit strengths and opportunities and nip weaknesses and threats in the bud before they become full-blown issues.

Social sites are also a great way to promote a brand, advertise a promotion, or build expectations for an upcoming event. DiGiorno, for example, decided to use Twitter along with traditional print and broadcast to launch their new flatbread pizza. DiGiorno is tapping into the social outlet's strong following by offering food in exchange for tweetups or live meetings. For every tweetup hosted by influential tweeters, Nestlé—DiGiorno's parent company—will deliver their new flatbread pizza to the event.

The producers of the movie *Sex and the City* used social media sites to build buzz about the film prior to its opening. They also sponsored a promotion centered on a gift-giving campaign, where users could send virtual shoes as a gift to fellow Facebook friends. And Esurance, as part of a public relations campaign for their sponsorship of the 2009 *Star Trek* film, created their own home pages on Facebook and MySpace and asked *Star Trek*-savvy fans to submit videos that promote their devotion to the ongoing iconic storyline.

A relatively new member of the Internet entertainment arsenal is Hulu. As "one of the great innovations of 2008," according to then NBC Universal CEO Jeff Zucker, Hulu brings television programming to online video. This technological breakthrough delivers viewers' favorite programs to them whenever and wherever they choose. Advertising on the site comes primarily through sponsorships and is relatively unobtrusive.

Pay-Per-Click

A simple text ad, pay-per-click advertising is one of the more successful forms of Internet advertising. Most ads are placed on one or more sites that generate a large amount of traffic. The goal is to capture the surfers' attention and encourage them to click on the link. Fees are based on how long the visitor stays on the sponsoring site. Visits lasting more than five to ten seconds require the advertiser to pay the host a fee.

Mobile Communication Moves with the Target

The Mobile Marketing Association defines mobile marketing as "a set of practices that enables organizations to communicate and engage with their audience in an interactive and relevant manner through any mobile device or network."

Mobile marketing simply means a marketer can reach the target with a message delivered via cell phone using a *Short Message Service* (SMS) or text message that may or may not include a link to a sponsoring Internet site. Because wireless communication uses a low bandwidth, messages should contain no more than 160 characters. Short messages keep download time to a minimum but are nonetheless effective. Most wireless advertising does little more than remind, reward loyalty with valuable incentives, and encourage purchase. Campaigns that employ SMS technology will find it flexible, measurable, convenient, and affordable.

Mobile's highly targetable reach makes it more effective and efficient than traditional advertising methods. Research has shown that mobile texts are opened sooner than traditional e-mails and that consumers are more receptive to messages delivered via their mobile phone. A good mobile advertising campaign that reaches the target near hot sale locations makes them anywhere from three to ten times more likely to be engaged by the message, making mobile advertising very attractive.

Targeted consumers who have opted in to receive advertising can be reached wherever they are with a message that will interest them. Mobile delivers a diverse array of advertising, promotional, and entertainment options and is

Figure 12.3 **Sample Ad: Toro Lawn Mowers**

Source: Created by Jina Eun, The University of Tennessee, Knoxville.

capable of employing banners, audio and video, animation, interstitials, coupons, GPS and mapping capabilities, and accelerometers (a device that allows the phone to detect movement when shaken). This makes it great for games and for controlling the direction of mapping, among other uses.

The slow economy has actually helped new and alternative advertising vehicles such as mobile to grow. As marketers slashed budgets and pulled out of more traditional vehicles, the door opened for smaller, less expensive options such as the Internet or mobile. Mobile advertising—especially mobile search—is primed to take off with the improving economy.

Every day, mobile marketing's reach and capabilities are expanding with options such as *premium short message service* (PSMS), or the ability to

purchase something such as a ring tone; *wireless application protocol* (WAP), or a wireless web connection; *multimedia-messaging service* (MMS), an extension of SMS that allows users to send longer text messages, and send and receive mobile photographs as well as audio and video clips; and mobile video (MV), or the ability to watch TV via a cell phone.

This targeted, instantaneous, relatively inexpensive and measurable vehicle can reach the target at the point of sale or assist with purchase by announcing nearby sales and delivering coupons. It can send, receive, inform, and personalize a message. By incorporating mobile advertising into the media mix, a product or service can be cross-promoted and more competitive. Like most alternative media vehicles, mobile marketing creates a more direct and sustainable relationship with the target and is a great support vehicle for traditional forms of advertisements. Wireless also delivers:

1. Greater recall and response rates.
2. Increased brand awareness.
3. Increased consumer loyalty.
4. An opportunity to reach high-income professionals.
5. A highly targeted opt-in consumer market.
6. Increased Internet traffic.
7. A chance to purchase or to visit a website.

Mobile's biggest asset is that it can now target potential buyers by location. Mobile technology can send a customized text message about a sale the target is walking by or driving near and offer an immediate link to available coupons. This permission-based service will notify consumers when they near the sales location and send an alert that includes the name, address, and link for a coupon or other important promotional information. It works something like a trip wire: Once the target steps near or drives by a location, say a pet shop, it activates a locator device that can send a coupon alerting the target to a sale on their preferred brand of dog food. This makes mobile marketing a great point of sale device, encouraging the target to make an impulse or unplanned purchase. Location-based mobile ads are a great interactive device and an excellent way to build a lasting, one-on-one relationship with the target. To maintain consumer support, it is important messages be relevant and on-target; in addition, the choice to opt out should be easy and permanent.

Since mobile carriers have opened up their client lists to advertisers, it is easier for brands to target individual users. Mobile carriers collect a large amount of demographic and psychographic data that can assist advertisers with more precise targeting: Where does the target go? How do they use

their phones? Just to make calls, or to send texts as well? And, perhaps most important, what does the target buy?

Mobile as a Promotional Vehicle

Technology has introduced what is known as "the third screen" into the promotional mix. The three screens refer to television, computers, and the smaller screens found on mobile phones, iPods, or PSPs.

Researchers have found that small "third screen" devices are used mostly as a way to kill time. Viewers prefer to watch sports, real-time news, and music videos. The size and portability of small screens present both opportunities and challenges. They must: (1) offer content that is interesting enough to encourage viewers to opt in; (2) offer multiplatform entertainment and viral opportunities; (3) alleviate boredom and find a way to both educate and entertain; and (4) employ branded entertainment as a way to engage receivers.

Promotions have a lot to accomplish, so it is important to capture the target's attention by getting them to do something, whether it's entering a short code or requesting a coupon. Advertising efforts may first employ a radio ad to promote a 25 percent savings on various sporting equipment if the target texts a specific short code. Once sent, the texter will receive a coupon or promotional code redeemable at sponsoring retail locations. Short code promotions are relatively common, most often used on reality television shows to vote for a favored participant and as a way to receive promotional items at sporting events or download video to mobile devices.

One of the newer uses occurred when short codes played a major role in a political election. Barack Obama was the first American presidential candidate to reach voters by text message. Staffers used texting to encourage voters to cast their ballots and to keep supporters updated on important issues. To reach potential voters, campaign workers set up the short code 62262, which is the tech spelling for Obama on telephone keypads. The short code was used in advertising to encourage supporters to sign up to receive campaign messages. For only a small investment, the Obama camp used texting and social networking to get his message out to those who had opted in to receive the communiqués. Obama's unprecedented use of mobile texting brought renewed attention to the new media vehicle when he used it to announce his running mate to loyal subscribers before anyone else.

Interactive forms of advertising such as coupons or short codes that are sent via cell phones or made available on the Internet are more memorable and more likely to be acted upon. Unilever is participating in a trial that allows consumers to download select coupons to their cell phones before purchase. Like traditional coupons, they are redeemable at the time of checkout. The only

hitch is the consumer has to hand their cell phone over to the sales clerk to have the bar codes scanned. After use, each coupon is automatically deleted.

Campaigns that combine both mobile and Internet options keep information timely and interactive. Messages that include links can say and show more than a simple text message. An interactive mobile ad allows the consumer to click on the link and be taken to a wireless website for more information, and call-through links can hook up the wireless user directly with a customer service representative.

Procter & Gamble successfully paired mobile with the Internet to promote their SitOrSquat.com site. This technology-based campaign allows the target to locate, rate, and recommend clean and fully stocked public restrooms across the country. Verizon also used both mobile and the Internet to launch its "Daily Scoop." This destination site delivers scores, weather, trivia, coupons, and advertising.

Finally, consumer product giant Johnson & Johnson paired print with a mobile coupon delivery campaign to reach pregnant women. Print ads were first used to introduce women to the program. In order to be eligible to receive pregnancy-related coupons, the mothers-to-be needed to text their delivery date to the company. Once they had their babies, these new moms could continue to receive coupons for various types of baby products.

iPhones and Smartphones

The launch of the Apple iPhone made technological history in late 2007. The iPhone was the first to make the Internet mobile and easy to use with the tap and flick of a finger. Smartphones like the iPhone were also the first to introduce apps, which has taken the cell phone industry by storm. Apps are buttons that take the mobile user to a specific Internet site.

Kraft, for example, jumped on the phone app bandwagon with iFood, a mobile destination offering recipes that can be accessed while shopping. The app known as the iFood Assistant makes it easier to plan meals and purchase ingredients while on the go. Each recipe comes complete with a convenient shopping list and complete cooking instructions. Good recipes are a great viral component, as cooks send them on to friends and family members.

Wireless or mobile advertising use is on the rise. Exactly what form it will take is still unknown, but new developments include starting cars remotely, making cashless purchases, and banking via apps. What is known is that consumers will decide if they want to receive advertising via their cell phones, pagers, or personal digital assistants (PDA) by opting in to receive them.

13

Guerrilla and Other Forms of Alternative Media

Figure 13.1 **Sample Ad: K•B Toys**

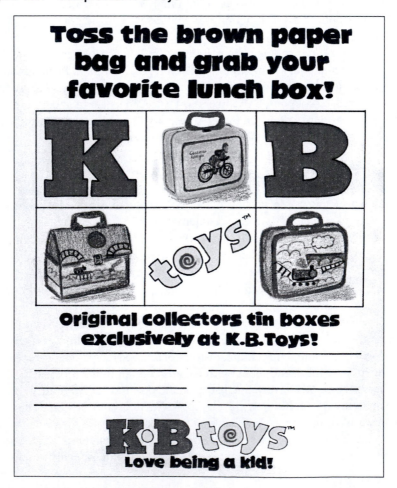

Source: Created by Carly Reed, The University of Tennessee, Knoxville.

Guerrilla Marketing Is an IMC Campaign Event

Guerrilla marketing uses unconventional means to promote a product, attract attention, and create memorable encounters. The more unique the experience or unusual the locale, the bigger the impact on the target. Because fewer consumers are listening to, reading, or watching traditional advertising, alternative media vehicles like guerrilla marketing must surprise and titillate by giving the target something they don't expect. Creating stunts or spectaculars like those used in guerrilla marketing step up and away from the cluttered advertising arena by engaging the consumer in the experience. The unconventional—and often unexpected—promotional solutions offered by guerrilla marketing help captivate and extend message life through word of mouth.

The nontraditional use of space and events is guerilla marketing's way of gaining maximum results from minimal resources. Today, the term guerrilla marketing is used to describe any form of advertising that does not fit the traditional print or broadcast format. Technically, it can be defined as any alternative, high-impact, niche marketing tactic whose goal is to produce maximum results (sales, awareness) using a minimal investment (time, resources, budget).

Economic factors, fractionized audiences, and less effective traditional advertising methods are a few of the reasons marketers are looking for new and innovative ways to reach their target audience.

Originally, the goal of guerrilla marketing was to level the playing field between small businesses and their larger competitors. For a small investment, small business owners can use guerrilla techniques to stand out from the pack. However, today's larger, more established brands are jumping on guerrilla marketing as well, creating even more spectacular and innovative promotional events. Take, for example, Scholastic Media's guerrilla event in Manhattan in the fall of 2008. Times Square has enough traffic to make or break any guerrilla marketing campaign. To promote their interactive game, *Goosebumps HorrorLand,* Scholastic Media and its partner, Interface, Inc., arranged for an elementary schoolteacher to display his pumpkin-carving prowess live in Times Square on Halloween. The goal was to break his own Guinness Book pumpkin-carving record of 42 pumpkins completed in just one hour—and capture the attention of the many busy and distracted passersby in the process. Sam Ewen, founder of Interface, Inc., was astounded by the event's success in attracting and holding the attention of busy New Yorkers. The goal of a successful marketing event not only is to capture attention but also to interrupt what the target is doing. "Brands" said Ewen, in a December 2008 brandweek.com article, "[have to] give people something else to think about."

Another example comes from the advertising arsenal of IKEA. For its guerrilla marketing event, the Swedish home furnishing store commandeered an

entire monorail train in the Japanese city of Kobe. To showcase its products, IKEA decorated each car using couches, chairs, window treatments, and other home decorating products that riders could find in their new location. Many items sported price tags featuring the name of the item and a web address to help any interested shoppers make a purchase. This interactive display not only announced IKEA's arrival in the area but also let riders actually sit on, try out, and inspect the products as they wound their way through the city to work.

It is not beneath a guerrilla campaign to scare the target into action. In 2009, Bosch Security Systems focused a guerrilla marketing campaign on several neighborhoods in the city of Johannesburg, South Africa. Advertising agency DDB sent out guerrilla teams to the area to "scare up" interest in security systems. Focusing on over 300 homes in high-crime-rated neighborhoods, the guerrilla teams took Polaroid shots of each home. Once developed, a sticker was placed on the back that read: "With a CCTV Security System, you would have seen me outside your house." The photo-turned-advertisement was then placed in the homeowner's mailbox. Not only did the sale of home security systems go up, but the campaign garnered additional positive publicity in the local press.

Scaring consumers does not always garner favorable publicity, however. Arguably one of the first and most memorable guerrilla campaigns, considered a disaster at the time, was the "War of the Worlds" broadcast launched in 1938 by Mercury Theatre on the Air. This highly imaginative broadcast by Orson Welles led radio listeners to believe that a Martian invasion was taking place on Earth. CBS Radio took a great deal of heat when the broadcast's news-bulletin format was labeled "cruelly deceptive." The ruse was easier to pull off because the program aired without commercial breaks. But it did its job—we are still talking about it nearly 75 years later because it was memorable, creative, unusual, inventive, and engaging.

In a more recent example, the 1999 movie *The Blair Witch Project* heated up both viral and word-of-mouth discussions. This thriller features a group of young college students trekking through the Maryland woods to prove and film the existence of the Blair Witch. The movie was not successful because of multimillion-dollar financing—actually, it was made on a shoestring budget—but because the word on the street was that the Blair Witch really existed: A very successful viral campaign got the rumor going and growing. Movies like this one, and other simulated events, can make it difficult for consumers to tell the difference between great advertising and subterfuge, or what's known as *astroturfing*, a media term that refers to the creation of artificial buzz.

Most experiential marketing is successful because it is both unconventional and unexpected. But marketers need to be sure their attempts do not go too far and annoy consumers, as the California Milk Producers' guerrilla marketing campaign did in San Francisco. Chocolate chip scent strips were placed

in bus shelters throughout the city. The goal was to encourage commuters to have a tall glass of cold milk with a chocolate chip cookie. This great "scent-sational" idea did not go over well with many who encountered it. Almost immediately, commuters complained that the conjured-up smell gave them headaches, made them hungry, or aggravated their allergies.

Planned guerrilla marketing events that do not fully research local laws or clear events with city, state, or federal officials can quickly turn a promotional event into negative publicity, as occurred when Microsoft let fly thousands of butterfly stickers on unsuspecting New Yorkers. The 2002 "fly by" was not well received by local citizens or city officials: Microsoft was issued both a fine and a forceful request for immediate cleanup. Guerrilla campaigns that fail affect brand image, so before launching one, creative teams must have a thorough understanding of how large a distraction the target will tolerate, or whether they might find the event annoying or downright offensive.

A small video game company found out just how easy it is to offend when they wanted to place ads on tombstones. Their promise to pay for the privilege was condemned by the public in general and varied religious sects specifically. Protecting their reputation, they assured the community they were only kidding and quickly put an end to their quest for afterlife advertising.

Taking It to the Streets

There are too many forms of guerrilla marketing to list here, but some of the more commonly used and interesting types include stealth and street marketing, pop-ups, video projection, event graffiti, and skywriting.

Stealth Marketing

Stealth marketing—also known as word-of-mouth, buzz, or ambush marketing—often uses actors to talk about or use a product in social situations. For example, Sony employed stealth marketing techniques when it hired actors to coerce strangers into taking their pictures. Once engaged, these faux tourists handed over their picture phone while talking up its features. Detractors label stealth marketing as undercover marketing, since consumers often do not realize they are being targeted.

Street Marketing

Street marketing, like stealth marketing, interacts directly with consumers by using heavily trafficked areas like malls, street corners, parks, or other public places to hand out fliers, samples, or other marketing materials. This more

open form of guerrilla marketing brings the product to the target by turning the visual/verbal message found in more traditional vehicles into an interactive one-on-one experience with the brand.

Pop-Ups

Pop-ups bring a temporary showroom to a public place, such as when a popular brand of shampoo set up sinks and hair stylists to wash and style hair on a busy street corner in New York City. This type of surprise event extends the brand experience to real-life events or encounters, creating an interactive and memorable experience. Another pop-up temporary store was set up by Procter & Gamble in midtown Manhattan, where consumers could stop by and pick up coupons, sample products, or even get a beauty makeover with P&G products. Unilever and Meow Mix have also interacted with consumers in temporary street locations, offering a one-on-one brand experience.

Video Projection

Video projection advertising takes a recognizable visual image and projects it onto the sides of buildings, reflects it in water or on window frontage, or otherwise displays it in a public place—even on cruise ships. These larger-than-life displays are an excellent way to generate buzz and connect with consumers in major markets, especially during the evening hours. Usually seen in larger cities, they are often accompanied by street teams handing out samples, free tickets, or coupons. Projected commercials are known as *guerrilla video projection.* These 30-second commercials are most often projected in areas with a high percentage of pedestrian traffic. Other images can include logos and visual/verbal stationary messages. To attract as much attention as possible, the projections often appear on more than one building in more than one location. Outdoor guerrilla video projection can also utilize street teams, texting, video games, and Bluetooth broadcasts.

Event Graffiti

Another form of guerrilla marketing is the event graffiti performance, which uses the skills of highly creative graffiti artists to produce an outdoor mural for a product or service. Live six- to eight-hour performances are usually conducted at outdoor concerts, sporting events, festivals, and street fairs. Also known as *mural street art,* this one-of-a-kind permission-based outdoor mural is hand-painted live during an event by street or graffiti artists, often on the sides of older urban buildings.

Event graffiti can backfire, however. Sony used it in a 2005 guerrilla event for a PSP handheld game. Street artists were legally commissioned to spray paint images of gamers using the PSP. Local residents objected to the graffiti, and before long all drawings were defaced in some negative and suggestive ways. The campaign ran in several cities with basically the same negative results.

Skywriting

Even the sky is a great place for a guerrilla marketing spectacular. Event advertising can now take to the skies with an environmentally safe machine that spits out specifically designed cloud formations that can be seen for miles. Known as *Flogos,* or flying logos, these clouds have been used by the Los Angeles Angels on baseball's opening day to send up an "A" with a halo from the outfield; they also were used to form McDonald's golden arches and a signature "S" for Sheraton Hotels.

Logo-shaped clouds may be considered a novelty, but the sky has been used for decades as a clutter-free venue to reach a large but generally inattentive audience. Blimps, airplanes towing banners, and hot air balloons have all been used to showcase logos and slogans.

The closest promotional vehicle to Flogos is skywriting, a process by which vaporized fluid from a plane's exhaust is used to spell out floating messages that can be seen for miles. These super-sized messages span more than five miles, with each letter reaching heights equivalent to the size of the Empire State building. Skywriting is out of the ordinary and will catch viewers' attention from up to 15 miles away.

Whatever the surface, whatever the brand, and message, guerrilla marketing is a great way to get in the consumer's face in an entertaining and memorable way. The more the tactics are talked about on the web, by phone, at work, at home, or in the press, the more powerful and lasting the effect will be. To be successful, guerrilla marketing tactics must include: (1) impact; (2) exposure; (3) reach; and (4) creative flexibility and ingenuity.

As a rule, guerrilla marketing's goal is not to encourage an immediate sale but to promote word-of-mouth discussions, the strongest and least expensive form of advertising. These unusual and often unconventional tactics are a great way for marketers to interact with consumers on a one-to-one basis, get immediate product feedback, and leave a memorable impression.

Reaching the Target in Alternative Ways

The days of limited media resources are long gone. Today's consumers use varying resources to receive information and comparison shop before purchas-

ing. This multiple use of resources is known as *media multitasking,* the main source of target fractionalization. Reaching the intended target with the right message in the right media requires research, message repetition, interactive options, and creative ingenuity.

The choice of media is as important as the development of the creative message. It should advance the brand and use an assortment of old or *brand-centric* and new or *consumer-centric* media vehicles. Visual/verbal messages that are unique and offer some type of interactive and/or viral component can incorporate the use of both.

Since most alternative media such as guerrilla marketing play a supportive role in an IMC campaign, it is difficult to determine their precise return on investment. It is important, then, that inquiries be tracked back to varied vehicles by incorporating different promotional or marketing codes for each vehicle used in the campaign.

By inserting guerrilla marketing events into a traditional campaign, creative teams can reach the target in more unconventional ways. Add in interactive opportunities and it becomes a very targeted and consumer-focused member of the media mix. If you can take a static print ad and give it a voice, 3-D qualities, a smell, a taste, or a bigger-than-life personality, then the consumer will start talking. Now that's good advertising.

This very interactive and consumer-focused form of advertising is a concrete way to create dialogue, build a relationship, and obtain feedback, making consumers feel they are a part of the brand's success.

Understanding Alternative Media's Strengths and Weaknesses

The versatility of IMC's voice requires a thorough understanding of what each vehicle brings to the campaign. Let's take a look at the strengths and weaknesses of alternative media.

Strengths

1. Reach. Messages are received because the target has opted in to receive them, making this a great relationship-building device. These diverse vehicles are also a great way to reach the target where and when they least (or most) expect it.
2. Unconventional. The unique and often unconventional tactics used with alternative media often stop consumers in their tracks, encourage word-of-mouth exchanges, and/or creates a great viral opportunity.
3. Targetable. Many vehicles are highly targetable or permission based.

4. Creative and Interactive. Vehicles that are both engaging and interactive are always more memorable.
5. Expense. Some alternative vehicles require little or no cost to deliver.

Weaknesses

1. Ineffective. Alternative media by itself will not reach the target. To be effective, it must be seamlessly woven into a traditional media campaign.
2. Ethics. It is important that all guerrilla methods are clearly exposed as advertising so as not to be labeled misleading, deceptive, or unethical.
3. Expense. Not all alternative media options are inexpensive. Guerrilla marketing can be both expensive and a public relations disaster if not carried out correctly.
4. Word of Mouth. Buzz is only as good as the product, the event, or the visual/verbal message.

Alternative Media in an IMC Campaign

Alternative media refers to any media vehicle that does not fall under the umbrella of traditionally used media such as print, broadcast, direct marketing, and out-of-home. Basically, an alternative vehicle can be defined as any surface flat or otherwise that can hold a message. These nontraditional surfaces can surprise and reach the target wherever they are, often when they least expect it.

Although a bit of a misnomer, alternative vehicles are also known as *new media*. This label implies the surfaces have never been used before, while *alternative* suggests they are a replacement or substitute for a more traditional surface. A more precise definition of an alternative vehicle is a creative promotion or ad displayed in a highly visible venue that will reach the target with a creative, tantalizing, and/or shocking message.

Advertisers employ alternative media when traditional vehicles are unsuccessful at reaching the target. The diversity of these vehicles assures the message will reach the target wherever they are and whether they consciously choose to receive the message or not. Alternative media methods have grown in popularity because (1) the power of traditional media to persuade has declined; (2) they are versatile; (3) they are sometimes less expensive than traditional options; and (4) they can be highly targetable.

Often found in and on unusual places and surfaces such as elevator doors,

Figure 13.2 **Sample Ad: Knoxville Zoo**

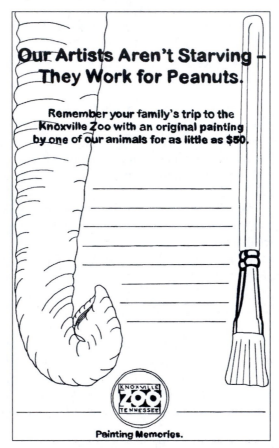

Source: Created by Amanda Sherrod, The University of Tennessee, Knoxville.

manhole covers, bathrooms, restaurants and bars, grocery carts, shopping bags, cups, seats and benches, construction barricades, or even people, anything goes: No surface is immune to a highly unconventional creative statement. The best part is that, unlike most other vehicles, alternative media cannot be clicked out of, turned off, zapped, or deleted.

Many still consider alternative media as anything associated with computer technology because of its interactive nature. However, the Internet is so vital to all forms of advertising in the twenty-first century that it no longer qualifies as an "alternative" to the success of a traditionally launched campaign; rather, it is an integral part of any campaign's promotional voice.

Because interactivity is important to stopping attention and creating memo-

rable encounters, messages will visually and verbally speak to the target in diverse ways. Some are thought provoking, others funny, and still others shocking; however, all work to invoke curiosity and generate excitement in very creative ways.

One of the most exciting aspects of alternative media is that the public tends to fall for a very creative visual/verbal voice. Because of this, marketers are adopting alternate methods of advertising in order to attract consumer attention. There are hundreds if not thousands of forms of alternative media that can be incorporated into any event or program or placed on any surface. The list that follows is just the tip of the iceberg.

- 3-D Catalogs
- 3-D Out-of-Home (Extreme Out-of-Home)
- ATM Machine Advertising
- Advergaming
- Aerial Advertising
- Airport Advertising
- Augmented Reality
- Automated Shelf and Aisle Advertising
- Banners
- Bathroom Advertising
- Bilingual Street Teams
- Blogs
- Body Billboards
- Branded Vinyl Stickers (Postering)
- Bubble Clouds
- Buses (Inside and Out)
- Bus Shelters
- Bus/Train/Subway Terminals
- Bus Wraps
- Business Card Backs
- Buzz Advertising
- CDs
- Card Deck Mailings (Polypacks)
- Catalog Bind-Ins/Blow-Ins
- Chairs/Benches
- Chopstick Advertising
- Cinema Advertising
- Coffee Cup Sleeves
- Consumer Generated Advertising (Social Media)
- Co-op Mailings
- Coupons
- DVR Advertising
- Digital Out-of-Home
- Direct Marketing/Relationship Marketing
 * Direct Mail
- Doggie Bag Advertising
- Door-to-Door Advertising
- Downloadable Videos
- Drive-In Advertising
- E-direct marketing
- E-zines
- E-mail
- Endorsements
- Escalator Handrail and Steps
- Event Graffiti Performances (Wallscapes)
- Event Sponsorships
- Exercise Equipment
- Faxes
- Flyers (Traditional/Suction Cups)
- Freestanding Inserts (FSI)
- Fruits and Vegetables
- Gaming
- Gas Pump Top Advertising

- Gas Pump Nozzles
- Grocery Cart Advertising
- Guerrilla Marketing
- Hand Stamp Advertising
- Home Video Advertising
- Influencer Marketing
- Inserts
- Interactive TV
- iPods
- Issue Advertising
- Live Mobile Billboards
- Manhole Covers
- Milk Cartons
- Mobile Advertising
- Mobile Billboards
- Mobile Video
- Mobile Video Cubes
- Movie Promotions
- Moving Walkways
- Newsletters
- On-Cart Advertising
 * Grocery
 * Golf
- Online Classifieds
- Online Video Advertising
- Out-of-Home
- Package Inserts (PIP)
- Parking Garage Advertising (Entrance/Exit Gates)
- Parking Garage Ticket Backs
- Parking Meters
- Payroll/Credit Card Stuffers
- Pedicabs (Pedal-Powered Taxi)
- Podcasts
- Point of Purchase Displays (POP)
- Police Cars
- Pop-Up Brand Experiences
- Postering Campaigns
 * Splash Campaigns
 * Blanket Campaigns
- Product Placement

- Projection Advertising
- RSS (Web-Feed Format)
- Ride Alongs
- Rip-Away Posters
- Search Advertising
- Sampling Programs (Product/ Brand Sampling)
 * Event-Based Sampling
 * Flash Mob Brand Sampling
 * Guerrilla Street Team Sampling
 * Fill Concept Brand Sampling
 * Point of Use Product Sampling
 * Nightlife Product Sampling
 * Covert Product Sampling
 * In-Venue Brand Sampling
 * Van Product Sampling
 * Intercept Brand Sampling
- Satellite Radio
- Scaffolding
- Search Engine Advertising
- Shopping Bags
- Snappable Ads
- Sports Marketing
- Statement Stuffers
- Street Art (Sidewalks and Streets)
- Stickers
- Supermarket Shelf Advertising
- Supermarket Shelf Talkers
- Sweepstakes/Contests
- Take-a-Ways
- Taxi Cabs (Inside/Outside)
- Telemarketing
- Texting
- Ticket Jackets (Airline, Rail, Bus)
- Tissue Packs
- Toilet Seats
- Toilet Stalls
- Tradeshows
- Trucks

- Vacant Storefront Windows
- Valet Parking Tickets/Parking Permits
- Vehicle Wraps
- Videogame/Online Gaming
- Video Projection
- Vinyl Stickers
- Viral Marketing
- Wall Murals
- Webisodes
- Websites
- Wild Posting

* Rip-Away Wild Postings
* Snipe Media Wild Postings
* Sidewalk Chalkings
* Sidewalk Decals
* Static-Cling Wild Postings
* Urban Street Pole Postings
* Reverse Graffiti and Clean Graffiti
* Creative Outdoor Poster Billboards.
- Word-of-Mouth Marketing
- Workout Equipment

Figure 13.3 Sample Ad: Soothing Naturals

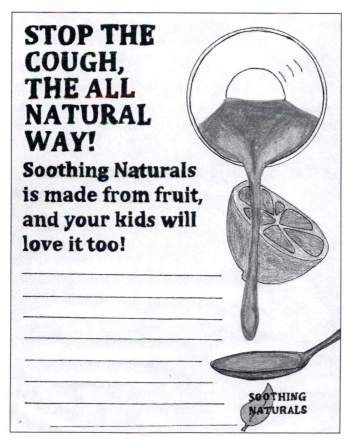

Source: Created by Katie Gilles, The University of Tennessee, Knoxville.

Alternative Media in a Supportive Role

As a support vehicle, alternative media is a great way to build brand awareness, launch a new product, reinforce an existing brand image, or remind the target about a mature or reinvented brand. Its flexibility and variety make it a great choice for local, national, or internationally advertised products, services, and charities. The choice of how to use it depends largely on the target, the creativity of the vehicle(s) employed, and the quality of the message.

The use of alternative media is on the rise because it is hard for consumers to avoid it, and traditional media vehicles can no longer reach a fractionalized target audience effectively. Alternative media brings the message to where the target is and gets them to talk about it. The goal is to create interest thorough interaction with the product or service, thus encouraging feedback. It is also attractive to marketers because its unexpected nature and in-your-face tactics have been successful in connecting with that all important 18- to 34-year-old target audience. This is the group most resistant to traditional advertising techniques and the most likely to generate additional buzz.

The diversity of vehicles makes it very difficult to define the overall visual/verbal voice of a "typical" alternative vehicle. This is made doubly hard, since few vehicles are actually considered "typical." What is known is that the majority of alternative vehicles rely on a powerful visual/verbal message and creative placement in an unexpected location to get their point across. Copy-light, like out-of-home, it never contains more than one or two sentences plus a logo, slogan, or tagline.

If the key consumer benefit's visual/verbal voice is about some kind of danger or employs varied demonstrations or testimonials throughout the campaign, choose alternative media vehicles that can easily and creatively deliver that same message visually. Resurrect colors, typefaces, headline styles, spokespersons and character representatives, slogans and taglines, a unique layout style, or photographic, illustrative, or graphic images wherever possible to ensure campaign compatibility.

Let's take a look at a few examples of how corporations and charitable organizations have employed alternative media.

The human rights group Witness Against Torture used elevator doors as their canvas to campaign for the closing of the Guantanamo Bay detention camp. From the outside, observers could see two sets of fingers that looked like they were attempting to wedge the door open from the inside. Once viewers stepped inside the elevator, they saw the back of that same man in prison garb and leg-cuffs. The copy read, "More than 90% of Guantanamo detainees are held without charge and in extreme isolation. Help stop the abuse. Visit witnesstorture.org."

VIP Gym strongly suggested that people work out a little after that big dinner. To get consumers out of their dinner chairs and running, they covered the backs of chairs in local restaurants with images of flabby, out-of-shape, flattened, naked bottoms, symbolizing the sitters' rear ends: The idea was to let diners know in a not–so-subtle way that they actually might be bigger than they think. Copy read, "VIP GYM. Get up and run."

To bring attention to the plight of starving children in Africa, Feed South Africa placed pictures of undernourished children sitting in the bottom of grocery carts with their hands outstretched. Any items placed in the cart gave the illusion they were going directly into the hands of the very children who needed them most.

And finally, an Australian campaign for water safety placed life-sized posters on the bottom of swimming pools; the graphic depicted a child in swimming trunks lying facedown and motionless. This awareness campaign by Watch Around Water provided a startlingly realistic view of a drowning child from above. Copy read, "Where's Your Child? WATCH AROUND WATER."

Although we have looked at a lot of alternative media examples throughout this text, let's take a brief look at just a few more popular examples.

Product Placement

Very simply, product placement is the placing of a clearly recognizable brand in a movie or television show. Over the last few years, a plethora of paid product placements have appeared in movies, on television shows, and in interactive games. A subtle form of advertising, product placement can be accomplished in three major ways: (1) the product is clearly recognizable in a scene; (2) the brand is used by an actor in a scene; or (3) an actor actually refers to the product by name in a scene.

A viable substitute for traditional or passive advertising, product placement ties brands to a character or theme in a memorable way. Getting a brand logo a close-up is a good use of product placement; getting it integrated into the plot and mentioned in the dialogue is a great way to build brand image and create brand awareness. Subway, for example, took their product and slogan placement one step further by actually having the slogan worked into a script for NBC's *Chuck:* In the episode, one character delivers the recognizable sandwich to another and—as part of the dialogue—recites the sandwich maker's familiar "$5 footlong" slogan. This type of product placement is actually a mini-commercial appearing inside popular programming.

These types of programs, along with the emergence of other narrowly defined programming channels such as the Food Channel or HGTV, which have a small but loyal following of interested viewers, make it easier to pro-

mote the embedded products featured in the programming. It is important that placement not disrupt: The point is to get away from intrusive, in-your-face sales pitches by showing the product in use.

Gaming

In-game advertising can be defined loosely as using computers, television, and mobile marketing vehicles to promote advertising in video games. The earliest in-game advertising included static or unchangeable virtual billboards or varied product placements. Some played no role in the games at all, while others could actually become obstacles the players had to tackle. Today's in-game advertising is dynamic and can be changed out easily to accommodate a new product launch, a reinvention, an event announcement, or an advertisement for a candidate's position on the issues, to name just a few.

Barack Obama used in-game advertising during his run for the White House. Appearing in 18 popular games such as Burnout Paradise, Guitar Hero, and Madden 09, the ads were used to remind players to register, to cast their votes, and to visit the Obama website (www.barackobama.com) for more information. This method proved to be a great way to reach the 18- to 34-year-old target group and became another first for the Obama campaign and new media.

Advergaming is the prominent placement of advertising in free online video games. Nissan used computer games to build buzz for the launch of its GT-R sport coupe. Food and beverage companies like Cheetos and Burger King have also used video games as a brand reminder and to attract attention.

Three-Dimensional Advertising

Three-dimensional advertising is a creative way to make old publishing and technology exciting again. Besides the rebirth of three-dimensional movies, look for three-dimensional ads on television, on cell phones, and in magazines. Known as *augmented reality* (AR), it is commonly seen during football broadcasts that use a yellow line as a first-down marker. Lesser-known users like Papa John's Pizza and the U.S. Postal Service are employing this very interactive and memorable advertising device to create buzz. In Papa John's case, an AR image of a vintage Chevy Camaro was affixed to the back of millions of pizza boxes. Consumers with webcams were directed to a website where they were asked to hold up the image to the video camera, enabling them to use their keyboards to drive an animated version of the 1972 Camaro on their screens. Why a Camaro? The car plays a prominent role in the fast food franchise's current advertising campaign. In the future, Papa John's

wants to place discount offers in its AR images to encourage purchase and better track return on investment.

In a campaign for its flat rate Priority Mail service, the U.S. Postal Service directs consumers to prioritymail.com. Once there, visitors are introduced to a "virtual box simulator." They are asked to place the object to be mailed—perhaps a book or a vase—in front of their webcam so they can receive a three-dimensional image that helps them to determine the proper size of box needed for shipping.

AR is an incredible interactive device, but designers must eliminate all glitches before distribution or launch to ensure consumers will not be disillusioned. AR is on the rise as more and more consumers own computers with built-in webcams. The sheer ingenuity of the device keeps visitors at the site longer, lingering over the three-dimensional images.

In the final analysis, choosing to use guerrilla or alternative media depends on the product or service being advertised. Unique products will stand out without the use of over-the-top stunts or unusual creative ideas; however, products with little or no product differentiation need creative ingenuity to stand out from a crowded competitive pack. Unique messages delivered in unconventional ways will not only attract the target's attention but also create a memorable experience the target will want to pass on via word of mouth, or virally via e-mail or social sites, thus extending the life of the message.

How or whether alternative media should be a part of an IMC campaign will require taking a thorough look at the target, objectives, key consumer benefit, strategy, and brand. If the goal is to build or reinforce brand image, develop awareness, or astound the target, alternative media can help accomplish it: Alternative media engages the target with an advertising event that transforms apathy into curiosity and genuine interest.

Part II. Campaign Development Exercises

1. Each chapter contains two different layouts you can use to develop separate campaigns. Define who you think the target audience is for each one, and what the key consumer benefits might be. For each campaign choose at least two different vehicles and use a diverse set of vehicles to ensure you understand how each one works. Be sure the message matches the existing style and voice of each original ad, and clearly speaks to and reaches the target in a unique way.

2. Begin the first campaign by writing out 15 to 20 creative directions for each vehicle.

3. Compose 5 to 10 headlines for each vehicle that will help to successfully push the key consumer benefit. Be sure to match styles.

4. Next, create 10 to 15 thumbnails for each of the new vehicles.
5. Choose three to four thumbs from each design that can be developed into a multiple vehicle campaign. Remember, each campaign must have at least an additional two pieces beyond the original ad. Do not repeat vehicles.
6. Once completed, write appropriate length body copy for each idea.
7. Create roughs or super comps for each idea.
8. Remember to use the campaign essentials list (see Chapter 1) to ensure the campaign is on-target and on-strategy.
9. Present for critique.
10. Repeat the above exercises for the next campaign. Do not repeat vehicles.

Glossary

Advertising. A nonpersonal, paid form of one-way communication that uses persuasion to sell, entice, educate, remind, and/or entertain the target audience about one specific brand.

Alternative Media. Also called emerging media and new media; media vehicles that are used as an alternative to more traditional vehicles such as print (newspaper and magazine) and broadcast (radio and television). These creative and unusual vehicles deliver meaningful and memorable ads that are often more effective at reaching the target than traditional vehicles.

Ascenders. The lines that extend up from the body of a letterform such as those in the letters "d," "k," or "h."

Assorted Media Mix. An assorted media mix uses a variety of different types of media vehicles throughout the campaign.

Astroturfing. The creation of artificial buzz.

Augmented Reality (AR). A form of three-dimensional imaging used most often on the Internet.

Behavioristics. A research technique used to determine why the target buys.

Big Idea. A big idea is a creative way of promoting the key consumer benefit to make it stand out from other brands within its category.

Billboards. See outdoor boards.

Brainstorming. See conceptual development.

Brand. Refers to a product or service's name and anything used to represent that name visually or verbally.

Brand Awareness. Awareness is achieved when the target uses a brand's visual/verbal identity to recognize it over other brands within the same product category.

Brand-Centric Media. Focuses on the use of traditional media.

Brand Equity. Equity is a brand's value in the mind of the consumer.

Brand Image. Refers to the perceived image of the product or service by the target.

Brand Loyalty. Refers to the customer who regularly repurchases the product or uses the service without the assistance of advertising or exposure to competing products.

Brand Switchers. Consumers who have no loyalty to any single brand and will switch brands based on the current promotion.

Brand Value. A brand's overall worth to the target.

Campaign. A family of ads that share a visual/verbal identity, promote a single idea, and are aimed at a defined target audience.

Cognitive Dissonance. The guilt or remorse that buyers often feel after making a purchase.

Concentrated Media Mix. A concentrated media mix uses one or two single media vehicles.

Conceptual Development. Also known as brainstorming; a technique used by the creative team to come up with a number of possible ideas to promote a product or service.

Consumer-Centric Media. Focuses on the use of new or alternative media vehicles.

Cooperative Advertising. A method of advertising in which local businesses combine advertising efforts with nationally advertised brands to defray some of the cost.

Copytesting. See pretesting.

Creative Brief. Developed by the account manager, a creative brief defines the communications plan of attack.

Creative Strategy. The creative strategy defines how creative efforts will accomplish the stated objectives, promote the key consumer benefit, and talk to the target.

Crossruffing. Crossruffing takes place when a coupon is placed on or within packaging or when brands share a cooperative advertising offer.

Customer Relationship Marketing. Also known as direct marketing, this form of personalized advertising builds and maintains a relationship between buyer and seller.

Database Marketing. The collection of a detailed list of customer names and contact information created by an individual marketer.

Demographics. Deals with the target's personal characteristics such as gender, age, income, education, etc.

Descenders. The lines that extend below the body of a letterform, as in the letters "p," "g," and "j."

Die Cuts. A cutting method that can partially or completely cut out or around a specially designed shape.

Direct Marketing. A form of personalized advertising that is delivered directly to an individual rather than a mass audience.

Direct Response. A form of direct marketing that encourages the target to make a call, visit a website or brick and mortar store for more information, or make a purchase.

Elements of Design. The building blocks of a design's visual structure.

E-mail Marketing. See permission marketing.

Emerging Media. See alternative media.

Essential Verbal Design Elements. These copy components include headlines, subheads, body copy, slogans or taglines, and jingles.

Essential Visual Design Elements. These visual components include layout styles, visual images, typeface and style, spokespersons or character representatives, and color and logos.

Experiential Marketing. Marketing that is both participatory and personally relevant to the target.

Extensions. The part of an outdoor board that extends beyond the main surface of the board.

Focus Groups. Usually these groups consist of 10 to 12 representative members of the target audience who will interact with the brand in a controlled environment.

Font. The set of uppercase and lowercase characters, numbers, and punctuation marks that make up a style of typeface.

Formal Surveys. Surveys that use closed-ended questions where participants choose from a predetermined set of responses.

Freestanding Insert (FSI). Also known as supplemental advertising, an FSI is a series of coupons that are often reproduced in four-color and not physically attached to an ad.

Geographics. Breaks down where the target lives by country, region, province, state, city, or zip code.

Guerrilla Marketing. A form of nontraditional advertising that uses unconventional means to attract attention, generate sales, and create memorable encounters.

Influence Marketing. Pairs a brand with influential members within the target's life (such as hairstylists, DJs, and so on) to openly discuss a brand's perceived virtues.

Infomercials. A form of direct response, infomercials are long television commercials that last 30 to 60 minutes.

Informal Surveys. Open-ended surveys that allow participants to give their opinions.

Instant Redemption Coupons. Coupons that can be used immediately at the time of purchase.

Integrated Marketing Communication (IMC). IMC is all about creating a relationship with the intended audience and delivering one coordinated message through multiple media vehicles.

Issue Advertising. Highlights important issues such as health care to legislators, other members of government, or the public at large.

Jingle. A catchy tune used in commercials that reminds the target of what the brand does or how it is used.

Junk Mail. A derogatory term used to describe direct mail.

Kerning. Refers to the amount of white space appearing between letter-forms.

Key Consumer Benefit (KCB). The KCB refers to the one brand feature and its benefit to the target that research has shown the defined target is interested in and will respond to. It becomes the single visual/verbal voice of a campaign.

Layout Styles. The diverse and eye-catching ways in which essential elements can be arranged on the page.

Leading. Pronounced "LEDD-ing"; refers to the amount of white space that appears between lines of text.

Legibility. Refers to how quickly and easily an ad can be read and understood.

Life Cycle Stages. Refers to a brand's length of time on the market. Most successful brands go through three separate stages in their lifetime: the new product launch, the mainstream or maintenance period, and the reinvention phase.

Lobbyist. The designated person who is paid to present an organization's or a corporation's point of view in order to influence government officials to vote in their favor.

Logo. A logo is a recognizable emblem found on all advertised or promoted materials. Its job is to represent the company's brand (or the service's name), image, or use.

M-commerce. Mobile advertising.

Magazine Bleed. The area outside the trim where images or blocks of color can extend.

Magazine Live Area. The area located inside the trim that ensures type will not be cut off accidentally during printing.

Magazine Trim. The specified size of an ad after being printed and bound.

Marketing Plan. This large document is the client's business plan of action that defines sales initiatives, usually for the coming year.

Mechanical. Is where the rough or super comprehensive (or computer generated design) is broken down into its individual parts and colors in preparation for final printing.

Media Convergence. When alternative media and/or traditional vehicles successfully deliver a cohesive message.

Media Mix. The media mix dissects the promotional mix into individual vehicles such as direct mail, TV, magazines, and so on.

Media Multitasking. Brands using a varied mix of media resources.

Media Vehicle. Any surface flat or otherwise that can be used to deliver a message to the relevant target.

Mobile Video (MV). The ability to watch TV via one's mobile phone.

Multimedia-Messaging Service (MMS). An extension of short message service (SMS), MMS allows users to send longer text messages and to send and receive mobile photographs and audio and video clips.

Multiple Selling Propositions (MSP). A way to promote the key consumer benefit using multiple rotating messages in multiple media vehicles; the goal is to sell one feature/benefit combination to the target.

New Media. See alternative media.

Niche Market. Advertising efforts that are focused on a small, underserved, narrowly defined group that is not targeted by a competitor.

Objectives. Objectives define what an ad or campaign needs to accomplish.

Observation Tactics. Involves watching the target in the place where the product or service is purchased or used to help determine ease of use, types of comparisons made, level of difficulty to assemble, and so on.

On-location Shoot. A television shoot that takes place outside of a controlled environment.

Orphans. In a multicolumn display, an orphan occurs when one or two short words end a line of text that appears alone at the top of an adjoining column.

Outdoor Boards. Also known as billboards, these huge signs can be found along any street or highway and direct commuters to local establishments or events.

Out-of-Home Advertising. Any advertising seen outside the home.

Pantone Matching System (PMS). A numbered color system used in printing and many desktop publishing software packages to match specific colors used in a design.

Permission Marketing. Also known as e-mail marketing; a form of advertising in which the targets give their permission to be contacted.

Piggybacking. When a brand purchases one 30-second television or radio spot and breaks it into two separate but related 15-second spots.

Point of Purchase Displays (POP). Stand-alone displays found along store aisles or at the end of an aisle.

Positioning. Positioning refers to how a brand is thought of or positioned in the mind of the consumer compared to competing brands.

Posttesting. A means of periodically checking on how a brand is performing either during a campaign's life cycle or upon the completion of a campaign.

Premium Short Message Service (PSMS). Allows consumers to use their mobile phones to purchase something (a ring tone, for example).

Press Release. A news article that is sent unsolicited to a newspaper editor or reporter about a brand, service, person, or event.

Pretesting. Also known as copytesting, pretesting allows members of a focus group to read and comment on the informative quality of copy.

Primary Target Audience. That group of individuals currently using the brand, having used the brand in the past, or being targeted as most likely to use the product or service in the future.

Principles of Design. The principles of design are the visual rules that govern the way the elements of design are used on the page.

Product Features and Benefits. The section of the creative brief that lays out a brand's features or attributes and their benefits to the target audience.

Product Placement. The placing of a clearly recognizable brand in a movie or television show.

Promotional Device. An incentive that helps to make a quick sale.

Promotional Mix. The mix of media vehicles—such as advertising, direct marketing, outdoor and so forth—that is employed within a campaign.

Psychographics. Deals with lifestyle issues, attitudes, beliefs, activities, and personal interests of the target audience.

Public Relations. A mostly nonpaid source of news that focuses on building, maintaining, or reinforcing the relationship between a company and its key external audiences.

Publicity. The result of sustained public relations planning to make a brand, service, cause, person, or organization newsworthy.

Publics. The outside audience targeted by public relations practitioners.

Qualitative Research. Secondary research that already exists or can be collected via open-ended surveys or farmed from focus groups.

Quantitative Research. Primary research that involves collecting new research in order to find an answer to a particular set of marketing needs.

Readability. Refers to whether an ad can be read quickly and easily.

Relationship Marketing. A marketing strategy that is defined by the amount of one-on-one interaction that takes place between the brand and the target.

Repositioning. A brand is repositioned when its image is changed in order to attract a new target market.

Reverse. The placement of light-colored text on a black or dark-colored background.

Roughs. Full-size renderings of what the final design idea will look like.

RSS. An acronym for Rich Site Summary or Really Simple Syndication; a subscription-based group of web-based formats that deliver constantly changing audio and video web updates.

Sales Promotion. Giving the target an incentive; for instance, a coupon or gift in exchange for loyalty or trial.

Sans Serif Typeface. A sturdy, solid, unembellished style of typeface; for example, Arial.

Scenes. The video portion of a television storyboard.

Screen Tint. A tint of one or more colors appearing in an ad. A great way to add depth and color with little additional cost.

Script. The audio portion of a television or radio commercial.

Secondary Target Audience. That group of individuals—typically family and friends—most likely to influence a purchase or those most likely to purchase a product on behalf of the primary audience.

Serif Typeface. A style of typeface that has fine lines and delicate feet or extensions; for example, Times New Roman.

Share of Voice. Refers to a brand's equity or dominance within its brand category based on the percentage of advertising dollars spent as compared to other competitors.

Shareholders. The inside audience targeted by public relations practitioners.

Short Message Service (SMS). A mobile text message that may or may not include a link to a sponsoring Internet site.

Skyscrapers. A skyscraper is a vertical banner ad used on the web.

Slogans. Usually located by the logo, a short statement of the company's mission statement or philosophy.

Sound Effects (SFX). The sounds heard on radio and television beyond dialogue.

Spot Color. The addition of one or more colors to a black-and-white photograph.

Stealth Marketing. Also known as word of mouth, buzz, or ambush marketing, this type of marketing often uses actors to talk about or use a product in social situations.

Storyboard. The combined audio and video portion of a television commercial.

Super Comprehensives. A finished design executed on the computer.

Supplemental Advertising. See freestanding insert (FSI).

Support Statement. An additional feature/benefit combination found on the creative brief that will be pushed in advertising and promotional efforts.

Taglines. Usually located by the logo, a tagline has a shorter life span than a slogan and is usually no more than a short statement of the current campaign's theme or creative direction.

Target Audience. Also known as the target market; the group of individuals that research has shown to be most likely to buy the product or use the service.

Target Market. See target audience.

Text Wrap. A way to lay out type so it will wrap around an image.

Thumbnails. Small proportionate drawings that are used to get preliminary ideas down on paper.

Tone. Gives the key consumer benefit a visual/verbal voice and defines the brand's personality and image through the use of humor, demonstrations, testimonials and so forth.

Transit Advertising. Any advertising that appears on the interior or exterior of buses, taxis, subway cars, commuter trains, and ferries, or at stations, platforms, terminals, and bus stops or benches.

Type Weight. The thick or thinness of a typeface's body.

Typeface. The name given to an individual set of letterforms such as Futura or Garamond.

Unique Selling Proposition (USP). If a brand is new or has a unique feature competitors do not have, the key consumer benefit can be promoted using a USP.

User Generated Content. Information that is passed along by consumers via e-mail, Internet postings, or word of mouth.

Visual Images. A way to show a product or service through photographs, illustrations, graphic designs, spokespersons, character representatives, or clip or line art.

Viral Marketing. Also called word-of-mouth marketing; an advertising message that is passed along between acquaintances on the Internet.

Wallscapes. Large outdoor boards that are hand painted on the sides of buildings or hung off the sides of buildings.

Webcast. Delivery of a one-way flow of information to the viewer.

Webinar. A web-based seminar that allows the user to conduct live meetings, lectures, seminars, or workshops on the Internet at either a predetermined time or on demand.

Widow. Widow refers to one word or possibly two short words that appear alone at the end of a paragraph or column of text.

Wireframe. A way of organizing a web page during the design stage.

Wireless Application Protocol (WAP). A wireless web connection.

Word-of-Mouth Marketing. See viral marketing.

Bibliography

Allen, Gemmy, and Georganna Zaba. *Internet Resources for Integrated Marketing Communication.* Orlando, FL: Harcourt, 2000.

American Marketing Association. "Marketing Power." www.marketingpower.com, 2011. http://www.marketingpower.com/_layouts/Dictionary.aspx?Letter=D.

Avery, Jim. *Advertising Campaign Planning.* Chicago, IL: Copy Workshop, 2000.

Bangs, David H. *The Market Planning Guide.* 5th ed. Chicago, IL: Upstart Publishing, 1998.

Bendinger, Bruce. *The Copy Workshop Workbook.* Chicago, IL: Copy Workshop, 1993.

Berman, Margo. *Street-Smart Advertising: How to Win the Battle of the Buzz.* Lanham, MD: Rowman & Littlefield Publishers, 2007.

Bernbach, William. *Bill Bernbach Said. . . .* New York: DDB Needham Worldwide Books, 1989, p. 87.

Blake, Gary, and Robert W. Bly. *The Elements of Copywriting.* New York: Simon & Schuster, 1997.

Blakeman, Robyn. *The Bare Bones of Advertising Print Design.* Boulder, CO: Rowman & Littlefield Publishers, 2004.

———. *Integrated Marketing Communication: Creative Strategy from Idea to Implementation.* Boulder, CO: Rowman & Littlefield Publishers, 2007.

———. *The Bare Bones Introduction to Integrated Marketing Communication.* Lanham, MD: Rowman & Littlefield Publishers, 2009.

Blanchard, Robert. "Parting Essay." July 1999. Excerpted on Brand / Cool Marketing: Resources, Brand Quotes. http://brandcool.com/node/21.

Book, Albert, C., and Dennis C. Schick. *Fundamentals of Copy and Layout.* 3d ed. Lincolnwood, IL: NTC Business Books, 1997.

Burnett, John, and Sandra Moriarty. *Introduction to Marketing Communications.* Upper Saddle River, NJ: Prentice Hall, 1998.

Burnett, Leo. *100 LEO's.* Lincolnwood, IL: NTC Business Books, 1995, p. 52.

Burton, Philip Ward. *Advertising Copywriting.* 7th ed. Lincolnwood, IL: NTC Business Books, 1999.

Clow, Kenneth A., and Donald Baack. *Integrated Advertising, Promotion and Marketing Communications.* Upper Saddle River, NJ: Prentice Hall, 2002.

Della Femina, Jerry. *From Those Wonderful Folks Who Gave You Pearl Harbor.* New York: Simon & Schuster, 1970.

Duncan, Tom. *IMC: Using Advertising and Promotion to Build Brands.* Boston, MA: McGraw-Hill, 2002.

Evans, Joel R., and Barry Berman. *Marketing.* 4th ed. New York: Macmillan, 1990.

Guth, David W., and Charles Marsh. *Public Relations: A Values-Driven Approach.* 2d ed. Boston, MA: Allyn and Bacon, 2003.

Hafer, Keith W., and Gordon E. White. *Advertising Writing.* St. Paul, MN: West Publishing, 1977.

"Herd on the Street," www.brandweek.com, December 2008. http://brandweek. printthis.clickability.com/pt/cpt?/action=cpt&title= .

Hester, Edward L. *Successful Marketing Research.* New York: Wiley, 1996.

Jakacki, Bernard C. *IMC: An Integrated Marketing Communications Exercise.* Cincinnati, OH: South-Western College Publishing, 2001.

Jaffe, Joseph. *Life After the 30-Second Spot: Energize Your Brand with a Bold Mix of Alternatives to Traditional Advertising.* New York: Wiley, 2005.

Jay, Ros. *Marketing on a Budget.* Boston, MA: International Thomson Business Press, 1998.

Jewler, A. Jerome, and Bonnie L. Drewniany. *Creative Strategy in Advertising.* Belmont, CA: Thomson Wadsworth, 2005.

Jones, Susan K. *Creative Strategy in Direct Marketing.* 2d ed. Chicago, IL: NTC Business Books, 1998.

Krugman, Dean M., Leonard N. Reid, S. Watson Dunn, and Arnold M. Barban. *Advertising: Its Role in Modern Marketing.* 8th ed. Fort Worth, TX: Dryden, 1994.

Levinson, Jay Conrad. *Guerrilla Creativity.* New York: Houghton Mifflin Company, 2001.

———. *Guerrilla Marketing.* 4th ed. New York: Houghton Mifflin Company, 2007.

Malickson, David L., and John W. Nason. *Advertising: How to Write the Kind That Works.* New York: Charles Scribner's Sons, 1977.

McDonald, William J. *Direct Marketing: An Integrated Approach.* Boston, MA: Irwin/ McGraw-Hill, 1998.

Mitchell, Alan. "Out of the Shadows." *Journal of Marketing Management* 15, no. 1–3 (January-April 1999): 25–42. www.brandcoolmarketing.com.

Mobile Marketing Association. mmaglobal.com, 2009. http://mmaglobal.com/news/ mma-updates-definition-mobile-marketing.

Monahan, Tom. *The Do It Yourself Lobotomy.* New York: John Wiley & Sons, 2002.

Moscardelli, Deborah M. *Advertising on the Internet.* Upper Saddle River, NJ: Prentice Hall, 1999.

Ogden, James R. *Developing a Creative and Innovative Integrated Marketing Communication Plan: A Working Model.* Upper Saddle River, NJ: Prentice Hall, 1998.

Ogilvy, David. *Ogilvy on Advertising.* New York: Vintage Books, 1985.

———. *Confessions of an Advertising Man.* New York: Ballantine Books, 1971.

O'Guinn, Thomas C., Chris T. Allen, and Richard J. Semenik. *Advertising and Integrated Brand Promotion.* 3d ed. Mason, OH: South-Western Educational Publishing, 2003.

Parente, Donald, Bruce Vanden Bergh, Arnold Barban, and James Marra. *Advertising Campaign Strategy: A Guide to Marketing Communication Plans.* Orlando, FL: Dryden, 1996.

Percy, Larry. *Strategies for Implementing Integrated Marketing Communication.* Chicago, IL: NTC Business Books, 1997.

Peterson, Robin T. *Principles of Marketing.* Orlando, FL: Harcourt Brace Jovanovich, 1989.

Reeves, Rosser. *Reality in Advertising.* New York: Alfred A Knopf, 1981.

Ries, Al, and Jack Trout. *Positioning: The Battle for Your Mind.* New York: McGraw-Hill, 2000.

Rothenberg, Randall. *Where the Suckers Moon: An Advertising Story.* New York: Alfred A. Knopf, 1994.

"Secondary vs. Primary Market Research." AllBusiness.com, July 2009. http://www.allbusiness.com/marketing/market-research/1310–1.html.

Shimp, Terence A. *Advertising Promotion: Supplemental Aspects of Integrated Marketing Communication.* 5th ed. Orlando, FL: Dryden, 2000.

Sirgy, Joseph M. *Integrated Marketing Communication: A Systems Approach.* Upper Saddle River, NJ: Prentice Hall, 1998.

Throckmorton, Joan. *Winning Direct Response Advertising.* 2d ed. Lincolnwood, IL: NTC Business Books, 1997.

van Bel, Egbert Jan. "Want Loyalty? Buy a Dog!" TheMarketingSite.com, 2004. http://www.themarketingsite.com/live/content.php?Item_ID=3569&Revision=en%2F1&Start=0.

Vanden Bergh, Bruce, and Helen Katz. *Advertising Principles.* Lincolnwood, IL: NTC Business Books, 1999.

Wilcox, Dennis L., Glen T. Cameron, Philip H. Ault, and Warren K. Agee. *Public Relations Strategies and Tactics.* 7th ed. Boston, MA: Allyn and Bacon, 2003.

Index

Italic page references indicate photographs and boxed text.

Advertising, 104. *See also* Campaign, advertising; *specific type*; Traditional advertising
Advil ads, *38, 174*
Aflac ads, 49, 122, 143
Agri Feed & Supply ad, *54*
Alignments of type, 64, 70–71
Alka Seltzer's song, 87
AllBusiness.com, 30
Allstate ads, 7
Alternative media. *See also specific type*
 defining, 215
 diversity of, 220
 Integrated Marketing Communication and, 4, 215–216, 220–223
 popularity of, 221
 strengths of, 214–215
 in supporting role, 220–221
 target audience and, reaching, 213–214
 visual/verbal messages of, 217–221
 weaknesses of, 215
AMA, 16, 175
Ambush marketing, 211
American Marketing Association (AMA), 16, 175
Analogy, 83
Annual reports, 122–123
Anomaly as design principle, 59
Apple ads and brand, 7, 19, 47, 127, 130, 143, 201
Approval phase of design, 62–64
AR, 222–223
Ascenders, 67
Assorted media mix, 15
Astroturfing, 210
Asymmetrical design, 58–59
AT&T ads, 130
Athlete as spokesperson, 93

Augmented reality (AR), 222–223
Avis ads and brand, 47–48
Awareness of brand, 5, 13, 39

Balance as design principle, 58
Bally Total Fitness cooperative promotion, 180
Banner ads, 197–198
Bayer Aspirin ads, 48
Behavioristic profiles, 18, 33
Bench advertising, 155–156
Bennett Galleries ad, *148*
Bernbach, William "Bill," 17
Big type layout style, 88
Billboards, 150–152
Blair Witch Project, The (film), 210
Blanchard, Robert, 39, 41
Bleed part of ad, 134
Bleeding (running of ink), 75
Blogs, 188
Body copy. *See also* Copywriting; Type
 background color and, 97
 in brochure, 168
 in catalogs, 162–163
 easy-to-read, 70, 75
 in geometric layout, 64
 in interior cards, 153–154
 leading of, 70
 in magazines, 75, 134
 in newspapers, 75, 129
 in press releases, 116
 in print ads, 75
 readability of, 70
 in roughs, 60
 in transit advertising, 153
 on websites, 195
Bonus packs, 182
Borders (frames), 89, 130

Bosch Security Systems guerrilla
 marketing, 210
Brainstorming, 16, 51–53
Brand. *See also specific name*
 awareness, 5, 13, 39
 benefits, 18–19
 building, 39–41
 buzz, 28, 109, 210–211
 campaign and, advertising, 7
 customer service and, 44
 defining, 39
 developing, 39–40
 employees in managing, 43–44
 equity, maintaining, 8, 44–45
 essence, 41
 features, 18–19
 as generic label, 45
 identity, 53–55
 image, 5, 40–41, 49
 Integrated Marketing Communication
 and, 43
 launching, 5
 life cycle stage, 12–13, 49
 loyalty, 4, 41–43
 media vehicles and, 13
 memorable, 8
 message, 49
 name of, 40
 performance, 40
 personality of, 56
 positioning, 19, 46–47
 pricing of, 45
 primary market segment and, 35
 reinventing, 5
 repositioning, 47–48
 reputation, 41
 secondary market segment and, 35
 story of, 85–86
 strengths of, 40
 switchers, 176
 symbols encompassing, 48–49
 testimonials and, 133
 traditional advertising and, 5
 value, 48
 weaknesses of, 40
Brand-centric media vehicles, 214
Broadcast media, 76–77. *See also* Radio
Brochures, 75, 167–170
Browsers, 194
Burnett, Leo, 51, 143
Burnout Paradise game, 222

Bus advertising and wraps, 154–155
Business plan, 17
Businesses, 16–17. *See also specific
 name*
Buzz, 28, 109, 210–211

California Milk Producers guerrilla
 marketing, 210–211
Callouts, 128–129
Campaign, advertising
 appearance of, 14–15
 brand and, 7
 cost of, 8
 defining, 6–7
 essentials, list of, *26*
 exercises, 100, 223–224
 goals, 14
 key consumer benefits and, 7
 life cycle of, 7–9
 logo and, 7
 marketing plan and, 16–20
 media vehicles for, selecting, 13, 15,
 80–81
 message of, 12–13, 55
 multimedia, 73–76
 on-strategy, 20
 product placement and, 7
 public relations and, 9
 reasons for employing, 8–9
 research and, marketing, 28
 sound of, 14–15
 successful, 6–7, 13–15, 20–21, *21*, 28
 target of, 6
 tone of, 6, 20
 top 100, 22–25
 types of, 9–11, *12*
 unifying image and message in, 8–9
 visual/verbal aspect of, 55, 79–81
Capital One ads, 7
Carlin, George, 115
Cartoon Network ads, 18
Catalogs, 75, 162–163
Celebrity as spokesperson, 93
Cell phones, 206–207
Center on center alignment, 64, 70
Chambers of Commerce, 30
Changes to design, 62–63
Character representatives, 9, 92–94
Chevy Camaro ads, 222
Chick-fil-A ads, 150–151
Chuck (NBC series), 221

Circus layout, 88–89
Clip art, 92
Clutter in design, 129
CMYK color acronym, 96
Cognitive dissonance, 36
Coke ads, 48–49
Color
 background of body copy and, 97
 in catalogs, 162
 CMYK acronym, 96
 as design element, 57
 of headlines, 97
 meanings of, diverse, 57, 97
 in mechanicals, 62
 Pantone matching system, 97–98
 reverses, 98
 screen tints, 98
 spot, 98
 symbolism of, 94–96
 type, 72
 visual/verbal messages and, 97
 on websites, 194–195
 wheel, 96–97
Comcast Cable, 202
Communication objectives, 18
Community relations, 110
Comparative brand name, 40
Concentrated mix, 15
Concentration as design principle, 59
Conceptual development, 51–53, 59–60
Consumer benefit. See Key consumer
 benefit
Consumer-centric media vehicles, 214
Contests, 185–186
Contrast as design principle, 58
Cooperative advertising and promotion,
 130, 180
Copy. See Body copy; Copywriting;
 Type
Copy-heavy layout style, 89
Copytesting, 31–32
Copywriting
 design elements, placing on page,
 99–100
 images and key consumer benefit and,
 79
 layout styles and, 88–91
 verbal design
 brand story and, 85–86
 detail copy, 86
 headlines, 81–84

Copywriting
 verbal design (continued)
 jingle, 86–87
 overview, 81
 slogans, 86
 subheads, 84–85
 taglines, 86
 visual design
 character representative, 92–94
 color symbolism, 94–98
 graphics, 92
 illustrations, 92
 layout styles, 88–91
 logo, 98–99
 overview, 87–88, 91
 photographs, 91–92
 spokesperson, 92–93
 visual images, 91–92
 visual/verbal message and, 79–81
Corporate advertising campaigns, 10–11.
 See also specific name
Coupons, 178–182
Crate&Barrel catalog, 162
Creative brief, 16–20
Creative phase of design, 51–57
Creative strategy, 20
Crisis communication, 110
Cross-product promotion, 180
Crossruffing, 180
Customer feedback mechanism, 17
Customer service, 44, 190

Database marketing, 159
Databases, 11, 159
DDB advertising agency, 210
Deadlines, 63
Decider audience, 37
Della Femina, Jerry, 40
Demographic profiles, 18, 32
Descenders, 67
Descriptive brand name, 40
Design. See also Copywriting; Type
 of annual report, 122–123
 approval phase, 62–64
 asymmetrical, 58–59
 brand identity and, 53–55
 of brochures, 167–168
 of catalogs, 163
 changes, 62–63
 clutter and, 129
 of coupons, 181–182

Design *(continued)*
 creative phase, 51–57
 development phase, 59–62
 of direct mail, 164–167, 171
 elements, 57–58
 geometric layouts of, 63–64
 of headlines, 81–84
 of logo, 99
 of newsletters, 120–122
 of press releases, 116–117, *118*
 principles, 57–59
 of subheads, 84–85
 symmetrical, 59
 of websites, 193–195
Destination website, 189
Detail copy, 64, 86
Development phase of design, 59–62
Die cuts, 168
DiGiorno ads on social media sites, 202
Digital LED boards, 152–153
Digital mobile outdoor boards, 156
Direct mail, 75, 163–167, 171
Direct marketing. *See also specific type*
 direct response and, 145, 158
 Integrated Marketing Communication
 and, 158–159, 173
 popularity of, 158
 as promotional device, 158
 strengths of, 158, 161
 traditional advertising and, 160
 types of, 161–173
 visual/verbal messages of, 161
 weaknesses of, 161
Direct response ads, 145, 158
Direction of type, 72
Dominance as design principle, 58
Domino's Pizza ads, 11
Dunkin Donuts sweepstakes, 186

E-mail marketing, 199
E-mail messages, 77, 159, 200
Electronic media. *See also specific type*
 buzz and, 109
 destination website, 189
 education of audience and, 189–190
 informational website, 189
 Integrated Marketing Communication
 and, 188
 interaction with audience and, 189–190
 press releases, 116
 relationship building and, 190

Electronic media *(continued)*
 strengths of, 192
 target audience and, 189–190
 technical limitations of, 195–197
 type design for, 76–77
 visual/verbal messages of, 194–197
 weaknesses of, 191–192
 website design and, 193–195
Embargo, 116
Employees and brand management,
 43–44
Energizer ads, 13, 93, 122
Engagement, successful, 5–6
Envelopes, 165, 170–171
Equity, maintaining brand, 8, 44–45
Esurance ads on social media sites, 202
Ethnic group segmentation, 33
Event graffiti, 212–213
Execution style or technique, 6, 20
Experiential marketing, 155
Extension in out-of-home advertising,
 151
External employees, 43–44
Eye flow as design principle, 58
Eyeballing type, 69

Facebook, 201–202
Fact sheets, 119
Flash mobs, 184
Floating ads, 199
Flogos, 213
Flush left, ragged right alignment, 64, 70
Focus groups, 28, 30–31
Folding brochures, 168–170
Foldouts, 135
Font, 66. *See also* Type
Food4Africa project, 11
Ford Motor Company brand, 45
Formal surveys, 29
Frame layout style, 89
Framing print ad, 130
Free-standing inserts (FSIs), 179–180
Free trials, 180, 184
FreeCreditReport.com song, 87, 145
FSIs, 179–180

Games, 185–186
Gaming, 222
Gatefolds, 135
GEICO ads, 20, 49, 93, 123, 143
General Electric banner ads, 198

Geographic profiles, 18, 33
Geometric layouts, 63–64
GNC ads, *95, 196*
Goosebumps HorrorLand interactive
 game, 209
Graphics, 9, 92
Green Giant character representative, 94
Guarantees, 186
Guerrilla marketing, 4, 155, 209–211.
 See also specific type
Guerrilla video projection, 212
Guitar Hero game, 222

Harley Davidson ads, 35
Harmony as design principle, 59
Headlines
 in brochure, 168
 color of, 97
 common styles of, 82–83
 design of, 81–84
 in geometric layout, 63–64
 key consumer benefits and, 81–82, 84
 price and, 84, 128
 in print ads, 75
 in roughs, 60
 subheads and, 84
Hertz brand, 47
Hills Science Diet ad, *112*
Horizontal banner ads, 197–198
Hulu (Internet entertainment), 203
Hurricane Katrina (2005), 11

Ideas, great and "big," 16–17, 51, 56–57
Identity, brand, 53–55
IKEA guerrilla marketing, 209–210
Illustrations, 9, 92
Image
 brand, 5, 40–41, 49
 in catalogs, 162
 employees in managing, 43–44
 with key consumer benefits, 79
 personality and, 40–41
 promoting, 8
 public relations in managing, 110–111
 type and, 66–67
 unifying with message, 8–9
 on websites, 195
Image-based retail advertising, 11
IMC. *See* Integrated Marketing
 Communication
Influencer audience, 37

Infomercials, 145–146
Informal surveys, 29
Informational website, 189
Initiator audience, 37
Inset graphic borders, 130
Inside out approach, 10
Instant redemption coupons, 178
Integrated Marketing Communication
 (IMC)
 alternative media and, 4, 215–216,
 220–223
 brand and, 43
 customer feedback mechanism and, 17
 defining, 4–5
 direct mail and, 164
 direct marketing and, 158–159, 173
 electronic media and, 188
 guerrilla marketing and, 209–211
 marketing plan and, 16–20
 marketing public relations and, 106–
 107
 media mix and, 5–6
 out-of-home media and, 4
 popularity of, 4–5
 public relations and, 104–107, 113–115
 radio and, 136
 sales promotion and, 175–176
 successful, 79
 traditional advertising and, 4–6,
 125–126
 websites and, 188
Interactive devices, 165, 178. *See also
 specific type*
Interactive folds, 135
Interactive television, 172–173
Interface, Inc., 209
Interior cards, 153–154
Internal employees, 43–44
Internet, 188, 191, 197–203. *See also*
 Electronic media; Websites
Interstitial ads, 198–199
iPhones, 207
Issue advertising, 115

Jack in the Box ads, 189
JCPenney catalog, 162
Jingle, 9, 40–41, 86–87, 138
Johnson & Johnson mobile ads, 207
Junk mail, 75, 163–165
Justified left and right alignment, 64,
 70

K·B Toys ads, *103, 124, 187, 208*
Keebler Elf character representative, 94
Keep Holland Clean Foundation ads,
 154
Kellogg's character representative, 94
Kerning, 68–69, 74
Key consumer benefits
 brand building and, 39
 campaign and, advertising, 7
 headlines and, 81–82, 84
 image and, 79
 images with, 79
 importance of, 19
 out-of-home media and, 150
 promoting, 19–20, 39
Kiosks, 156
Kleenex brand, 45
Knoxville Museum of Art ads, *121, 144*
Knoxville Zoo ads, *78, 216, 217*
Kraft phone app, 207
Kraft's Stove Top Stuffing Mix ads, 155

Layout
 of annual reports, 122–123
 geometric, 63–64
 styles, 88–91
 in super comprehensives, 60–61
 as unifying images in campaign,
 advertising, 9
 of websites, 194–195
Leading of type, 68, 70, 74
Legibility of type or message, 66, 69, 97
Letters, 165–167. *See also specific type*
Life cycle of advertising campaign, 7–9
Line art, 92
Line as design element, 57
Live part of ad, 134
Lobbying and lobbyists, 115
Local advertising campaigns, 10
Logo
 campaign and, advertising, 7
 in copywriting visual design, 98–99
 as core identity of brand, 49
 on coupon, 182
 in creative brief, 20
 design of, 99
 flying, 213
 in roughs, 60
 types, 98–99
Loyalty, brand, 4, 41–43

M. Booth and Associates, Inc., 104
M-commerce, 203–207
Madden 09 game, 222
Magalogs, 171
Magazines
 advertising, 131–135
 body copy in, 75, 134
 interactive opportunities of, 25
 special-interest, 133
 type design, 75
 visual/verbal messages of, 129–130,
 133–134
Market segmentation, 33–35
Marketing, 104
Marketing plan, 16–20
Marketing public relations (MPR),
 106–107
Marketing research. *See* Research,
 marketing
Mass media advertising. *See* Traditional
 advertising
McDonald's ads and brand, 49, 92, 127,
 213
McDonald's character representative, 94
Mechanical boards, 152
Mechanicals, 61–62
Media kits, 117, 119
Media mix, 5–6, 15
Media vehicles. *See also specific type*
 brand and, 13
 brand-centric, 214
 consumer-centric, 214
 research for identifying best, 37
 return on investment and, 5
 selecting, 13, 15, 80–81, 125–126, 214
 type design for multiple, 72–77
 visual/verbal messages and, 80–81
Message. *See also* Visual/verbal
 messages
 brand, 49
 of campaign, advertising, 12–13, 55
 legibility of, 97
 "me too" or "wanna be," 34
 out-of-home media, 148–149
 of radio, 137
 readability of, 97
 unifying with image, 8–9
Metaphor, 83
Mitchell, Alan, 5
Mitchell, Paul, 11
MMS, 205

Mobile Marketing Association, 203
Mobile media, 203–207
Mobile outdoor boards, 156
Mobile video (MV), 205
Mondrian layout style, 89
Monty, Scott, 45
Morton Sea Salt ad, *61*
MPR, 106–107
Mr. Clean character representative, 94
MSP, 19–20
Multi-panel layout style, 89–90
Multi-sensory advertising, 155
Multimedia advertising campaign,
 73–76
Multimedia-messaging service (MMS),
 205
Multiple selling proposition (MSP),
 19–20
Mural street art, 212–213
Murals, 153, 212–213
MV, 205

National advertising campaigns, 9–10
Negative/positive space as design
 principle, 58
New media, 9, 215, 222
Newsletters, 75, 119–122
Newspapers
 advertising, 127–130
 body copy in, 75, 129
 interactive opportunities of, 125
 type design, 74–75
 visual/verbal messages of, 129–130
Niche markets, 35, 110
Niche websites, 192
Nike brand, 92

Obama 2008 logo, 99
Obama, Barack, 206, 222
Ogilvy, David, 40, 49
On-location shoots, 146–147
On-strategy, 20
Order forms, 170
Orphan (line break), 71
Oscar Meyer Weiner song, 87
Out-of-home media. *See also specific*
 type
 extension and, 151
 Integrated Marketing Communication
 and, 4
 key consumer benefits and, 150

Out-of-home media *(continued)*
 message, 148–149
 strengths of, 150
 type design for, 76
 types of, 150–156
 visual/verbal messages of, 150–153
 weaknesses of, 150
Outside envelope, 165

Package insert programs (PIP), 182–183
Pantone matching system (PMS), 97–98
Papa John's Pizza ads, 222–223
Pay-per-click, 203
Percy, Larry, 36–37
Permission marketing, 199
Personal digital assistants (PDAs), 207
Personality of brand or image, 40–41, 56
PetSmart ads, *74, 162, 183*
Photographs, 9, 91–92
Picture window layout style, 90
Pictures, 9, 91–92
Piggybacking, 145
Pillsbury ads, 13
Pillsbury Doughboy character
 representative, 94
Pink Ribbon breast cancer brand, 92
PIP, 182–183
Pitch letters, 119
Placement of product, 7, 221–222
PMS, 97–98
Point of purchase (POP) advertising,
 184–185
Polaroid ads, 35
Polypaks, 171
POP advertising, 184–185
Pop-unders, 198
Pop-ups, 198, 212
Positioning, brand or product, 19, 46–47
Posttesting, 30, 32
Posters, 75–76, 155
Pottery Barn catalog, 162
Premium short message service (PSMS),
 204–205
Premiums, 185
Press kits, 117, 119
Press releases, 115–117, *118*
Pretesting, 30–32
Pricing, 11, 45, 128–129, 182
Primary market research, 30
Primary target audience, 18, 35
Principles of design, 57–59

Print ads and type design, 73–76, 129–130. *See also specific type*
Priority Mail service ads, 223
Procter & Gamble ads, 207, 212
Product
 competing, 19, 48
 launching new, 8
 parity, 11
 placement, 7, 221–222
 positioning, 19
 pricing, 45, 128–129
 promotional, 185
 warranties, 186
Profiles and profiling, 18, 32–34
Promotion, 104, 158
Promotional mix, 15
Promotional pricing, 182
Promotional products, 185
PRSA, 104
PSMS, 204–205
Psychographic profiles, 18, 32–33
Public opinion, 109
Public relations
 brand buzz and, 109
 campaign and, advertising, 9
 community relations and, 110
 databases and, 111
 defining, 104
 direct mail and, 164
 function of, 105–106
 image management and, 110–111
 Integrated Marketing Communication and, 104–107, 113–115
 lobbyists and, 115
 marketing, 106–107
 news and, 115
 niche markets and, 110
 options for design and copy
 annual reports, 122–123
 fact sheets, 119
 newsletters, 119–122
 overview, 115
 pitch letters, 119
 press kits, 117, 119
 press releases, 115–117, *118*
 public opinion and, 109
 relationship building and, 108–111
 scandals and, 109
 strengths of, 111–113
 target audience, 104
 tone and, 111

Public relations *(continued)*
 traditional advertising and, 105–107
 weaknesses of, 113
Public Relations Society of America (PRSA), 104
Publicity, 104
Publics, 104
Purchaser audience, 37

Qualitative research, 29–32
Quantitative research, 29–32

Radio
 advertising, 135–137
 Integrated Marketing Communication and, 136
 message of, 137
 scripts, 140, *142*
 spots, 136
 visual/verbal messages of, 137–139
Ray-Ban ads, *21, 87, 157*
Readability of type and message, 66, 69–70, 74, 97
Rebates, 185
Rebus layout style, 90
Recession, economic (2008–2010), 4–5, 45
Refunds, 185
Relationships, building, 40, 108–111, 190
Repetition as design principle, 59
Reply cards, 170
Repositioning of brand or product, 47–48
Research, marketing
 campaign and, advertising, 28
 copytesting and, 31–32
 defining, 29
 focus groups and, 30–31
 for media vehicles, identifying best, 37
 posttesting, 30, 32
 pretesting, 30–32
 primary, 30
 qualitative, 29–32
 quantitative, 29–32
 secondary, 30
 targets
 motivations for buying and, 35–37
 primary, 35
 secondary, 35
 zeroing in on, 32–34

Resolution (pixels), 196
Retail advertising campaigns, 11, *12*, 128–129
Return envelope, 170–171
Reverses (color), 98
Reward programs, 172
Ries, Al, 16, 47
Rooms to Go ad, *132*
Rothenberg, Randall, 12
Roughs (renderings), 60
Ruby Tuesday ad, *151*

Sales, 10–11, 104
Sales promotion. *See also specific type*
 defining, 175
 Integrated Marketing Communication and, 175–176
 popularity of, 175–176
 strengths of, 176–178
 successful, 176–177
 types of, 178–186
 weaknesses of, 176, 178
Samples, 180, 184
Sans serif type, 67–68, 74
Scandals, 109
Scenes, television, 145
Scholastic Media, 209
Screen tints, 98
Scripts
 defining, 145
 radio, 140, *142*
 television, 140, *142*, 145
Search engine marketing (SEM), 201
Search engine optimization (SEO), 201
Search engines, 201
Sears catalog, 162
Secondary market research, 30
Secondary target audience, 18, 35, 37
Segmentation of target audience, 33–35
Selling, 10–11, 104
SEM, 201
Sender, Sol, 99
SEO, 201
Serif type, 67–68, 73–74
Service advertising campaigns, 10
Shape as design element, 57
Shareholders, 104
Sharpie ad, *3*
Shoots, television, 146–147
Short Message Service (SMS), 203–205
Sidebars (vertical banners), 197–198

Silhouette layout style, 90
Simile, 83
SitOrSquat.com, 207
Skyscrapers (vertical banners), 197–198
Skywriting, 213
Slogan, 7, 20, 86
Smartphones, 207
SMS, 203–205
Social media, 109, 201–203
Soothing Naturals ads, *50*, *219*
Southwest Airlines ad, *12*
Space as design principle, 58
SPCA ad, *69*
Special events, 185
Special-interest magazines, 133
Specialty packaging, 182
Spokesperson, 9, 40–41, 92–93
Spot color, 98
Starbucks Coffee ads, *31*, *42*
Stealth marketing, 211
Storyboards, 145
Stove Top Stuffing Mix ads, 155
Street marketing, 211–212
Stuffers, 171
Subheads
 in brochure, 168
 design of, 84–85
 in e-mail messages, 77
 function of, 84–85
 in geometric layout, 64
 headlines and, 84
 price and, 128
 in print ads, 75
 in roughs, 60
Super Bowl ads, 19
Super comprehensives (super comps), 60–61
Supplemental advertising, 180
Support statement, 20
Surveys, 28–29
Sweepstakes, 185–186
Symbols encompassing brands, 48–49
Symmetrical design, 59

Tagline, 7, 20, 86
Target audience
 alternative media in reaching, 213–214
 classifications of, 32
 defining, 32
 educating, 189–190
 electronic media and, 189–190

Target audience *(continued)*
 interacting with, 189–190, 195–196
 mobile communication and, 203–207
 motivations for buying and, 35–37
 Percy's groups of, 36–37
 primary, 18, 35
 profile, 18
 public relations, 104
 secondary, 18, 35, 37
 segmenting, 33–35
 websites and, 189–190
 zeroing in on, 32–34
Target market. *See* Target audience
Target (store) ads, 127
Taxi advertising, 155–156
Television
 advertising, 140, 143
 Burnett's view of, 143
 via cell phone, 205
 interactive, 172–173
 sales and, 143
 scenes, 145
 scripts, 140, *142*, 145
 shoots, 146–147
 storyboards, 145
 visual/verbal messages of, 145–147
Terminal advertising, 156
Testimonials, 133
Text wrap, 70–71, 90
Texture as design element, 58
Third screen devices, 206
Three-dimensional advertising, 222–223
Thumbnails, 60
Tone, 6, 20, 111
Toothpick ad, *46*
Tootsie Roll ad, *27*
Toro Lawn Mower ads, *34*, *204*
Trade-in allowances, 186
Traditional advertising. *See also specific*
 type
 brand and, 5
 as business, 15–16
 cooperative, 130
 as creative process, 15–16
 direct marketing and, 160
 Integrated Marketing Communication
 and, 4–6, 125–126
 magazine, 131–135
 marketing plan and, 16–20
 newspaper, 127–130
 public relations and, 105–107

Traditional advertising *(continued)*
 radio, 135–139
 strengths of, 126
 television, 140, *142*, 143, 145–147
 weaknesses of, 125, 127
Transit advertising, 153–156
Transit shelter advertising, 155
Trial offers, 185
Trim part of ad, 134
Trout, Jack, 16, 46–47
Tuesday Morning ad, *179*
Tune, catchy, 9, 40–41, 86–87, 138
Twitter, 201–202
Tylenol ads, 48
Type
 alignments, 64, 70–71
 ascenders, 67
 in catalogs, 162
 color, 72
 descenders, 67
 design
 broadcast media, 76–77
 e-mail messages, 77
 electronic media, 76–77
 elements, 66, 68–70
 mistakes, 72
 for multiple media vehicles, 72–77
 out-of-home media, 76
 print, 73–76
 direction, 72
 eyeballing, 69
 image and, 66–67
 kerning and, 68–69, 74
 leading and, 68, 70, 74
 legibility of, 66, 69, 97
 line breaks, 71
 placement on page, 70–71
 readability of, 66, 69, 74
 sans serif, 67–68, 74
 selecting, 67–68
 serif, 67–68, 73–74
 size of, 71–72, 77
 on websites, 194
 weight of, 67–68
Type specimen layout style, 91
Typefaces, 9, 66. *See also* Type

Unilever's Dove Body Refresher
 sample, 180
Unique selling proposition (USP), 19
Unity as design principle, 59

Universal Product Code (UPC), 181
U.S. Census Bureau, 30
U.S. Postal Service ads, 222–223
User audience, 37
USP, 19

Value as design element, 58
Value of brand, 48
van Bel, Egbert Jan, 43
Verbal design elements. *See*
 Copywriting; Visual/verbal
 messages
Verizon ads, 130
Verizon's "Daily Scoop," 207
Vertical banner ads, 197–198
Vicks VapoDrops ad, *65*
Video projection advertising, 212
Vinyl boards, 152
VIP Gym ads, 221
Viral advertising, 200, 210
Visual design elements. *See*
 Copywriting; Visual/verbal
 messages
Visual/verbal messages
 of alternative media, 217–221
 of campaign, advertising, 55, 79–81
 color and, 97
 of direct marketing, 161
 of electronic media, 194–197
 of magazines, 129–130, 133–134
 media vehicles and, 80–81
 of newspapers, 129–130
 of out-of-home media, 150–153
 of radio, 137–139
 of television, 145–147
 of transit advertising, 153–156
Volkswagen Beetle ads and brand, 35, 47
Volume as design element, 58

Wall murals, 153
Wallscapes, 153
Wal-Mart, 11
WAP, 205

"War of the Worlds" broadcast (1938),
 210
Warranties, 186
Wasabi Steakhouse ad, *154*
Websites
 advertising on, 188, 191, 197–203
 body copy on, 195
 color on, 194–195
 design of, 193–195
 destination, 189
 educating audience via, 189–190
 image on, 195
 informational, 189
 Integrated Marketing Communication
 and, 188
 interacting with audience via, 189–190,
 195–196
 layout of, 194–195
 niche, 192
 relationship building and, 190
 resolution and, 196
 size of file and, 196
 target audience and, 189–190
 type on, 194
Weight of type, 67–68
Welles, Orson, 210
Wendy's slogan, 79
Widow (line break), 71
Wireframe, 193
Wireless application protocol (WAP),
 205
Wireless media. *See* Mobile media
Wite Out brand, 45
Witness Against Torture campaign, 220
Word-of-mouth advertising, 109, 200–
 201, 210–211
Wrapped text, 70–71, 90

Xerox brand, 45

Yankee Candle ad, *169*

Zucker, Jeff, 203

About the Author

Robyn Blakeman received her bachelor's degree from the University of Nebraska in 1980 and her master's from Southern Methodist University in Dallas, Texas, in 1996.

Upon graduation in 1980, she moved to Texas, where she began her career as a designer for an architectural magazine. She then took a position as mechanical director for one of the top advertising agencies in Dallas before eventually leaving to work as a freelance designer.

Blakeman began teaching advertising and graphic design in 1987, first with the Art Institutes and then as an Assistant Professor of Advertising, teaching both graphic and computer design at Southern Methodist University. As an Assistant Professor of Advertising at West Virginia University, she developed the creative track in layout and design and was also responsible for designing and developing the first online Integrated Marketing Communication graduate program in the country.

Blakeman has been nominated five times for inclusion in *Who's Who Among America's Teachers,* is included in *Who's Who in America*, and is a member of Kappa Tau Alpha.

In addition, Blakeman is the author of six books: *The Bare Bones of Advertising Print Design, Integrated Marketing Communication: Creative Strategy from Idea to Implementation, The Bare Bones Introduction to Integrated Marketing Communication, The Brains Behind Great Ad Campaigns, Advertising Campaign Design: Just the Essentials,* and *Strategic Uses of Alternative Media: Just the Essentials.* Professor Blakeman currently teaches advertising design at the University of Tennessee, Knoxville.